W9-BUF-128

Figurative Cast Iron

A Collector's Guide

Douglas Congdon-Martin

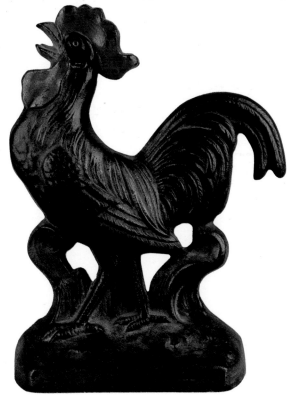

Schiffer Publishing Ltd

77 Lower Valley Road, Atglen, PA 19310

Dedication

This book is dedicated in memory of Frank Whitson, who became a friend to me during my work on it, and who, during his long career in the world of antiques, nurtured and befriended many. He is missed.

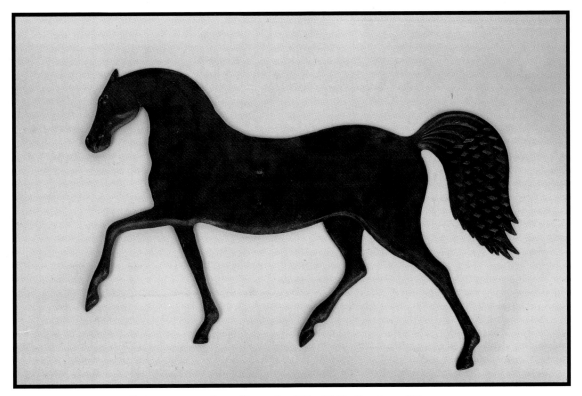

Gate ornament, from Kentucky, 18" x 27.5". *Courtesy of Nancy and John Smith.*

Copyright © 1994 by Schiffer Publishing, Ltd.
Library of Congress Catalog Number: 94-65628

All rights reserved. No part of this work may be reproduced or used in any forms or by any means–graphic, electronic or mechanical, including photocopying or information storage and retrieval systems–without written permission from the copyright holder.

Printed in China.
ISBN: 0-88740-622-X

Published by Schiffer Publishing, Ltd.
77 Lower Valley Road
Atglen, PA 19310
Please write for a free catalog.
This book may be purchased from the publisher.
Please include $2.95 postage.
Try your bookstore first.

We are interested in hearing from authors
with book ideas on related subjects.

Acknowledgments

I have long ago learned that putting together a book like this is a community effort. It depends on the willingness of others to share of themselves and their collections. I have been very fortunate to have been aided and abetted by a number of generous folks. I wish to thank

Frank and Fran Whitson
John and Nancy Smith and their children Todd and Brooke
Sheila and Edward Malakoff
Barbara and Bob Lauver
Linda Bilo
John Wright Foundry and it cast iron workers

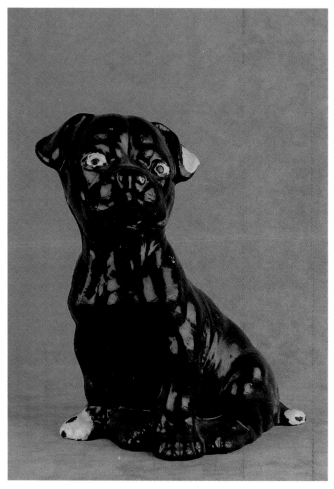

Three dimensional brown dog, 8.50" x 7". *Courtesy of Frank Whitson.*

Contents

In their classic work on cast iron, John Gloag and Derek Bridgwater trace the earliest use of iron to about 4000 B.C. in ancient Egypt. Iron beads which were refined from iron ore and wrought into shape have survived from that time to this. In the centuries that followed the knowledge of iron and its skillful use increased from generation to generation. Because iron was both strong and malleable, it's had a great variety of uses in ancient times, as it does today. Most notable were the weapons it formed and its use in building construction. An archeological exploration of the palace of the King of Assyria, from 722 B.C., yielded chains, horse-bits, and other utilitarian implements that show how common the use of iron had become.

Cast iron is of more recent origin. The earliest known examples date to China in the sixth century A.D., but there is evidence placing the origins of cast iron about 1000 years earlier than that. From its beginnings cast iron was used for figurative work. Among the earliest dated pieces is a pair of Chinese lions, dated on the base in the Chinese calendar's equivalent of September 11, 502 A.D.

Other examples shown by Gloag and Bridgwater are cast irons figures of Kwan Yin, a Chinese god, also from the sixth century, and the magnificent Great Lion of Ts'angchou, which is 18 feet long and 20 feet high, from the tenth century. (*Cast Iron in Architecture*, pages 1-5)

Iron was in use in Europe as early as 1400 B.C., and appeared in ancient Britain by 200 B.C., and perhaps earlier. The method of manufacture was probably quite primitive, but sufficient amounts of iron were produced to outfit the chariots that opposed the invasion of Caesar, as well as to manufacture other agricultural implements and weaponry.

Their weapons were not enough to keep the Romans out, however, and soon the occupiers introduced their more advanced iron technology to the British isles. British smiths developed a great deal of skill, which, in medieval times, would bring them fame and recognition. (Gloag & Bridgwater, page 9)

Cast iron, in the West at least, began as a mistake. The process of producing wrought iron involved heating the metal to a "bloom," a soft and malleable state, just short of melting. This could then be fashioned under the hammer to a strong, beautiful product. Occasionally, however, the furnace would get too hot. The iron would dissolve carbon from the charcoal that fired the furnace. This in turn, would lower the melting point of the iron, and the liquid metal would flow out the bottom of the furnace. When this iron cooled it was much more brittle than the wrought iron; so much so, that it was discarded by the furnace master.

It was not until the fourteenth or fifteenth century that the value of cast iron began to be recognized in the West. Foundries began producing cast iron objects in a variety of forms. The earliest castings were done by impressing a mold into the sand floor of the foundry. Molten iron was channeled directly from the furnace to the mold. A grave slab in England has been dated to 1350, and is probably the oldest piece in England. In addition to grave slabs, medieval uses for cast iron included andirons, firebacks, cannon, anvils, mortars, and cooking utensils. (Gloag & Bridgwater, page 11). The fluid nature of the molten iron led the ironmasters to experiment with added decorative flourishes to the work. They pressed various objects into the sand mold, leaving an impression that would be duplicated in the metal. They also carved, or had carved, more intricate designs from wood, which they pressed into the sand mold to add coats-of-arms, decorative flourishes, and pictures to the cast objects.

It is in these very early times that the figurative cast iron of the nineteenth and twentieth centuries finds its roots. But to move from that early, primitive casting to modern, mass-produced casting required some significant technological advances.

Primary among them was a question of energy. Refining and forging iron requires immense amounts of heat. In the early foundries, the fuel used to produce this heat was charcoal, which was made by burning wood under controlled conditions. According to Alex Ames (*Collecting Cast Iron*, p. 7), it took one acre of forest to produce, at most, twelve tons of charcoal. This amount of charcoal, in turn, would produce less than seven tons of pig iron. This vast energy requirement determined the direction of the iron industry in England. Its centers would be in those places where there was an abundance of forest and of iron ore. Transportation of either in the necessary amounts was impossible.

While the clearing of forests created somewhat of a boon to agriculture and transport, it was short lived. The country was becoming bare, and a great natural resource was going up in smoke. The growing ship making industry was finding it difficult to find suitable timber for its demand, as were others who needed timber for shelter and commerce. By the middle of the sixteenth century, the forests of England had suffered from such over-cutting that an act was passed in 1543 limiting the cutting of woods and coppices, except in Surrey, Sussex, and Kent, the iron centers. The shortage, however continued and, in an effort to support the ship makers, another act was passed in 1558 prohibiting the use of any trees growing within fourteen miles of the coast or navigable rivers as fuel. Again, the major iron centers were ex-

empt, but it was clear that their days were numbered unless another energy source was found.

The industry limped along for over a century, restrained in its growth by the lack of an alternative fuel. Some experiments were done with coke, or processed coal, but they had only limited application. The industry gradually moved out of the traditional regions to find new resources for its production. Interestingly, cast iron was less affected by these times than the other forms of iron. Because it was poured directly into molds from the furnace without the necessity to reheat it for shaping, it was more energy efficient and, therefore, more profitable.

The figure who pioneered the emergence of the cast iron industry was Abraham Darby. Born in 1676, he began an iron and brass works in 1699, following an apprenticeship. He brought the vigor of youth to the work and began to experiment with the applications of cast iron. A journey to Holland in 1704 yielded some secrets about hollow casting, and Darby applied them to the creation of new molds that would produce complex shapes like bellied pots and kettles. This was far beyond the capacity of the simple sand molds in use at the time, though pots and kettles were made in England at the time and had been imported from Europe. What was unique about Darby's 1707 patent is that it was for bellied pots. This required a new sophistication of technology, and the use of mold boxes for the casting. This two-part box gave almost limitless possibilities to the use of cast iron.

More notable still was Darby's introduction of a practical way to use coke as a fuel. Some time between 1705 and 1713 he successfully smelted iron ore using coke. It began a slow but steady revolution in the iron industry. Coal was an abundant resource, breaking the industry free from its dependence on wood, and allowing it to grow. As a side benefit, coke allowed for much larger furnaces. Charcoal simply could not support the weight of too much iron ore, limiting the size of the smelting furnace. The use of coke allowed for larger furnaces opening the way to mass production on a scale that had been impossible with charcoal-fired furnaces.

One final advantage to the use of coke for smelting was that the iron produced by coke flowed more freely than charcoal smelted iron. Because of this it could be used in much more intricate patterns. The ability to cast accurate and complicated iron parts and to reproduce them again and again, was the foundation of the industrial revolution. Cast iron was used for the engines that drove new industries, and, in turn, these engines made the production of cast iron more efficient and cost effective. By the late 1700s cast iron was being used for bridges, machinery, aqueducts, and architectural decoration throughout England.

Casting Iron in America

The earliest iron making venture in America began and ended in failure. The colonists in Jamestown thought they would find precious metals and a route to China. They failed in both. But they did find a quantity of iron ore. Some was sent back to England in 1607 and 1608, principally as ballast for the ships. It was found to be of good quality.

It took some years before the colonists at Jamestown were ready to turn from their search for the exotic and quick treasures, to the more mundane resource of iron. But as the forests in England disappeared and restrictions to iron production grew, some enterprising investors saw an opportunity for profit. In 1619, major efforts were undertaken to build iron works in the Virginia colony. One hundred fifty or more skilled workers undertook the construction of three iron works at Falling Creek, and in April, 1622 they expected to be in full operation.

These hopes were dashed when the Falling Creek settlement was massacred by Indians on March 22, 1622. Though there were some further efforts to begin an iron industry in Virginia, it was not to be.

The colonists in New England found more success. In part, according to James Mulholland in his book *A History of Metals in Colonial America*, this was because of a different attitude among the colonists. Where the Jamestown efforts were entirely directed at finding a product they could export to England and realize a profit, the colonists in New England were in America for other reasons, principle among them the pursuit of religious freedom. They saw that this was their new home. The product of their ironworks was not so much for export as it was for their use.

With the coming civil war in England, the resources that the colonists depended on from the mother country, began to dry up. In 1641 a mission headed by John Winthrop, Jr. went to England to find the resources and personnel to begin an ironworks in Massachusetts. In 1644 the ironworks opened near Braintree, Massachusetts. When the supply of charcoal ran out the works were moved to the Saugus River in Lynn, Massachusetts in 1647. It was never wildly successful from a financial perspective, but it continued in operation until 1676.

According to Mulholland, "When poor management brought about the failure of the company, the reservoir of technological know-how remained." (Mulholland, page 35). The iron industry in America continued to grow. It spread to other parts of New England and into New Jersey and Pennsylvania. By the beginning of the 18th century the American industry was quite strong, strong enough that England felt its own iron industry was suffering from the competition. They began to enact laws that restricted the

American industry. In large part the British attempts to regulate and slow the growth of the American industry were ignored by the colonists, and the industry continued its growth. Along with the Stamp Act, England passed an Iron Act in 1764 that imposed duties on import and export, and new limitations on manufacture. The issue of iron became part of the revolutionary debate, but even the debate was growing so was the iron industry. According to Mulholland, on average two new blast furnaces were being built every year following 1750 (Mulholland, page 113).

Figurative Cast Iron

The malleability of cast iron did not escape the artisan's eye even in its earliest times. As mentioned earlier, the ancient Chinese founders used it create the cat that is among earliest known examples of cast iron. The forms that figurative cast iron took, however, have been limited by the state of technology.

As technology advanced so did the art of cast iron. Some of the stoves and firebacks shown in Mercer's The *Bible in Iron*, reveal the intricacy that could be obtained from the molds in the floor of the iron furnace room. With the introduction of Darby's mold boxes and the use of multi-part complicated molds, the possibilities grew. And when the more malleable, coke-fired iron became the industry standard, cast iron found its way into everything from cannon to fine machine parts.

At the same time that the iron technology was reaching new levels, societal changes were leading toward new and creative uses. Michael Owen points to the growing urban populations in England in the late eighteenth century (Owen, page 5 ff.). In the dense urban communities, the call of the visitor at the door was much more frequent than in the country. Doorknockers were the genteel way to let one's presence be known, and cast iron was the perfect medium. Likewise, for letter boxes, railings, foot scrapers, doorporters and more; figurative cast iron became an inexpensive accent for the home, a touch of grace, a bit of art. In the age of industry and invention, the only limit seemed to be the imagination.

Doorstops

Among today's collectors the favorite form of figurative cast iron is, without a doubt, the doorstop. Bernard Hughes traces its origins to 1775 when two British inventors, John Izon and Thomas Whitehurst, patented a rising hinge that caused a door to close by itself if it was not propped open. Others suggest that the origin was earlier, probably a pretty rock used to keep the door open on a breezy day.

In England, the manufacture of doorporters may date to 1791, the year that the Archibald Kenrick & Sons was founded. Though no catalog from before 1840 exists, there were some 26 styles offered in a catalog of that year. One surmises that the form was introduced sometime before that. It reached its height in the Kenrick catalog between 1871 and 1880, when nearly fifty patterns were offered. Other founders producing doorporters and doorstops in England were Coalbrookdale, which produced 35 styles in 1875, Falkirk, T.J. Jones, Harper & Company, Baldwin, Son & Company, and Bowling Iron Works. (Ames, page 62 ff.) The production faded in the following years. In the Kenrick catalog of 1926 only 7 patterns were listed.

In America the interest in doorstops bloomed a little later, with the high point being in the early twentieth century. Jeanne Bertoia traces the height of their popularity to the late 1920s. (Bertoia, page 9). The Albany Foundry (1897-1932) listed 34 styles available in their 1924 catalog. Other American foundries included: A.M. Greenblatt (1924-1949); Bradley & Hubbard (founded 1854); Eastern Specialty Manufacturing Company (1893-1930); Hubley Manufacturing Company (founded 1894); Littco Products (1916-present); National Foundry (founded c. 1880); Wilton Products, Inc. (currently in business); John Wright Foundry (currently in business). (Bertoia, pages 16-17) In addition to these Jeanne Bertoia lists the American companies of Sculptured Metal Studios, Spencer, Creation Company, Virginia Metalcrafters, and Vindex, as well as companies using the marks EOM Co., cJo, and WS. Ms. Bertoia's research and the book it produced have encouraged the hobby of collecting doorstops, and remain an important tool for collectors.

Bookends

A close relationship exists between doorstops and bookends. Indeed many patterns were sold as sets: one doorstop and two bookends. Most of the manufacturers of doorstops also produced bookends. The Albany catalog cited above includes and equal number of bookends.

Bottle Openers

Necessity is the mother of invention, or, in this case at least, invention is the mother of necessity. In 1892, William Painter of Baltimore, Maryland invented the bottle cap. And this invention was the mother of the bottle opener. The urgency was even greater in 1903 when Michael Owens devised a machine that produced bottles of uniform size that the caps would fit snugly upon. That invention led to

the acceptance of the bottle cap and the growth of the bottle opener industry.

Of course, some openers are simple affairs, a loop of steel, the cut-out tab of a church key. But, as usual, the malleability of cast iron led to a variety of designs. Pretzels, birds, drunks holding up lamp posts, four eyed creatures with conveniently situated buck teeth, and dozens of other designs and variations, make bottle openers a fun area for cast iron collectors.

Doorknockers

From the late 18th century doorknockers were a mainstay of the cast iron industry. They came in a myriad of styles, to reflect the style of the architecture or simply the taste of the owner. The Kenrick catalog of 1840 lists nearly 100 styles, and their catalog of 1871 lists even more.

While the English turned principally to traditional designs, the Americans were more daring. As you will see on the following pages, the variety of design produced by our manufacturers is delightful.

Other Functional Forms of Figurative Cast Iron

The delightful thing about cast iron is the many forms it takes. It also makes it impossible in a book like this to completely cover the topic. Indeed, the world of cast iron toys alone, which are included here only as far as banks can be considered toys, has filled many volumes on its own, and can fill many others. What this book tries to do is give representative samples of the functional forms figurative cast iron takes: holding open doors, opening bottles, holding up books, knocking on doors.

There are other functional, yet figurative forms. At the desk a cast iron turtle serves as a paperweight or a pencil holder. At the counter a Jack-O-Lantern holds the string. On the bed table a beehive holds loose change. On the lawn a frog is a sprinkler. An alligator has been used to press corks in the pharmacy, a cat helps seal hems at the seamstress's table, and pot of flowers holds place cards. Rifles have aimed at iron eagles, windmills have been counterweighted by iron roosters, feet have been scraped clean by iron horses, and boots pulled off tired feet by iron "ladies."

No matter how mundane or inconsequential a task may have seemed, the industrial age produced an iron tool that could do the job. And more often than not the tool was as much an expression of art as of function. Not great art, to be sure, but an attempt by a creative mind to take the commonplace and make it special. That is the charm that captures the collector's heart to this day.

Bibliography

Ames, Alex. *Collecting Cast Iron*. Ashborne, Derbyshire, England: Moorland Publishing Co. Ltd., 1980.

Bertoia, Jeanne. *Doorstops: Identification & Values*. Peducah, KY: Collector Books, 1989.

D'Allemagne, Henry René. *Decorative Antique Iron Work: A Pictorial Treasury*. New York: Dover, 1968.

Gloag, John, and Derek Bridgwater. *A History of Cast Iron in Architecture*. London: George Allen and Unwin, Ltd., 1948.

Hamburger, Marilyn G., and Beverly S. Lloyd. *Collecting Figural Doorstops*. New York: A.S. Barnes and Company.

Hughes, G. Bernard. "When Nelson and Wesley Held the Door: The Vogue for Stops and Porters." *Country Life*, March 14, 1963.

Mercer, Dr. Henry C. *The Bible in Iron*. Doylestown: Bucks County Historical Society, 1941.

Mulholland, James A. *A History of Metals in Colonial America*. University, Alabama: The University of Alabama Press, 1981.

Owen, Michael. *Antique Cast Iron*. Poole, Dorset: Blandford Press.

Robertson, E. Graeme, and Joan Robertson. *Cast Iron Decoration: A World Survey*. New York: Watson-Guptill Publications, 1977.

Roe, F. Gordon. *Victorian Corners: The Style and Taste of an Era*. New York, Frederick Praeger, 1969.

DOORSTOPS

ADVERTISING

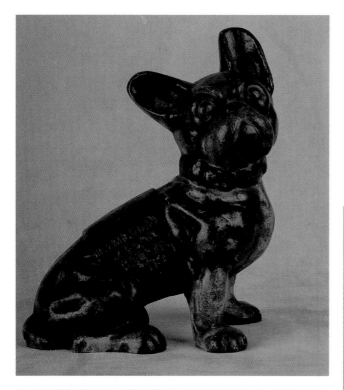

This boxer advertises the D.J. Murray Manufacturing Company of Wausau, Wisconsin. 5" x 6". *Courtesy of Sheila and Edward Malakoff.*

Eureka Steel Co. used this blue-flowers-in-basket doorstop for advertising. 6" x 4.50". *Courtesy of Sheila and Edward Malakoff.*

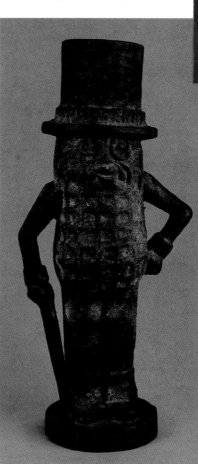

Two-piece cast Mr. Peanut doorstop and penny bank, advertising Planters Peanuts. 11.50" x 3.50". *Courtesy of Frank Whitson.*

Hollow back doorstop in the shape of a pump advertising the Cook Deep Well Pump. 8" x 5.75". *Courtesy of Frank Whitson.*

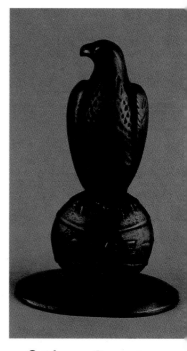

Cast bronze Case eagle doorstop. 7.50" x 5". *Courtesy of Frank Whitson.*

Chickens

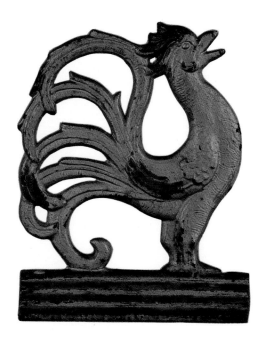

Stylized rooster, 7" x 6". *Courtesy of Frank Whitson.*

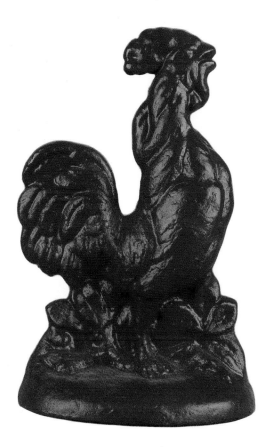

Red rooster, 10" x 6.50". *Courtesy of Frank Whitson.*

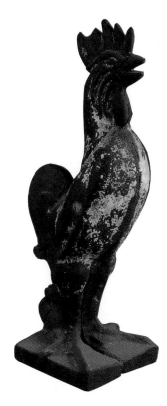

Early rooster doorstop, circa 1870. 12" x 5". *Courtesy of Frank Whitson.*

Rooster with two identical sides. 13" x 10". *Courtesy of Frank Whitson.*

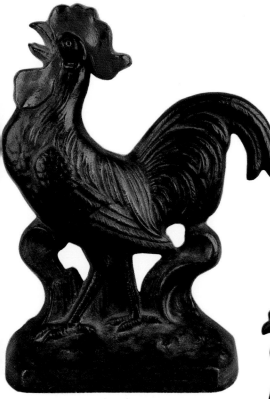

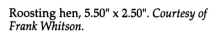

Roosting hen, 5.50" x 2.50". *Courtesy of Frank Whitson.*

Rooster, 7" x 5.50". *Courtesy of Frank Whitson.*

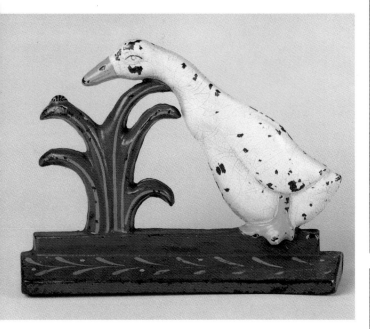

Duck and ladybug, 7.50" x 10.50". *Courtesy of Nancy and John Smith.*

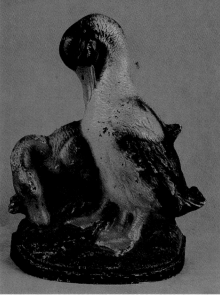

A pair of ducks, 8" x 7". Marked "291". *Courtesy of Frank Whitson.*

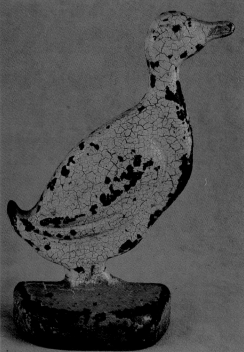

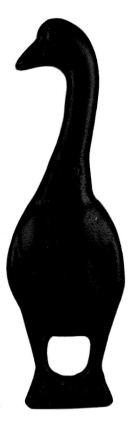

Black goose, copyright 1888. 13.25" x 4.50". *Courtesy of Frank Whitson.*

Duck, 9.75" x 6". *Courtesy of Frank Whitson.*

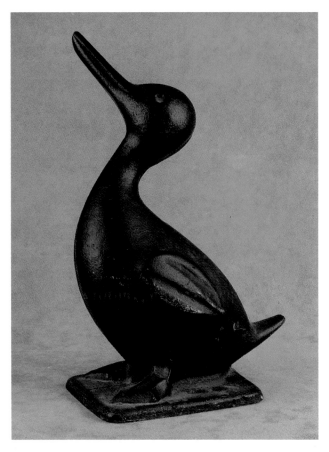

Three dimensional duck, 11.50" x 7". Marked "Copyright", "Mo8". *Courtesy of Frank Whitson.*

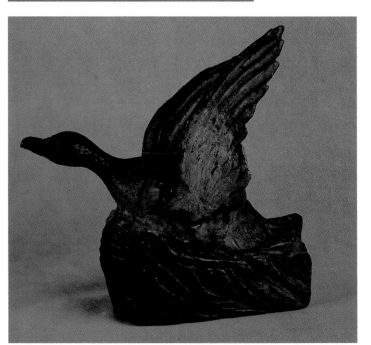

Duck taking flight. Hollow base and attached wings, 6.50" x 7.75". *Courtesy of Frank Whitson.*

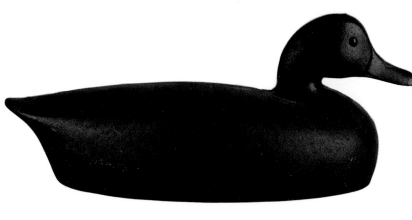

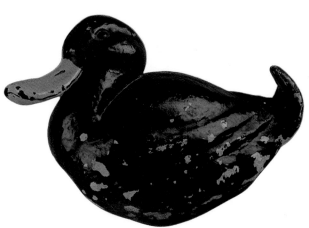

Decoy doorstop by Richard F.H. Clancy, South Street, Needham, Massachusetts. 6" x 14.50". *Courtesy of Frank Whitson.*

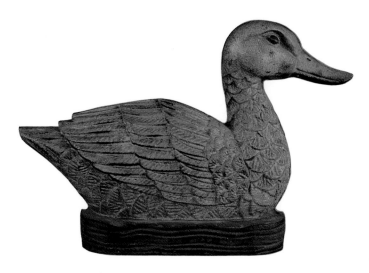

Mallard doorstop, 6.25" x 6.50". *Courtesy of Frank Whitson.*

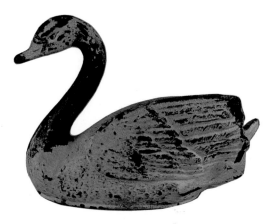

Duck on water. 7.50" x 11.50". *Courtesy of Frank Whitson.*

A swan in profile. 5.75" x 7.50". *Courtesy of Frank Whitson.*

Three dimensional goose head doorstop, 8" x 5.50". *Courtesy of Frank Whitson.*

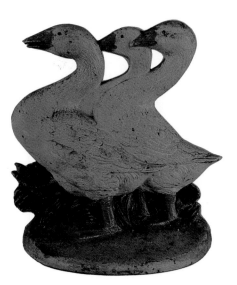

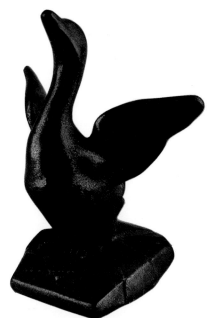

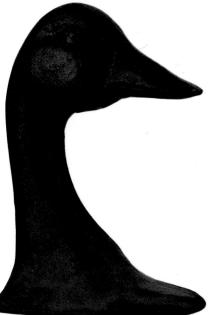

A trio of geese, 8" x 8". Marked "457". *Courtesy of Frank Whitson.*

Stylized duck taking flight. 7" x 5.50". *Courtesy of Frank Whitson.*

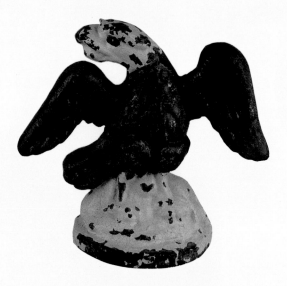

Eagle, polychrome, 7" x 8". *Courtesy of Frank Whitson.*

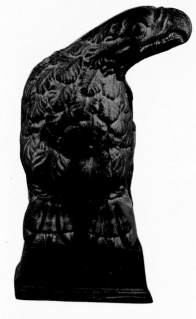

Golden eagle, 9" x 4.25". *Courtesy of Frank Whitson.*

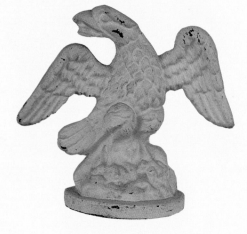

White eagle, 7" x 8". *Courtesy of Sheila and Edward Malakoff.*

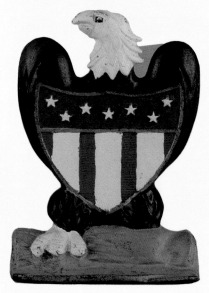

Eagle with shield, 10.50" x 7". *Courtesy of Frank Whitson.*

Owls

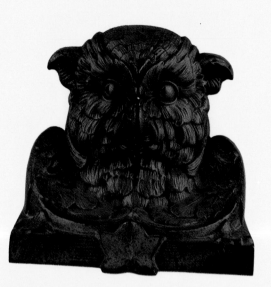

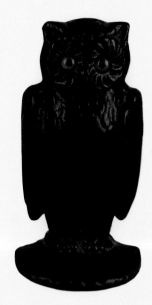

Nicely detailed owl, 6.25" x 7". Marked "9738". *Courtesy of Frank Whitson.*

Owl with glass eyes, 7" x 4". *Courtesy of Frank Whitson.*

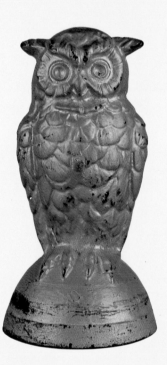

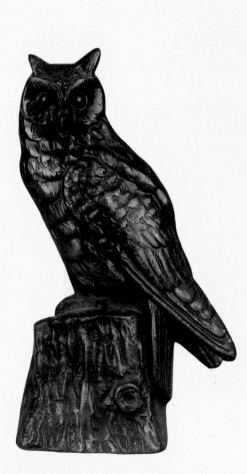

Three dimensional hollow owl, 7.75" x 4".

Pierced cast iron owl, 8.50" x 3.25". *Courtesy of Sheila and Edward Malakoff.*

Owl on a stump, 10" x 6". *Courtesy of Sheila and Edward Malakoff.*

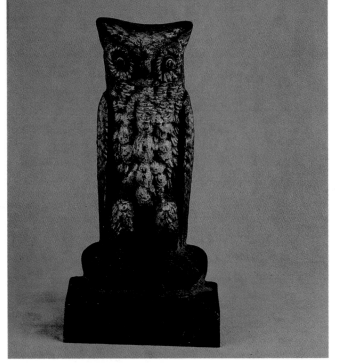

Bradley & Hubbard owl, 8" x 4.25". *Courtesy of Frank Whitson.*

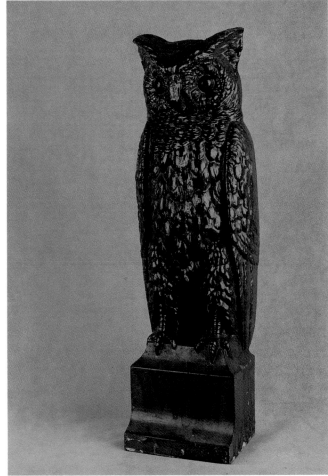

Bradley & Hubbard owl, 16" x 5.25". Marked "7797". *Courtesy of Frank Whitson.*

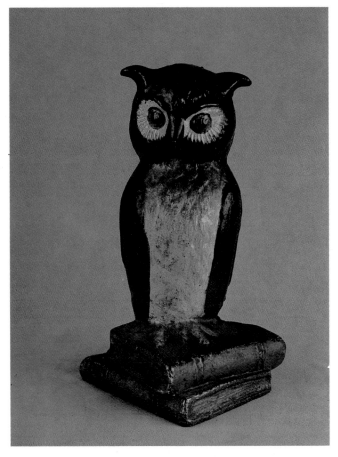

Polychrome owl, Eastern Specialty Mfg. Company, 9.50" x 6". *Courtesy of Frank Whitson.*

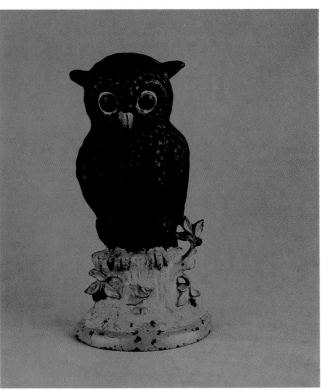

Polychrome owl, 10" x 5.25". *Courtesy of Frank Whitson.*

Parrots

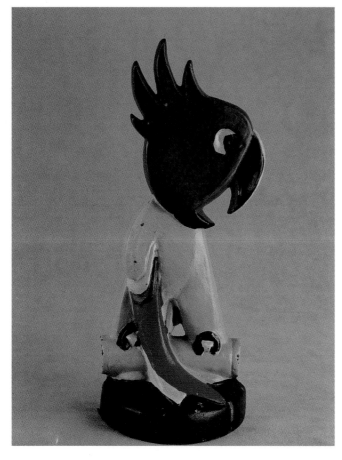

Taylor Cook parrot, c. 1930. 10.50" x 4.50". Marked "No. 4". *Courtesy of Frank Whitson.*

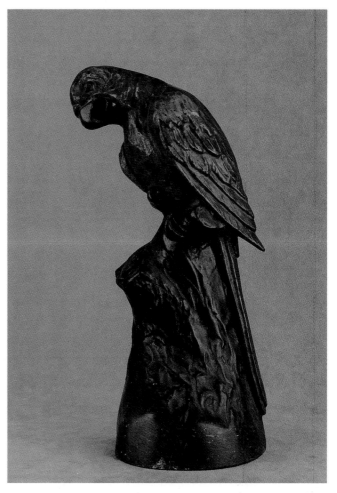

Parrot by Blodgett Studio, Lake Geneva, Wisconsin, 12.25" x 5". *Courtesy of Frank Whitson.*

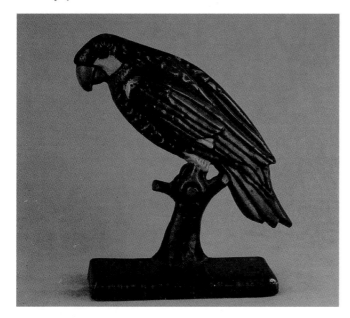

Polychrome parrot, 8" x 6". *Courtesy of Frank Whitson.*

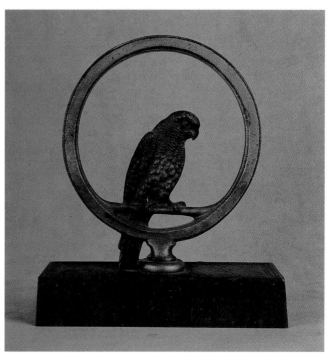

Parrot on a stand, 8" x 7". *Courtesy of Sheila and Edward Malakoff.*

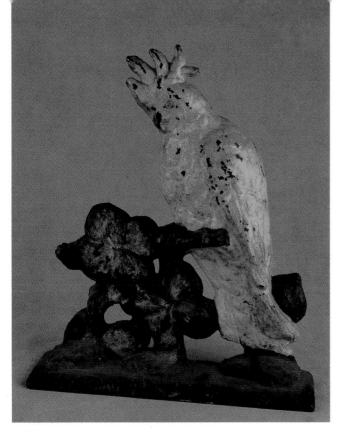

Cockatoo on a branch, 11" x 9.75". *Courtesy of Frank Whitson.*

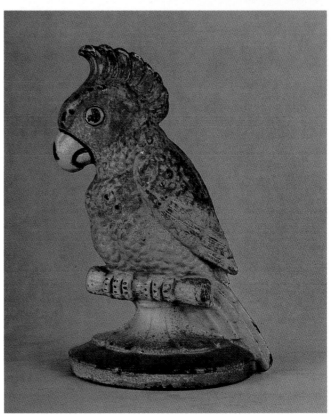

Color variation of the Hubley parrot (108), 8.25" x 5.50". *Courtesy of Sheila and Edward Malakoff.*

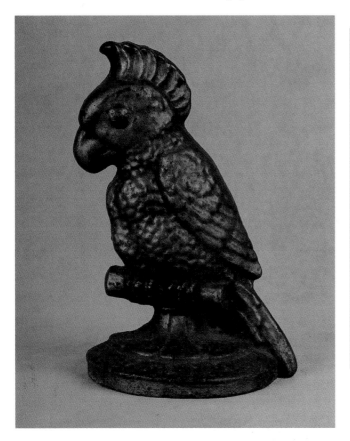

Hubley parrot, 8.25" x 5.50". *Courtesy of Sheila and Edward Malakoff.*

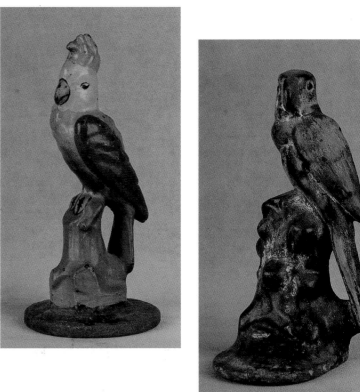

Three dimensional parrot, 7.25" x 3". *Courtesy of Sheila and Edward Malakoff.*

Parrot on a perch, 6.75" x 3.25". *Courtesy of Sheila and Edward Malakoff.*

Cockatoo, 14" x 4.50". *Courtesy of Frank Whitson.*

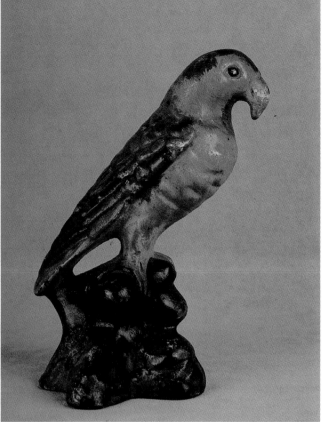

Polychrome parrot, 8.25" x 7". Marked KS. *Courtesy of Sheila and Edward Malakoff.*

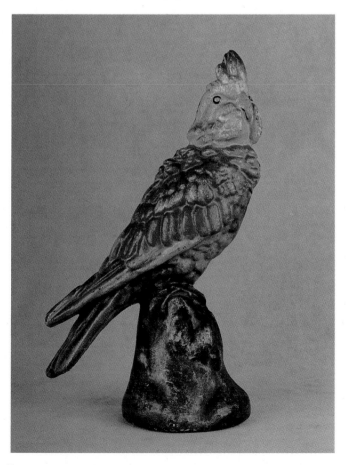

Parrot, 12.25" x 7". Albany Foundry. *Courtesy of Sheila and Edward Malakoff.*

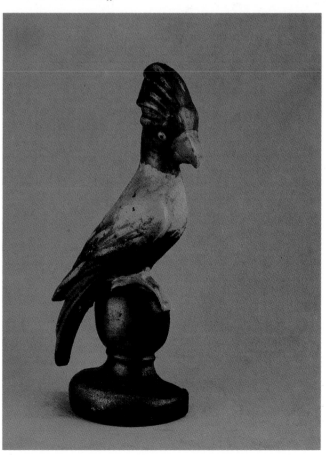

Parrot, 12.25" x 5.50". *Courtesy of Frank Whitson.*

Peacocks

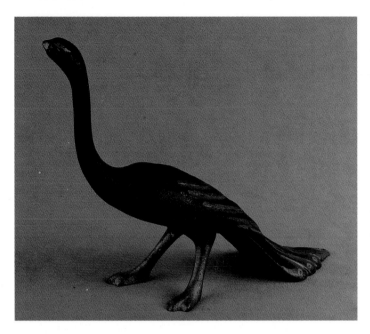

Three dimensional peacock, 12" x 3" x 7.50". *Courtesy of Frank Whitson.*

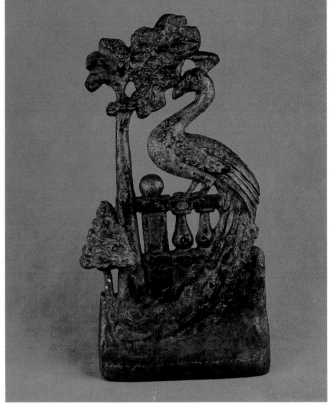

Peacock, 12" x 7.25". Marked "Copyright 1925 by AM Greenblatt Studios". *Courtesy of Frank Whitson.*

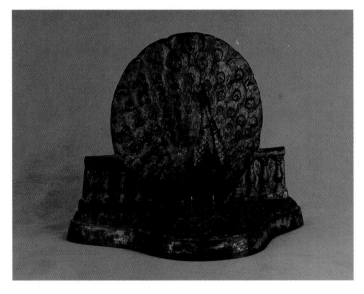

Peacock doorstop marked "YQ", 7" x 9". *Courtesy of Frank Whitson.*

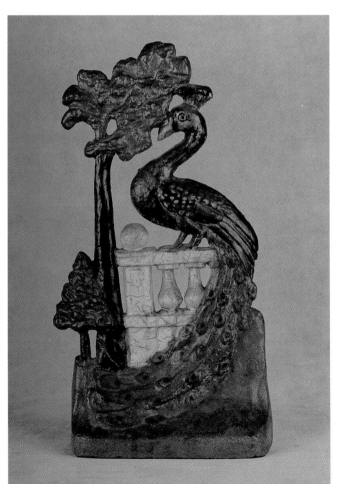

The same peacock with different paint, 12" x 7.25". Greenblatt Studios. *Courtesy of Sheila and Edward Malakoff.*

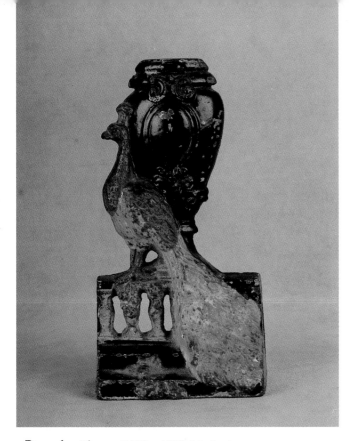

Peacock with urn, 7.75" x 4.25". Marked "209". *Courtesy of Sheila and Edward Malakoff.*

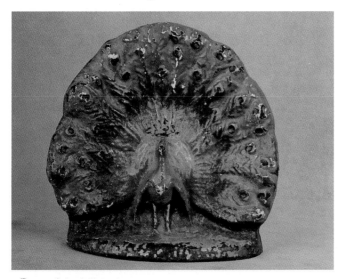

Peacock in full array, 6.50" x 6.50". *Courtesy of Sheila and Edward Malakoff.*

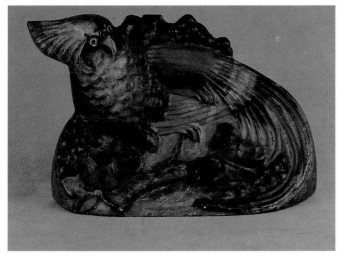

Turkeys

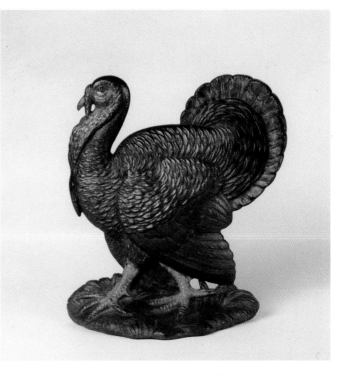

Turkey, 12.50" x 11". *Courtesy of Nancy and John Smith.*

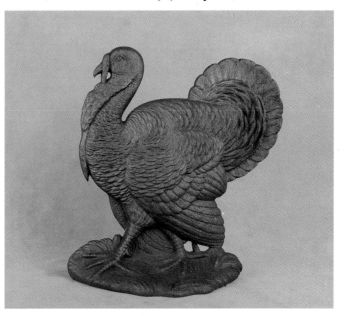

Plain painted turkey, 13" x 12". *Courtesy of Sheila and Edward Malakoff.*

Nicely styled peacock with fine paint, 5.75" x 9". *Courtesy of Frank Whitson.*

Penguins

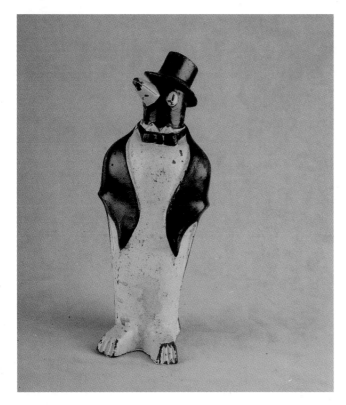

Three dimensional penguin with top hat, 11" x 4.50". *Courtesy of Frank Whitson.*

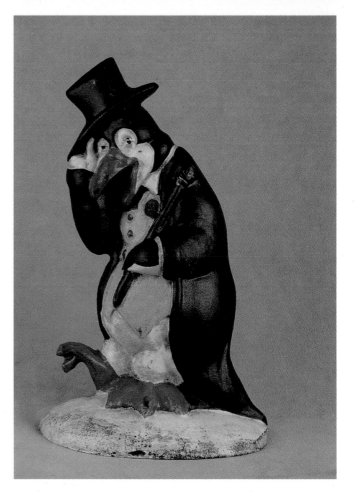

Lively penguin with blue vest, 11.50" x 7". Copyright LAP USA.

Taylor Cook penguin No. 1, copyright 1930. 9.50" x 6". *Courtesy of Sheila and Edward Malakoff.*

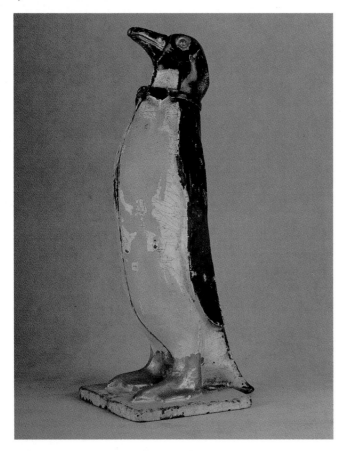

Three dimensional penguin with bow tie, 10.50" x 4". *Courtesy of Sheila and Edward Malakoff.*

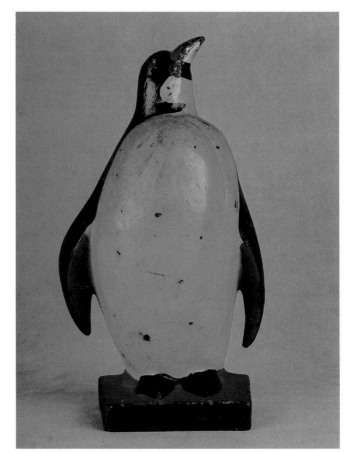

Other Birds

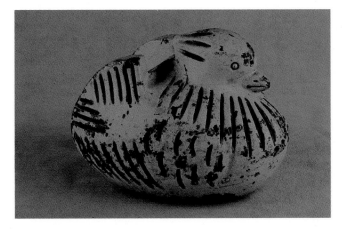

Chick, 5" x 6". *Courtesy of Frank Whitson.*

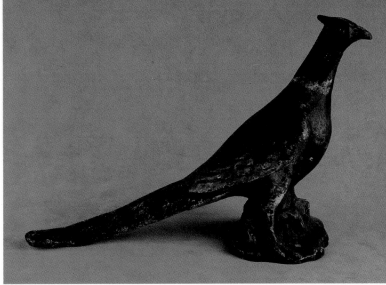

A nice, graceful ring-necked pheasant, 9.50" x 16". *Courtesy of Frank Whitson.*

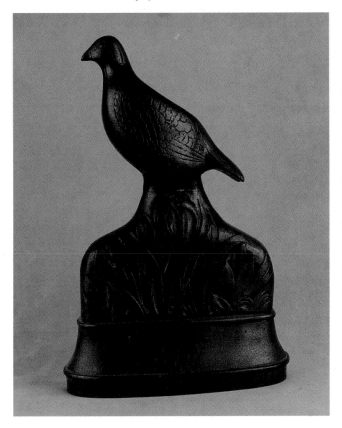

Partridge, 13.75" x 9.25". *Courtesy of Frank Whitson.*

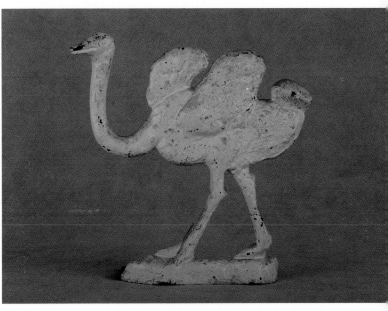

Ostrich, 8.50" x 8". *Courtesy of Sheila and Edward Malakoff.*

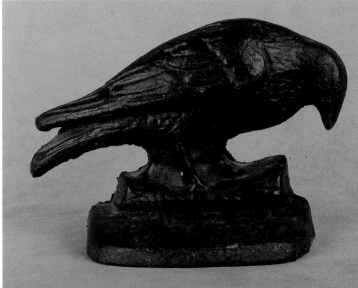

Raven looking down, 6.50" x 8.50". *Courtesy of Sheila and Edward Malakoff.*

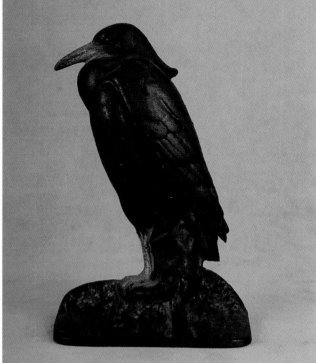

Blue heron, 8" x 5". *Courtesy of Sheila and Edward Malakoff.*

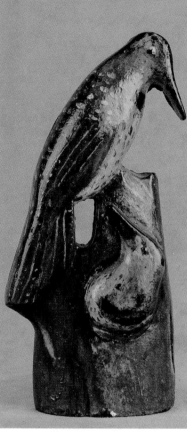

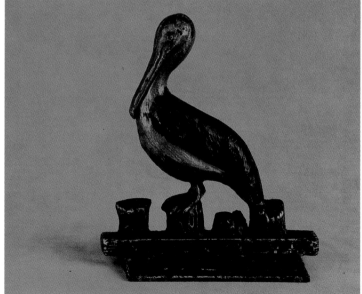

Hollow back birds, 8.25" x 3.75". *Courtesy of Frank Whitson.*

Three dimensional stork, 12" x 7". *Courtesy of Frank Whitson.*

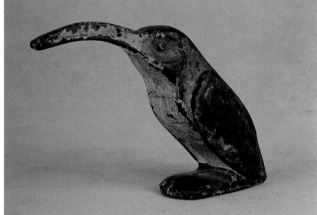

Three dimensional hummingbird, 4" x 7". *Courtesy of Sheila and Edward Malakoff.*

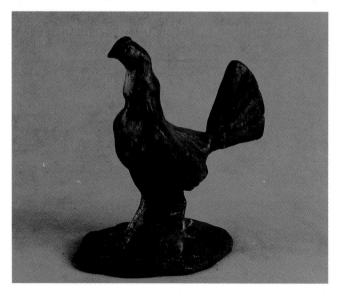

Pelican on a dock, Albany Foundry, 8" x 7.25" x 2". *Courtesy of Frank Whitson.*

Three dimensional Game Cock, 7.25" x 7". *Courtesy of Frank Whitson.*

DOGS

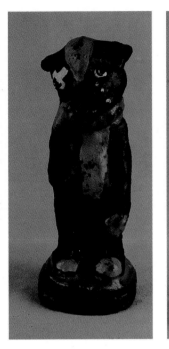

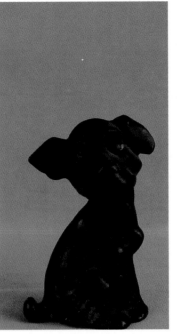

Angular sitting dog, Hubley, 11" x 5". *Courtesy of Frank Whitson.*

Crying dog, 8" x 3". *Courtesy of Frank Whitson.*

Sitting puppy, 5.50" x 3.50". *Courtesy of Frank Whitson.*

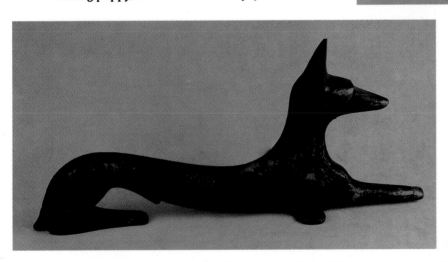

Sleek reclining dog, 7.50" x 17.50". *Courtesy of Frank Whitson.*

Caricature walking dog, Taylor Cook, 1930. 7.75" x 7.75". *Courtesy of Frank Whitson.*

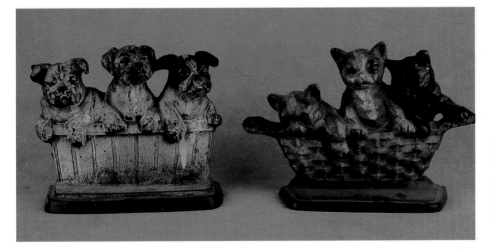

Left: Three puppies in a barrel, copyright 1932, M. Rosenstein, Lancaster, Pennsylvania, 6.50" x 8.25"; Right: Three kittens in a basket, copyright 1932, M. Rosenstein, Lancaster, Pennsylvania, 7.25" x 10.25". *Courtesy of Frank Whitson.*

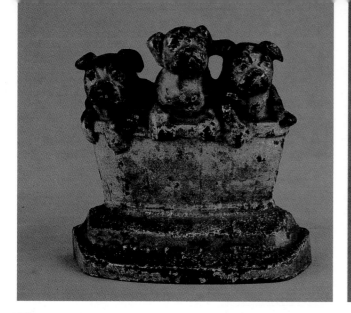

Three puppies in a barrel, 5" x 51/4". *Courtesy of Frank Whitson.*

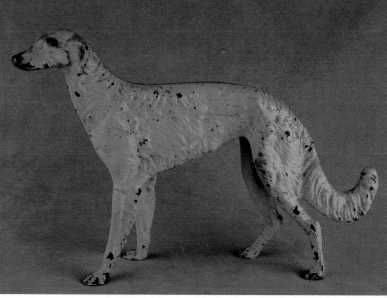

Three dimensional Afghan, 10" x 15". *Courtesy of Frank Whitson.*

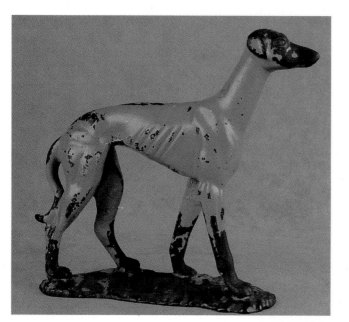

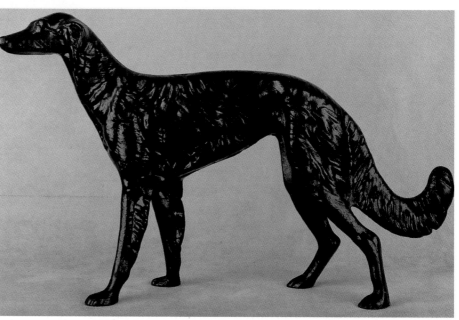

Three dimensional solid cast iron greyhound. 6.50" x 6.25". *Courtesy of Frank Whitson.*

Afghan color variation, 10" x 15". *Courtesy of Frank Whitson.*

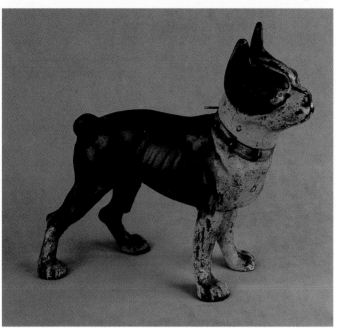

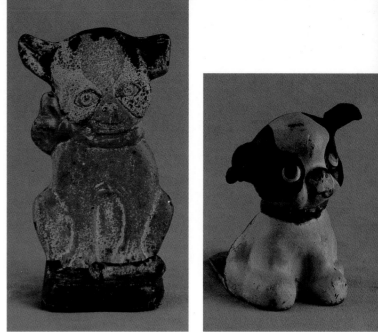

Three dimensional Boston Terrier, 2 piece construction, 9.50" x 8.50". *Courtesy of Frank Whitson.*

Terrier with orange bow, 5.25" x 3". Marked "GR", 1921. *Courtesy of Frank Whitson.*

Cute Boston Terrier puppy with red collar, 4.75" x 3". *Courtesy of Frank Whitson.*

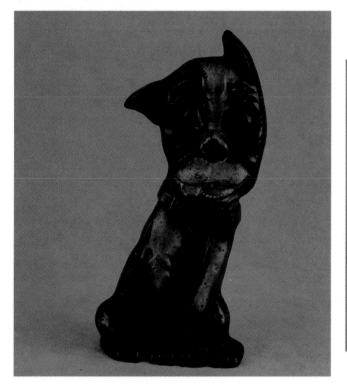

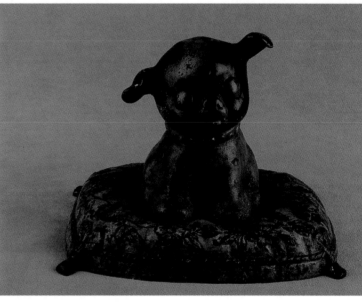

Boston Terrier on nicely painted polychrome pillow. 6" x 7.50". *Courtesy of Frank Whitson.*

Comical pup, A.M. Greenblatt Studios, 1927. 9.50" x 4.50". *Courtesy of Frank Whitson.*

Sitting terrier, 7.5" x 7.5". *Courtesy of Frank Whitson.*

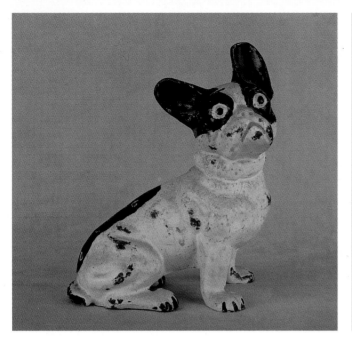

Sitting three dimensional Boston Terrier, 8" x 7". *Courtesy of Sheila and Edward Malakoff.*

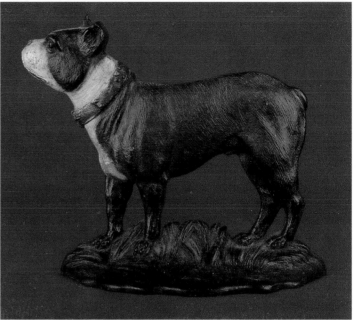

Bradley & Hubbard Boston Terrier. Rubber stops, 9.50" x 10.25". *Courtesy of Sheila and Edward Malakoff.*

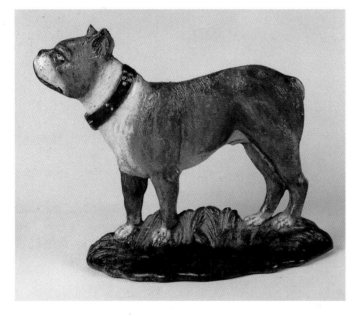

Boston terrier, 9.50" x 11". Marked "Dandy", B&H?. In unusual brundle paint. *Courtesy of Nancy and John Smith.*

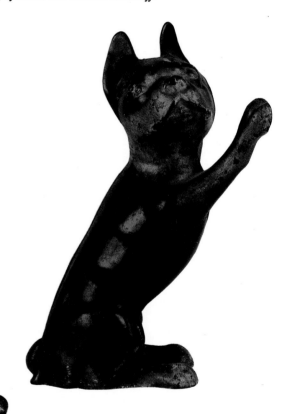

Boston Terrier, 9.25" x 7". *Courtesy of Sheila and Edward Malakoff.*

Three dimensional Boston Terrier pup, 8" x 9.25". *Courtesy of Frank Whitson.*

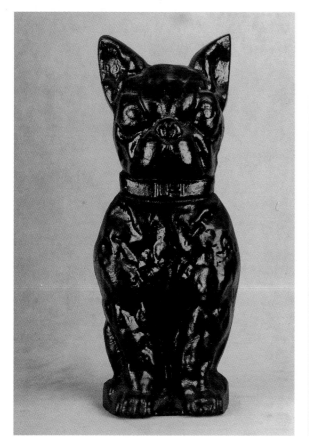

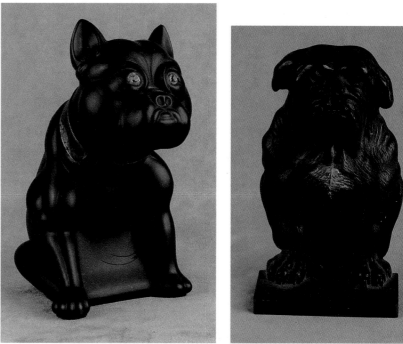

Sitting terrier, 11.75" x 5". *Courtesy of Sheila and Edward Malakoff.*

Three dimensional Bull Dog with glass eyes, 7" x 5". *Courtesy of Frank Whitson.*

A rather serious looking Bull Dog, Bradley & Hubbard, 6.25" x 5.25". *Courtesy of Frank Whitson.*

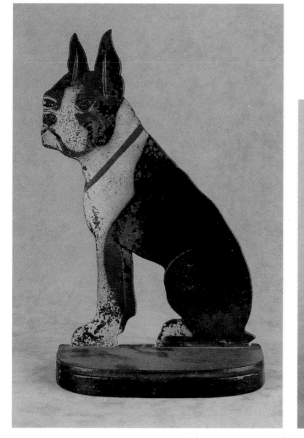

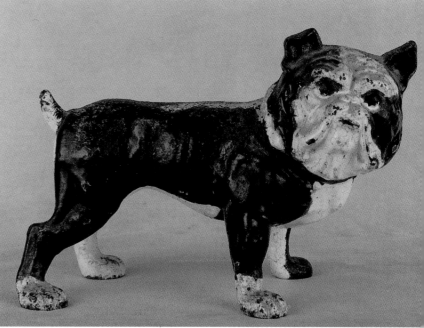

Flat Boston Terrier doorstop, 12" x 7.25". *Courtesy of Frank Whitson.*

Standing three dimensional Bull Dog, 6.75" x 9.25". *Courtesy of Sheila and Edward Malakoff.*

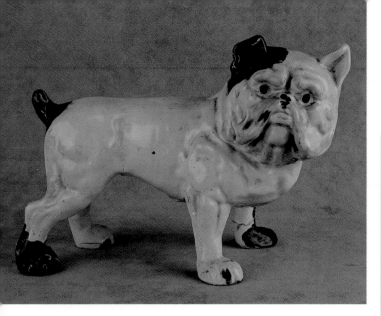

Nice example of an enameled Bull Dog, 6.25" x 8". *Courtesy of Frank Whitson.*

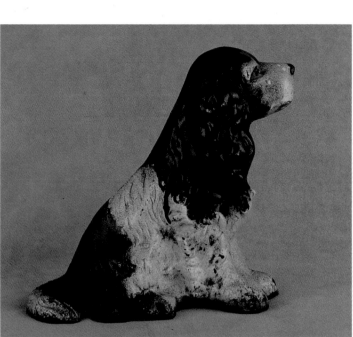

Three dimensional spaniel, 7" x 7". *Courtesy of Frank Whitson.*

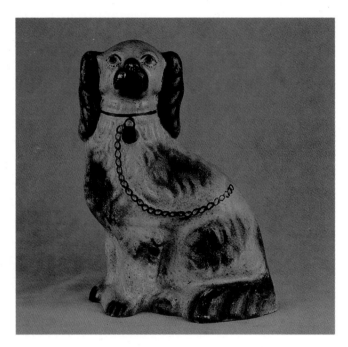

Staffordshire-style spaniel with lock and chain, 9" x7". *Courtesy of Frank Whitson.*

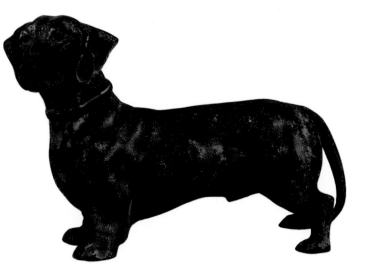

Standing Dachshund, 6.25" x 8.50". *Courtesy of Frank Whitson.*

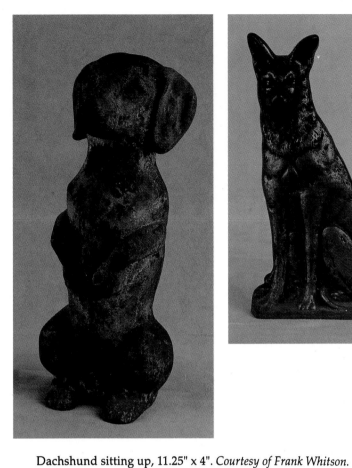

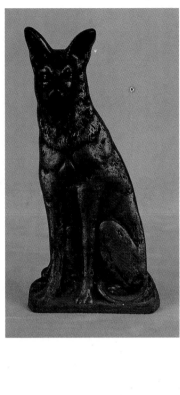

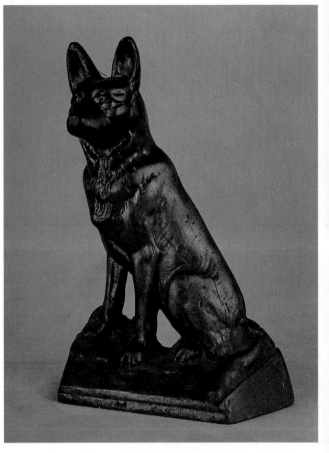

Sitting German Shepherd, 8.50" x 5.50". *Courtesy of Sheila and Edward Malakoff.*

Dachshund sitting up, 11.25" x 4". *Courtesy of Frank Whitson.*

German Shepherd, 6.50" x 3". *Courtesy of Frank Whitson.*

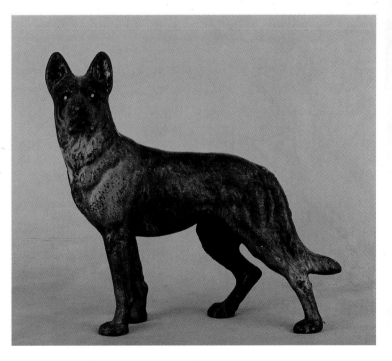

Nice standing German Shepherd, 9" x 9.25". *Courtesy of Sheila and Edward Malakoff.*

German Shepherd, 5.50" x 4.50". *Courtesy of Sheila and Edward Malakoff.*

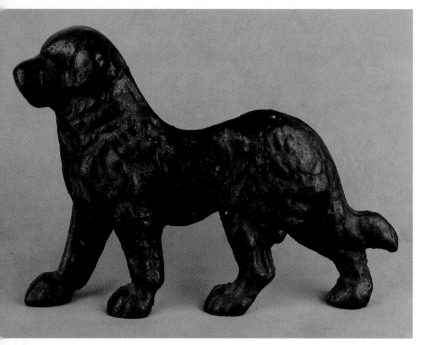

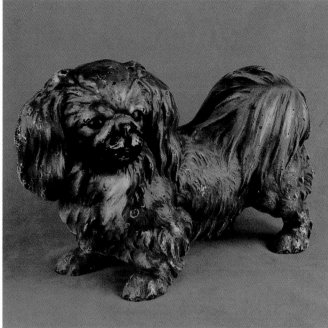

St. Bernard, 10" x 7.75". *Courtesy of Frank Whitson.*

Pekingese by Hubbard, 8.75" x 14".
Courtesy of Frank Whitson.

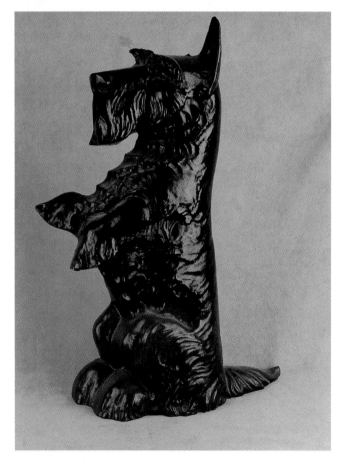

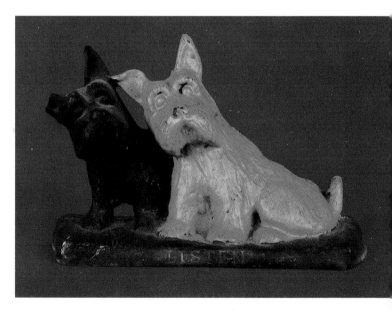

"Listen," two Scottish Terriers, 6" x 8.75". *Courtesy of Sheila and Edward Malakoff.*

Scotty sitting up, hollow, 16" x 10". Marked "JB68". *Courtesy of Frank Whitson.*

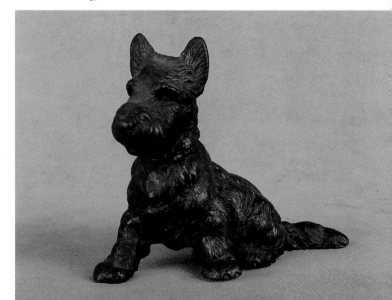

Small terrier in three dimensions, 5" x 6.50". *Courtesy of Sheila and Edward Malakoff.*

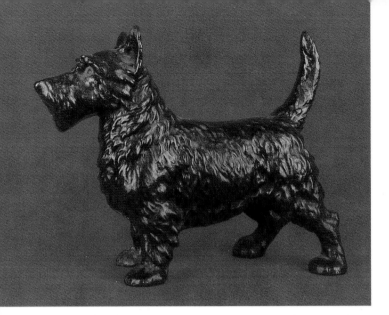

Standing Scottish Terrier, 8.25" x 10". *Courtesy of Sheila and Edward Malakoff.*

Sitting Scotty, three dimensional, 7.75" x 8". *Courtesy of Frank Whitson.*

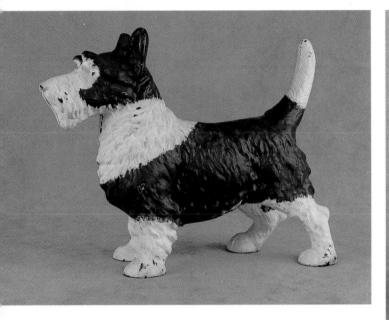

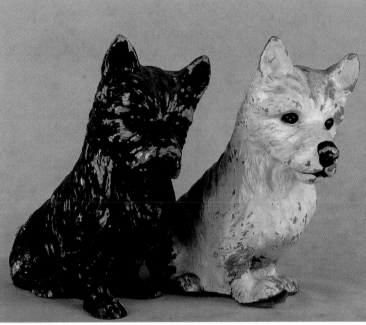

Standing Scottish Terrier, 8" x 10". *Courtesy of Frank Whitson.*

Two Scotties, 6" x 9". *Courtesy of Frank Whitson.*

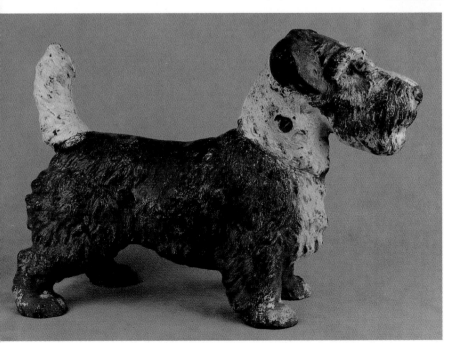

Terrier, 9.50" x 13". *Courtesy of Frank Whitson.*

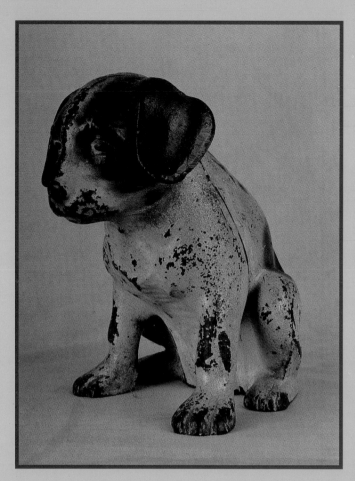

Sitting puppy, 7.75" x 8.50". *Courtesy of Sheila and Edward Malakoff.*

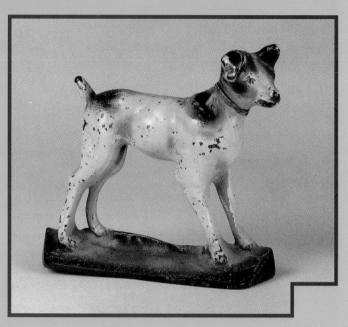

Whippet, 6.50" x 7". *Courtesy of Todd Smith.*

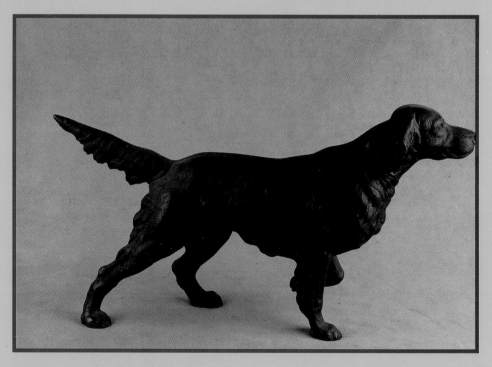

Setter, 9" x 15". *Courtesy of Frank Whitson.*

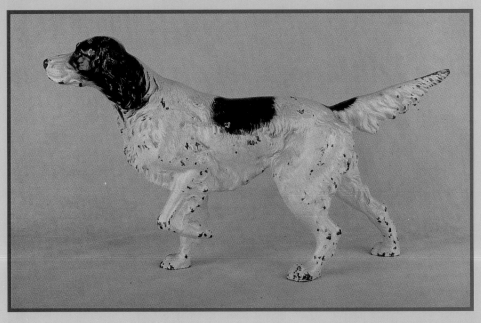

English Setter, 8.75" x 15.25". *Courtesy of Sheila and Edward Malakoff.*

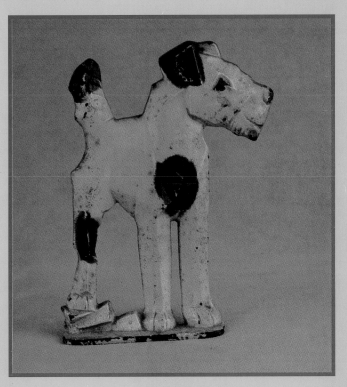

Terrier, two dimensional, Spencel Guilford Com., 6.50" x 4.50". *Courtesy of Frank Whitson.*

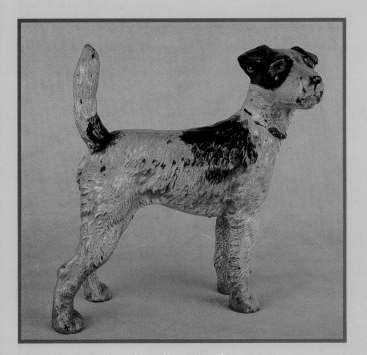

Standing terrier, three dimensional, 8.50" x 8". *Courtesy of Sheila and Edward Malakoff.*

Upright dog, 12" x 4.50". *Courtesy of Sheila and Edward Malakoff.*

Seated dog with collar, 6" x 5". *Courtesy of Sheila and Edward Malakoff.*

Three dimensional dog, 6.25" x 4". *Courtesy of Sheila and Edward Malakoff.*

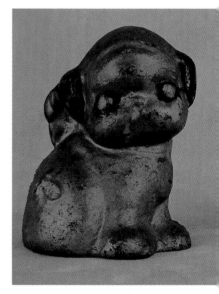

Dog and foliage, Arthur Mfg. Co., Baltimore, Maryland. 7.50" x 9.25". *Courtesy of Frank Whitson.*

A sad looking puppy, 5" x 4". *Courtesy of Sheila and Edward Malakoff.*

Seated dog on base, 14" x 9". *Courtesy of Sheila and Edward Malakoff.*

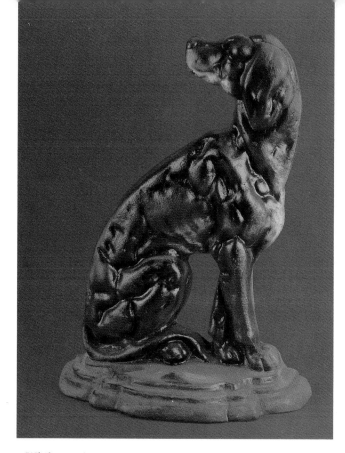

A three dimensional Pug, 6.50" x 8". *Courtesy of Frank Whitson.*

While similar to the previous example this has much more exaggerated sculpting and a different base. 12" x 9". *Courtesy of Sheila and Edward Malakoff.*

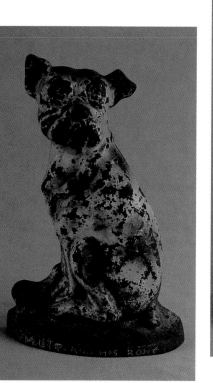

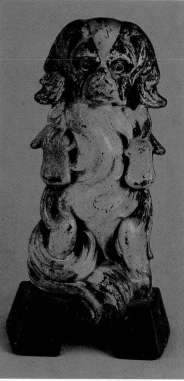

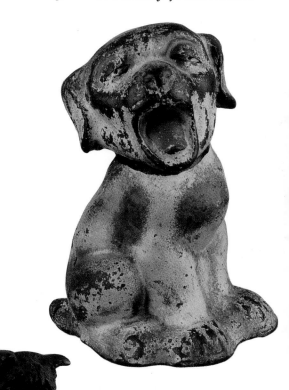

Yawning dog, 6.50" x 5". *Courtesy of Frank Whitson.*

"A Mutt and his Bone," 8.25" x 5.50". *Courtesy of Frank Whitson.*

Japanese Spaniel sitting up, 9" x 5". Marked "1267". *Courtesy of Frank Whitson.*

Cairn Terrier with its tongue out, Bradlley & Hubbard, 9" x 2.75". *Courtesy of Frank Whitson.*

CATS

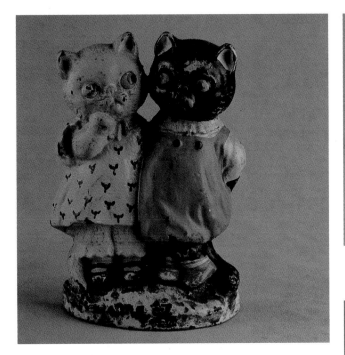

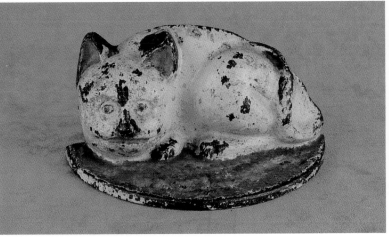

Cat on multi-colored rug, 3.75" x 7.25". Hollow back. *Courtesy of Frank Whitson.*

Two kittens, 7.50" x 5". *Courtesy of Frank Whitson.*

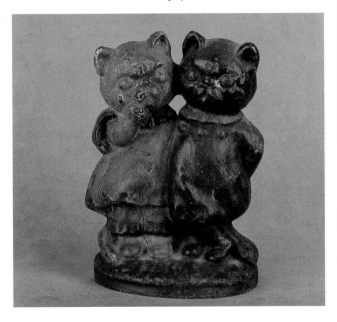

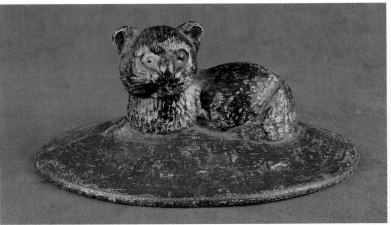

Three dimensional cat on rug. 3" x 7". *Courtesy of Frank Whitson.*

Paint variation of two kittens, 7.50" x 5". *Courtesy of Sheila and Edward Malakoff.*

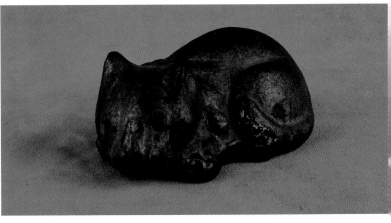

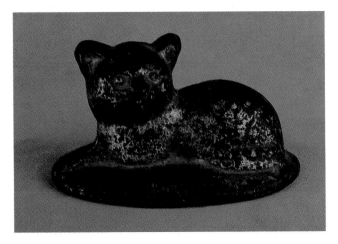

Lying cat, 3" x 4.50". *Courtesy of Frank Whitson.*

Small cat on rug, 3" x 5". *Courtesy of Frank Whitson.*

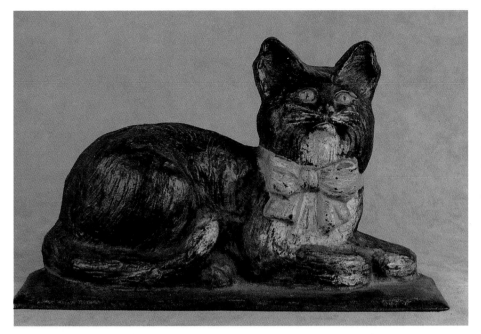

Cat with bow, polychrome, 6.50" x 11.25". *Courtesy of Frank Whitson.*

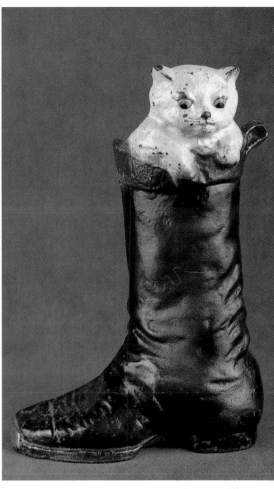

Kitten in boot, 8.25" x 5.75". *Courtesy of Frank Whitson.*

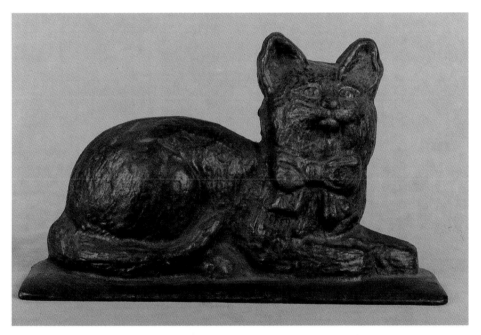

Cat with bow, monochrome. *Courtesy of Sheila and Edward Malakoff.*

Sleeping cat, 9.50" long. *Courtesy of Frank Whitson.*

Alert cat, 4.50" x 9". *Courtesy of Sheila and Edward Malakoff.*

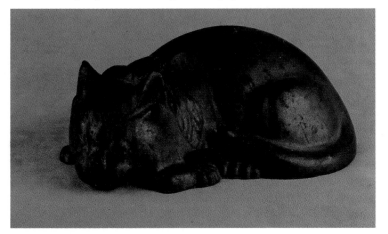

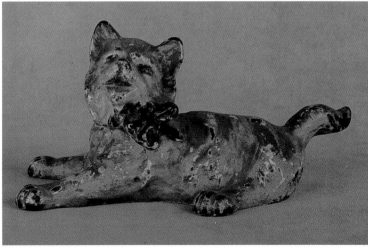

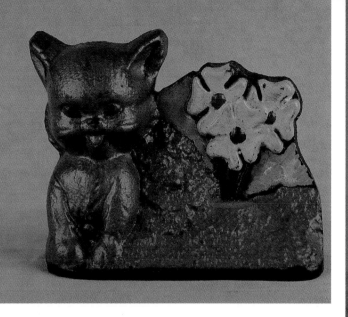

Kitten with flowers, 5" x 6.50". *Courtesy of Frank Whitson.*

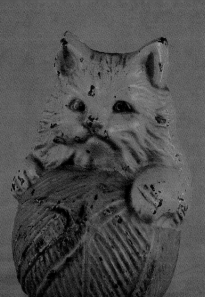

Cat with ball of yarn, 7.50" x 4.8". *Courtesy of Frank Whitson.*

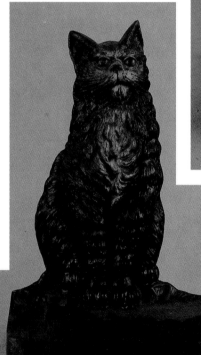

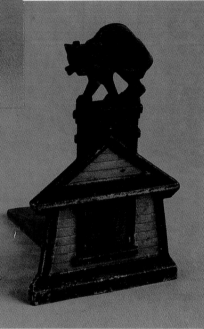

Cat on chimney, cast iron doorstop with wood wedge. 6.75" x 4". *Courtesy of Frank Whitson.*

Kitten playing with ball, 9.50" x 8.50". *Courtesy of Frank Whitson.*

Bradley & Hubbard cat, 7.50" x 5". *Courtesy of Frank Whitson.*

Three kittens on book, bookend and doorstop set. Bradley & Hubbard, doorstop, 5.25" x 6.25", bookends 4.50" x 5.50". *Courtesy of Nancy Smith.*

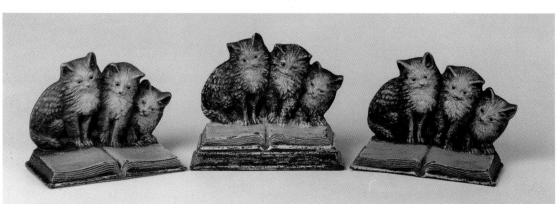

Sitting cat with bow, 8" x 6". *Courtesy of Frank Whitson.*

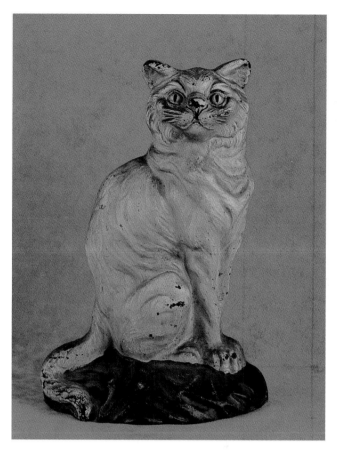

Nicely detailed cat. 10.75" x 7.50". *Courtesy of Frank Whitson.*

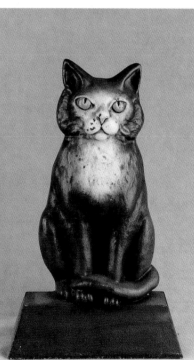

Three dimensional cat with green eyes, 10.50" x 4". *Courtesy of Frank Whitson.*

Sitting cat, 12.50" x 7.25". *Courtesy of Frank Whitson.*

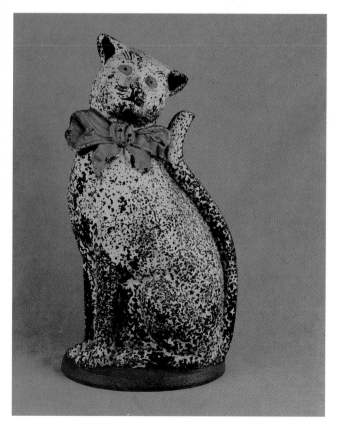

Sitting cat with blue bow, 14.50" x 8". *Courtesy of Frank Whitson.*

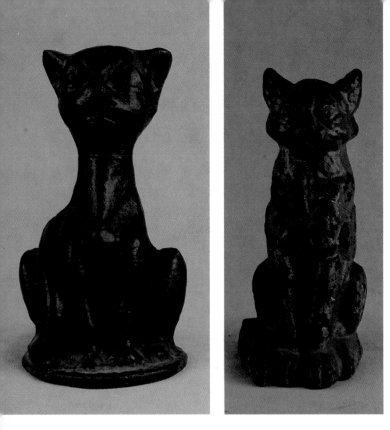

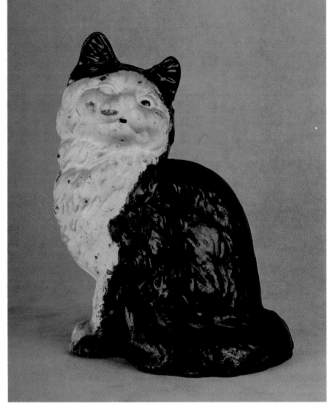

Sleeping three dimensional cat, 7.25" x 4". *Courtesy of Frank Whitson.*

Sitting cat, 9.75" x 5". *Courtesy of Frank Whitson.*

Three dimensional sitting cat, 9" x 7". *Courtesy of Sheila and Edward Malakoff.*

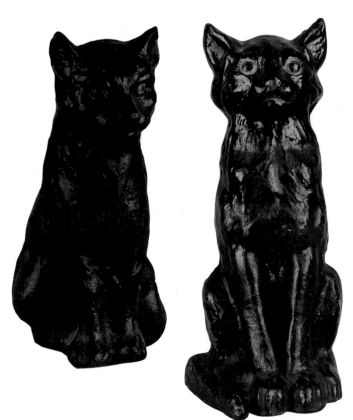

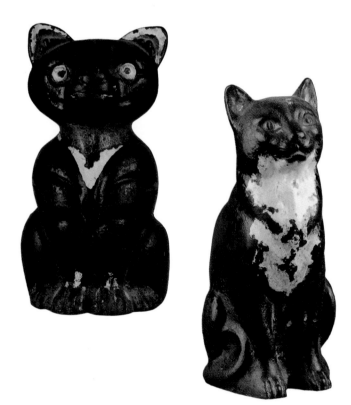

Black cat, 11" x 6". *Courtesy of Frank Whitson.*

Painted cat, 10.50" x 4.50". *Courtesy of Sheila and Edward Malakoff.*

Three dimensional cat, 7.25" x 4". *Courtesy of Sheila and Edward Malakoff.*

Siamese type cat. 5.75" x 3". *Courtesy of Frank Whitson.*

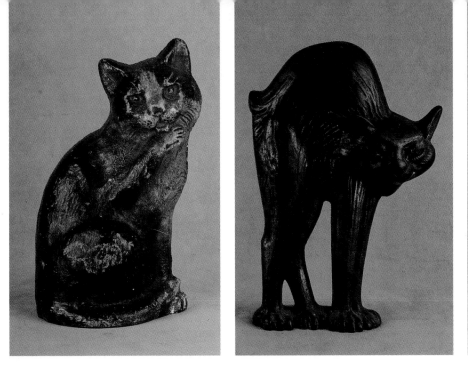

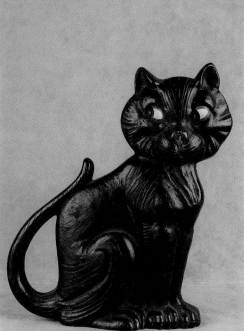

Preening cat, copyright 1926, Waverly Studio, Wilmette, Illinois. 8" x 5.75". *Courtesy of Sheila and Edward Malakoff.*

A.M. Greenblatt Studio cat, copyright 1927. 9" x 7". *Courtesy of Frank Whitson.*

Cat, A.M. Greenblatt Studios, 1927. 9" x 6". *Courtesy of Frank Whitson.*

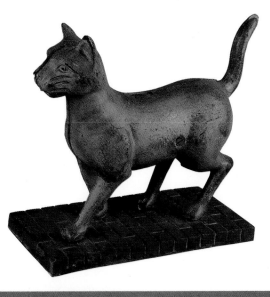

Cat on brick doorstop/bank in three dimensions. 8.25" x 9". *Courtesy of Frank Whitson.*

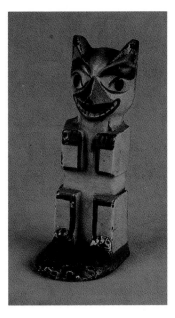

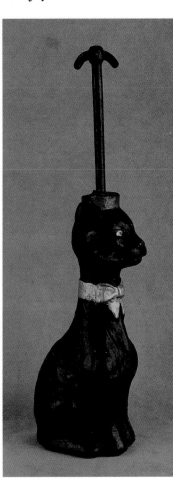

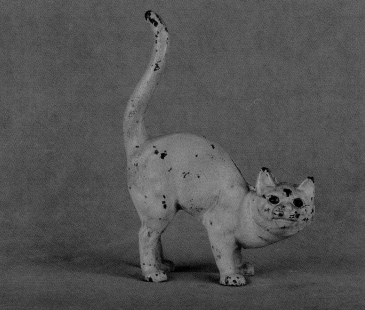

Totem cat, 6" x 2.50". *Courtesy of Frank Whitson.*

Cat doorporter, 15" x 4". *Courtesy of Frank Whitson.*

Three dimensional cat, 10.75" x 8". *Courtesy of Frank Whitson.*

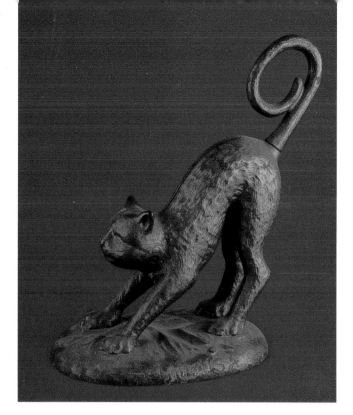

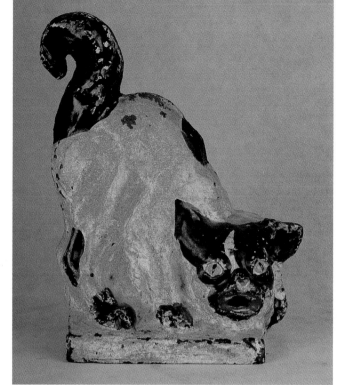

Stretching cat, Walter A. Zelnicker Supply Company, St. Louis. 11.50" x 9". *Courtesy of Frank Whitson.*

Cat with tail up, 6.25" x 8". Copyright 1915 by Budd and Fenderson, 44 West 22nd St., New York. *Courtesy of Sheila and Edward Malakoff.*

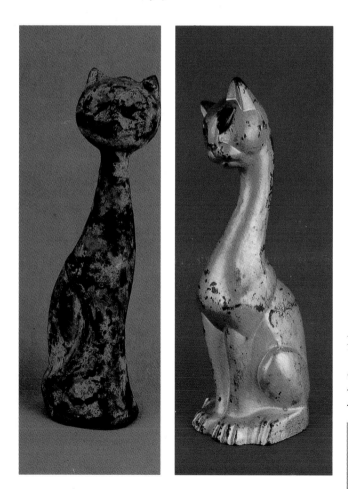

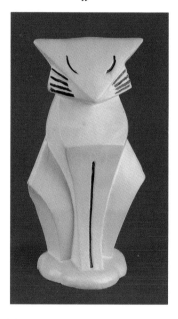

Hubley cat, 10" x 5". *Courtesy of Frank Whitson.*

Cat with traces of yellow paint, 3.50" x 4". *Courtesy of Sheila and Edward Malakoff.*

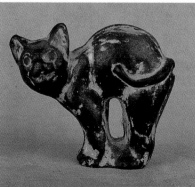

Cat with stone eyes, 10" x 3". *Courtesy of Frank Whitson.*

Stylistic cat, 13" x 4.50" x 5.50". *Courtesy of Frank Whitson.*

Comical cat with red bow. Three dimensional, 8.50" x 3.50". *Courtesy of Frank Whitson.*

OTHER ANIMALS

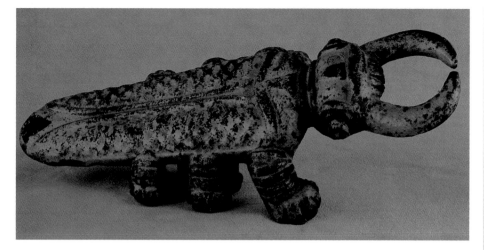

Cricket, 9" long x 4" wide. *Courtesy of Frank Whitson.*

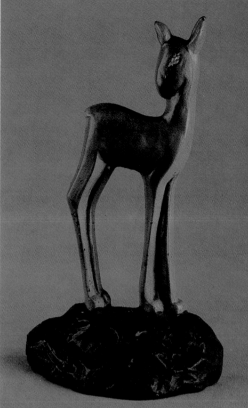

Fawn, Taylor Co., No. 6, 1930. 10" x 6". *Courtesy of Frank Whitson.*

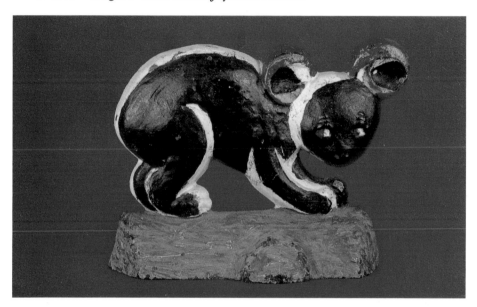

Koala bear, 6" x 7.75". *Courtesy of Sheila and Edward Malakoff.*

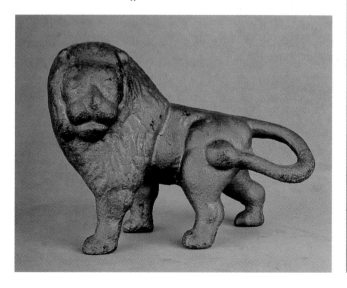

Lion, 7" x 9.50". *Courtesy of Sheila and Edward Malakoff.*

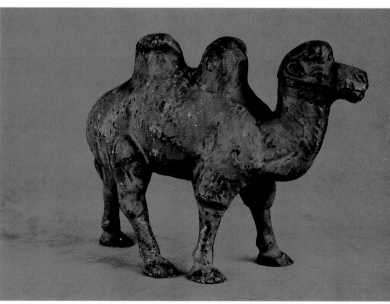

Camel, three dimensional, 7" x 9". *Courtesy of Frank Whitson.*

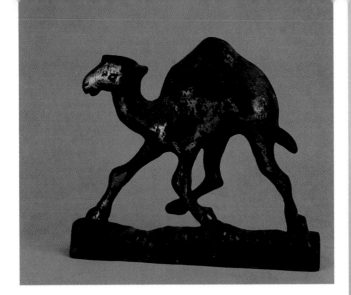

Running camel, 7" x 7.75". Marked "S119". *Courtesy of Frank Whitson.*

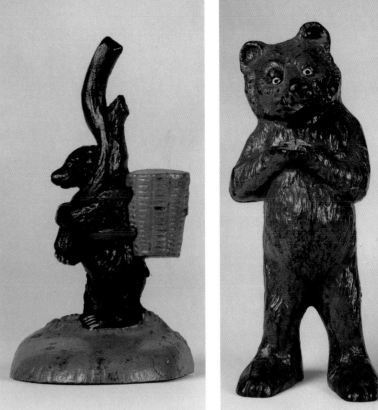

Bear with basket and branch, 7.75" x 4.50". *Courtesy of Nancy and John Smith.*

Three dimensional bear. Two-piece construction, 15.25" x 6.50". *Courtesy of Nancy and John Smith.*

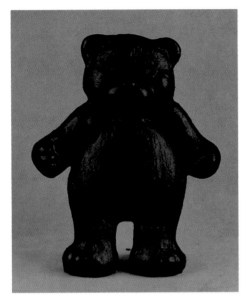

Black bear, 7.75" x 6.25".

Fox head, 5.50" x 5.50". *Courtesy of Frank Whitson.*

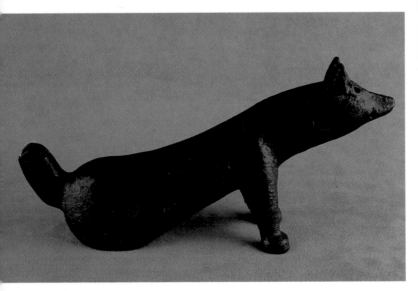

Stylized fox, 5.75" x 10.50". Marked Mfg. Dec. 15, 20". *Courtesy of Frank Whitson.*

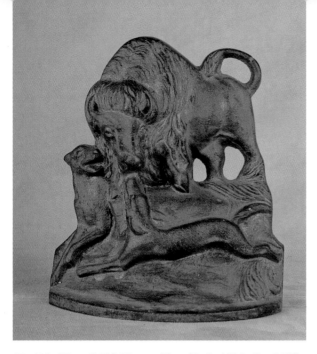

"Buffalo Hunt," Gift House, New York, 1926. 6" x 5.50".
Courtesy of Sheila and Edward Malakoff.

"King's Genius," cast bronze door stop, Rife-Loth Corporation,
Waynesboro, Virginia, 1938. 11.50" x 12". *Courtesy of Sheila and*

Two-piece giraffe, Hubley, 12.75" x 8".
Courtesy of Nancy and John Smith.

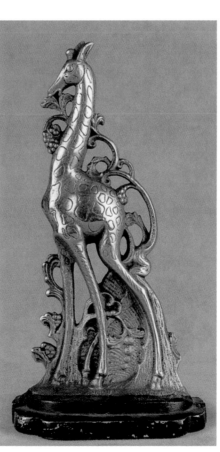

Nickel plated giraffe molded on both
sides. Marked "425". 10.25" x 51/4".
Courtesy of Frank Whitson.

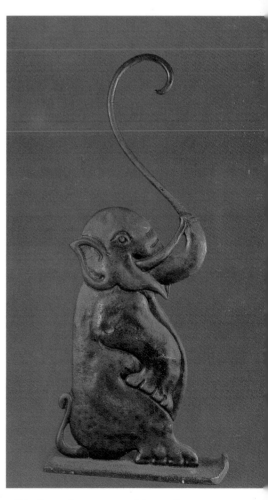

Elephant doorporter with trunk
forming handle. 20.50" x 9.25". *Courtesy
of Frank Whitson.*

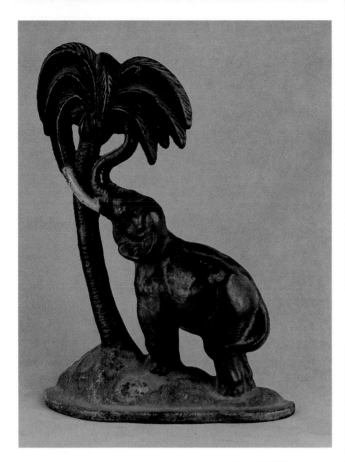

Elephant and tree, 13.50" x 10". *Courtesy of Frank Whitson.*

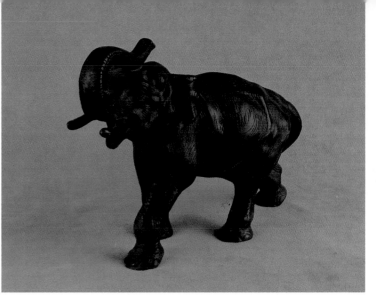

Trumpeting elephant, 8.25" x 11.75". Three dimensional. *Courtesy of Frank Whitson.*

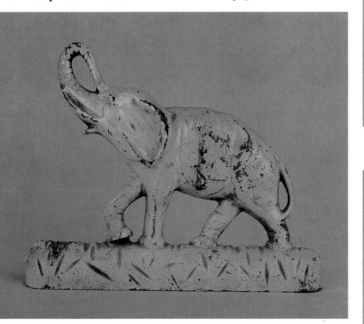

White elephant, 8.50" x 11". *Courtesy of Sheila and Edward Malakoff.*

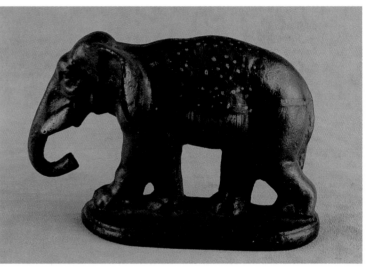

Circus elephant, 5.50" x 8.50". *Courtesy of Frank Whitson.*

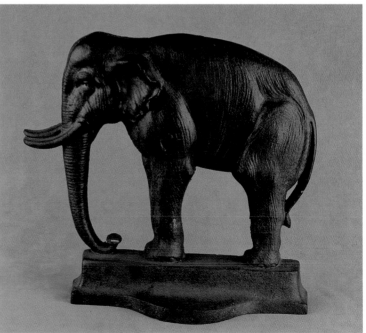

Elephant, 11" x 11.50". Bradley & Hubbard, No. 7799. *Courtesy of Frank Whitson.*

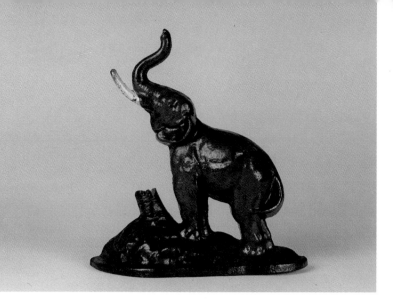

Bull elephant, National Foundry. 10" x 9.50". *Courtesy of Nancy and John Smith.*

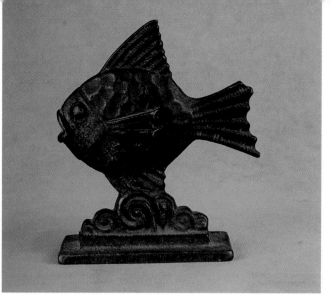

Fish, molded on both sides, 6" x 5". *Courtesy of Sheila and Edward Malakoff.*

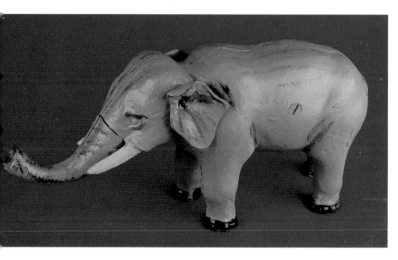

Two-piece penny bank door stop. 6" x 13". *Courtesy of Frank Whitson.*

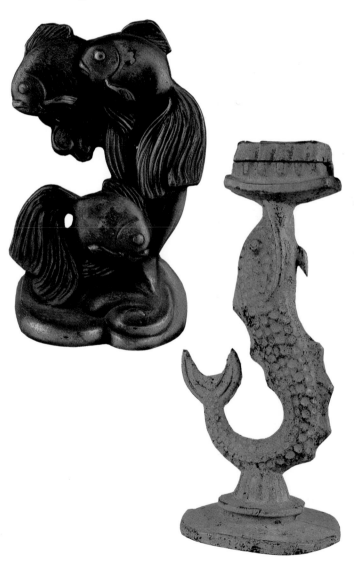

Nicely sculpted group of three fish, 10" x 6". *Courtesy of Frank Whitson.*

This English doorporter once had a handle. 11.50" x 5". *Courtesy of Frank Whitson.*

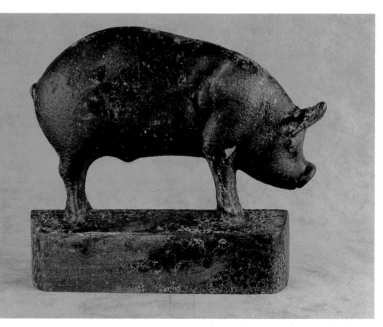

Pig, 6.75" x 7.50". Hollow back. *Courtesy of Frank Whitson.*

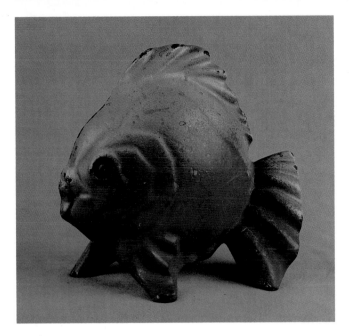

Polychrome three dimensional fish, 7.50" x 8". *Courtesy of Frank Whitson.*

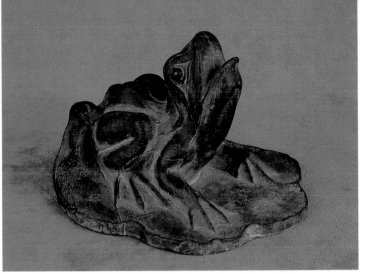

Frog on lily pad, 4.75" x 6.25". Three dimensional. *Courtesy of Frank Whitson.*

Standing frog, 8.75" x 4". Marked "Taiwan". *Courtesy of Frank Whitson.*

Two-piece frog, 3.50" x 7". *Courtesy of Nancy and John Smith.*

Red lobster, 8.25" x 5.75". *Courtesy of Frank Whitson.*

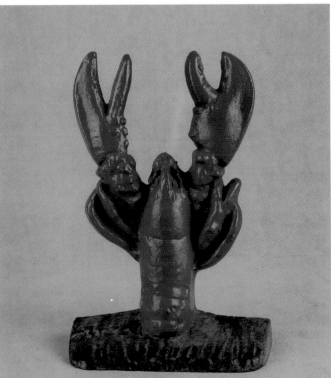

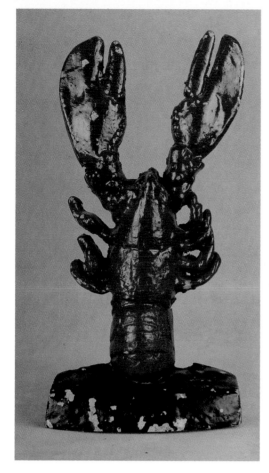

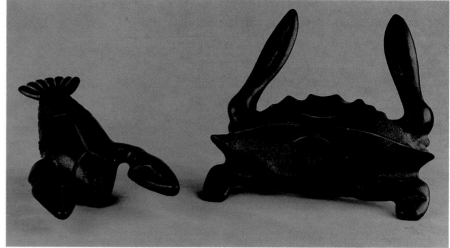

Stylized lobster and crab. The lobster is 10" long and the crab measures 7.25" x 7". *Courtesy of Frank Whitson.*

Three dimensional chimpanzee, 7.75" x 5". *Courtesy of Frank Whitson.*

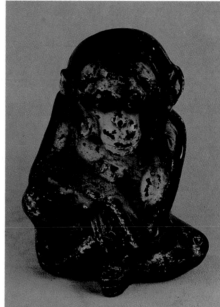

Lobster, 12" x 6". *Courtesy of Sheila and Edward Malakoff.*

Ape with book, "Essays on Evolution," Chicago Hardware Foundry Company. 7" x 3.25". *Courtesy of Frank Whitson.*

Same monkey as left with nice paint. *Courtesy of Sheila and Edward Malakoff.*

Monkey, 8.50" x 7". *Courtesy of Frank Whitson.*

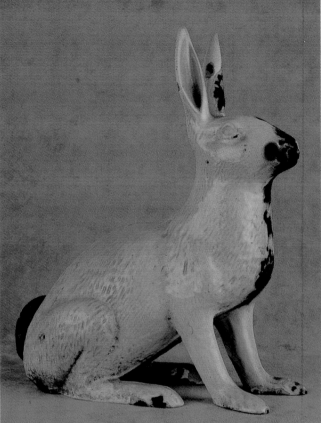

Enameled white rabbit, two-pieces. 11.75" x 9.50". *Courtesy of Frank Whitson.*

Upright rabbit, signed B.& H., 7800. 15" x 8". *Courtesy of Nancy and John Smith.*

Simple black rabbit, 11" x 7". *Courtesy of Frank Whitson.*

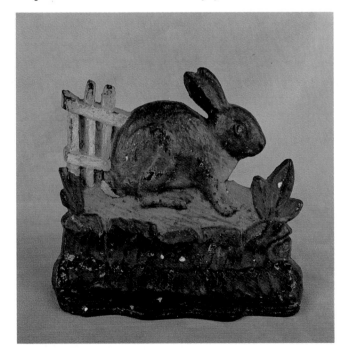

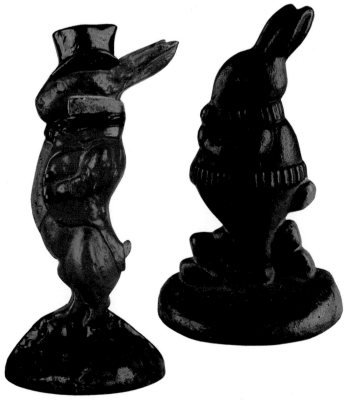

Rabbit in hat and tails, 10" x 4.50". *Courtesy of Sheila and Edward Malakoff.*

Rabbit in sweater, 8.25" x 5". *Courtesy of Frank Whitson.*

Bunny in garden setting, Davison, No. 26. 6" x 7". *Courtesy of Sheila and Edward Malakoff.*

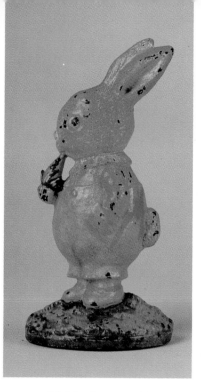
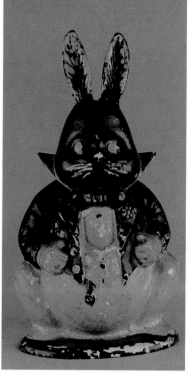
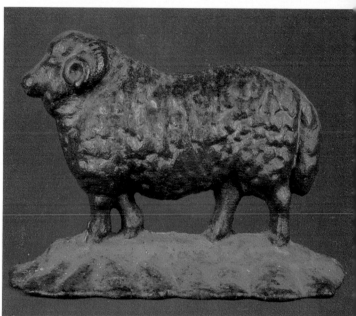

Hubley bunny with carrot, 9.50" x 4.75". *Courtesy of Nancy and John Smith.*

Peter Rabbit, Hubley, No. 96. 9.50" x 5". *Courtesy of Frank Whitson.*

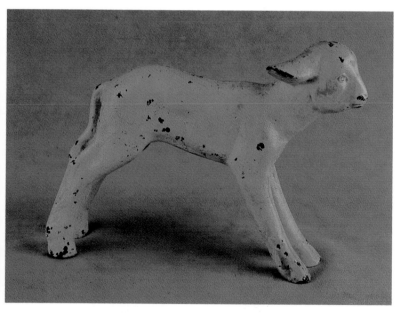
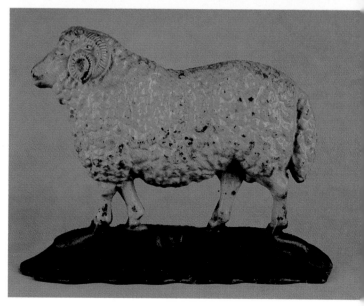

Three dimensional lamb, 7" x 9". *Courtesy of Frank Whitson.*

Three paint versions of the same ram, 7.50" x 10". *Courtesy of Sheila and Edward Malakoff, and of Frank Whitson.*

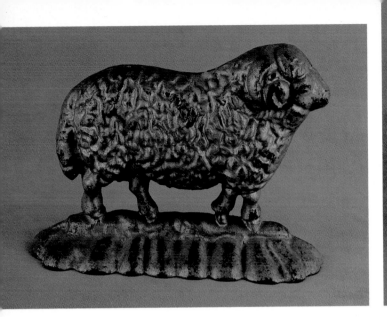

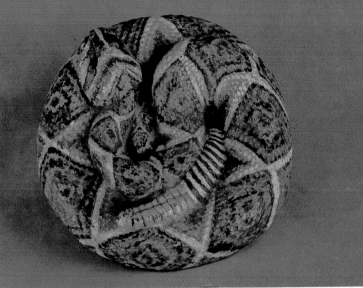

Ram, 6.50" x 9.25". *Courtesy of Frank Whitson.*

Beautifully painted rattlesnake marked "HES". 8.50" diameter. *Courtesy of Frank Whitson.*

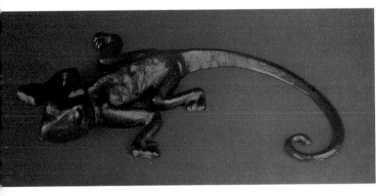

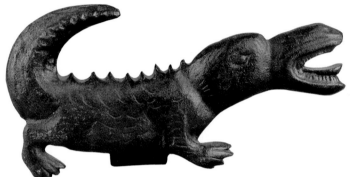

Lizard with curled tail, 10" x 1.50". Marked "The Sherwin Williams Co. Paints & Varnishes". *Courtesy of Sheila and Edward Malakoff.*

Crocodile, 5.50" x 11.75". *Courtesy of Frank Whitson.*

Squirrel eating, 9.25" x 4.25". *Courtesy of Frank Whitson.*

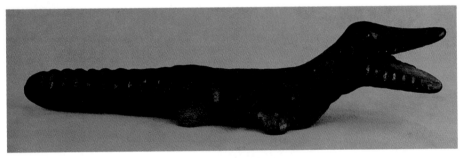

Alligator, 12" x 2.75". *Courtesy of Frank Whitson.*

Nicely cast horse doorstop, Hubley, 8" x 9.50". *Courtesy of Nancy and John Smith.*

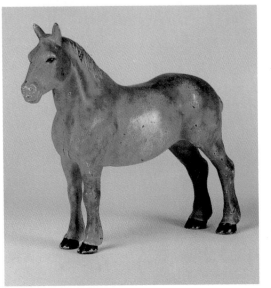

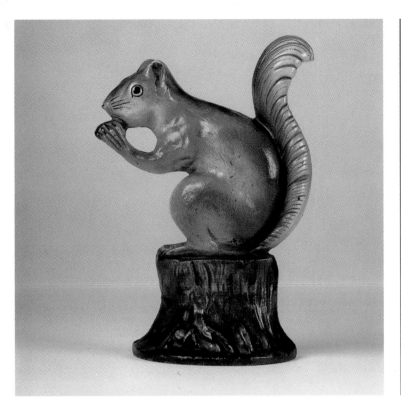

Squirrel on stump, No. 140. 9" x 6.25". *Courtesy of Nancy and John Smith.*

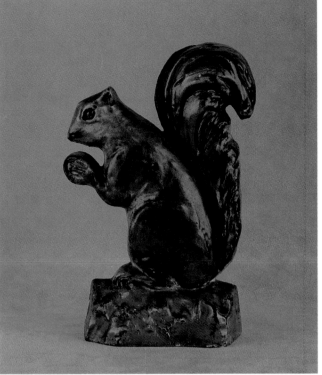

Red squirrel, Blodgett Studio, Lake Geneva, Wisconsin. 8.25" x 5.50". *Courtesy of Frank Whitson.*

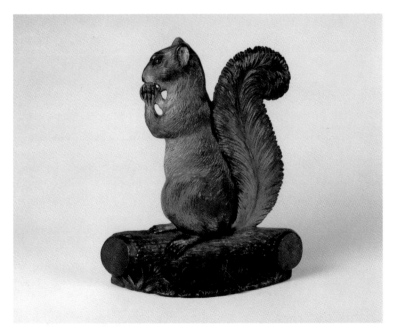

Squirrel, Bradley & Hubbard. 11.50" x 10". *Courtesy of Nancy and John Smith.*

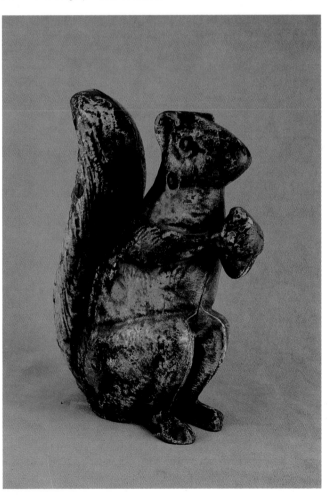

Squirrel with nut, 9.25" x 4.25". *Courtesy of Frank Whitson.*

Turtle, 7.75" x 5". *Courtesy of Frank Whitson.*

Turtle, 2.50" x 7.75". *Courtesy of Nancy and John Smith.*

Nicely detailed Wilton turtle. 3" x 8.75". *Courtesy of Brooke Smith.*

Green turtle, 3" x 8.75". *Courtesy of Frank Whitson.*

Turtle, 2" x 7.50". Marked S inside. *Courtesy of Brooke Smith.*

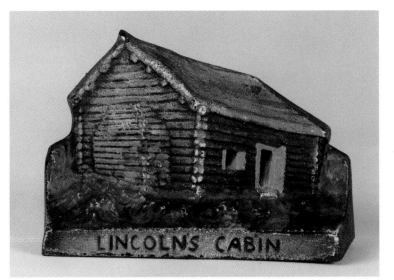

Lincoln's Cabin, 4.25" x 6.50". *Courtesy of Todd Smith.*

Church building, 8.50" x 6.50". *Courtesy of Frank Whitson.*

Ann Hathaway's house, two piece mold, 6.50" x 8.25". *Courtesy of Todd Smith.*

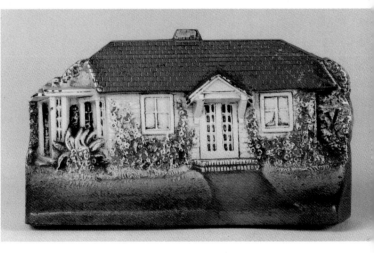

Hip-roofed cottage, 4.25" x 8.25". Marked "cJo 1283". *Courtesy of Frank Whitson.*

Set of bookends and doorstop with Edgar Allen Poe's birthplace in Connecticut. Bradley & Hubbard. Doorstop, 6" x 7.50"; bookends, 4" x 4.50". *Courtesy of Nancy and John Smith.*

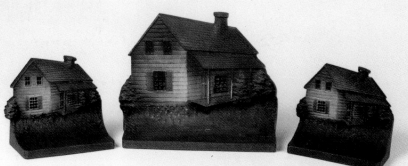

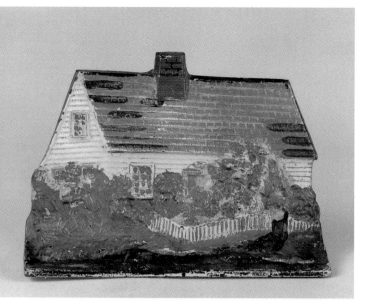

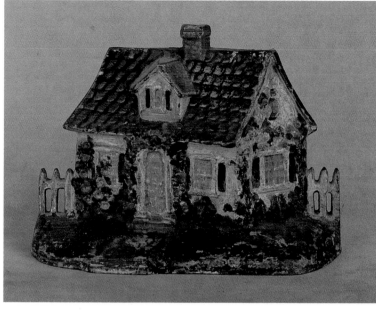

Green roofed cottage with yellow and green flowers, 6" x 9". Eastern Specialty Company. *Courtesy of Sheila and Edward Malakoff.*

Nicely defined roof shingles, a flowery trellis and a picket fence mark this cottage. 5.50" x 7.75". *Courtesy of Sheila and Edward Malakoff.*

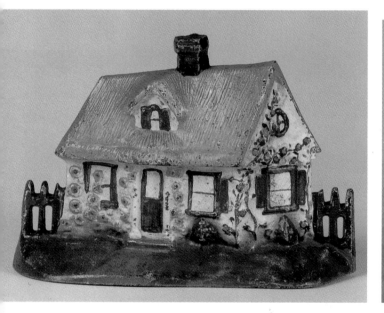

Thatched roof cottage, 5" x 7.25". *Courtesy of Todd Smith.*

Cape Cod styled house, 5.25" x 8.50". *Courtesy of Sheila and Edward Malakoff.*

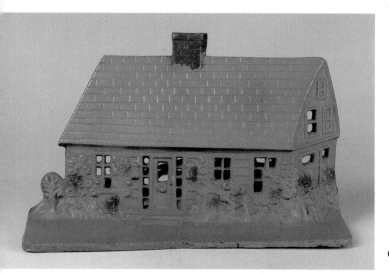

Cottage night light, 7.50" x 11.50". *Courtesy of Todd Smith.*

Cottage against trees, 8.25" x 7.50". *Courtesy of Todd Smith.*

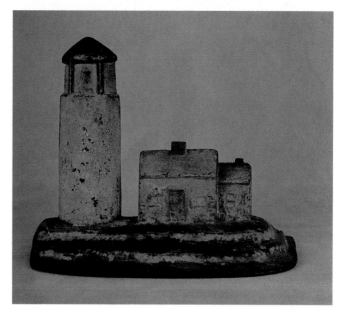

Lighthouse and lightkeeper's house, 8" x 6.25". *Courtesy of Sheila and Edward Malakoff.*

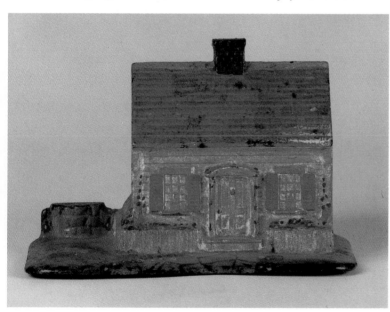

Cottage by A.A. Richardson, Quincy, Massachusetts, c. 1927. 6 14/" x 8". *Courtesy of Todd Smith.*

"Light of the World" lighthouse, 9.50" x 5". *Courtesy of Frank Whitson.*

Four sides of a hexagonal lighthouse, 13.50" x 8". *Courtesy of Frank Whitson.*

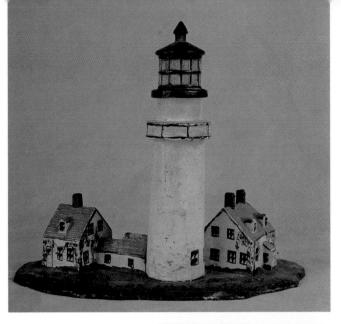

"Highland Light, Cape Cod," 8" x 9.25". *Courtesy of Sheila and Edward Malakoff.*

Nicely detailed lighthouse, 14" x 9". *Courtesy of Frank Whitson.*

The Bennington Monument, 7.75" x 6.50". *Courtesy of Frank Whitson.*

Windmill, 7.25" x 7". *Courtesy of Sheila and Edward Malakoff.*

The 1939 New York World's Fair, 6" x 4.75". *Courtesy of Frank Whitson.*

Windmill by the A.M. Greenblatt Studios, Boston, 1926. 12" x 9". *Courtesy of Sheila and Edward Malakoff.*

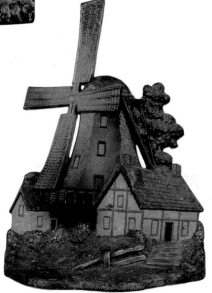

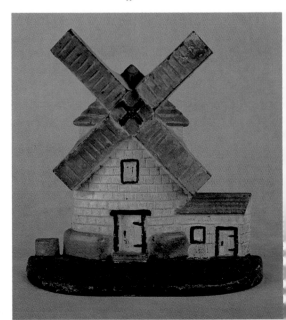

SYMBOLS

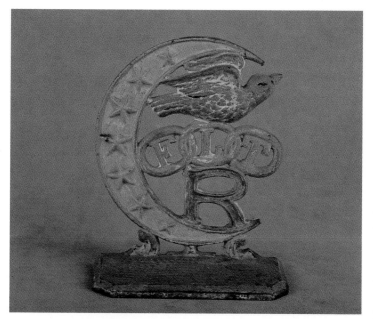

Lodge symbol, FLT in chain, 7.50" x 6". *Courtesy of Sheila and Edward Malakoff.*

Totem pole, 12" x 9". *Courtesy of Frank Whitson.*

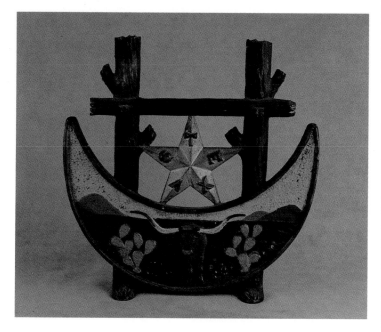

Texas doorstop with the name spelled in the star and the longhorn at the gate, 10"x 10.25". *Courtesy of Frank Whitson.*

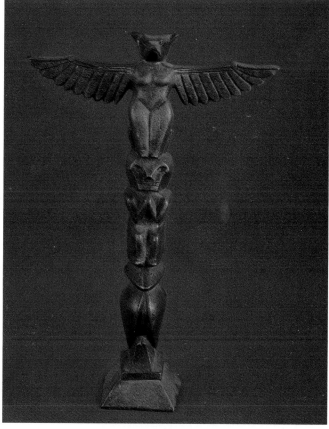

Boy Scout emblem, marked "Licensed & approved by B.S. of A." 6" x 6.25". *Courtesy of Frank Whitson.*

Boy Scouts of America, marked "Troop 11 Winona." 5.25" x 5.50". *Courtesy of Todd Smith.*

FLOWERS

IN BASKETS

Flowers in basket on pedestal, 8.75" x 4.25". *Courtesy of Sheila and Edward Malakoff.*

A squarish pedestal supports this flower basket. 6" x 4". *Courtesy of Sheila and Edward Malakoff.*

A festooned basket of flowers. 11 1/5" x 7". *Courtesy of Sheila and Edward Malakoff.*

Flowers in basket, 9.75" x 8". *Courtesy of Sheila and Edward Malakoff.*

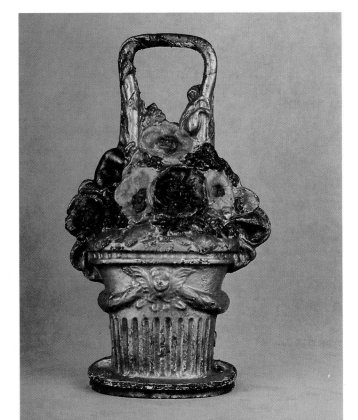

Flowers in basket, 11" x 8". Marked "121". *Courtesy of Sheila and Edward Malakoff.*

The paint on this basket of fruit gives the appearance of a theorem painting. 16" x 8". *Courtesy of Frank Whitson.*

A flower has fallen from this basket, 6.25" x 5.25". *Courtesy of Sheila and Edward Malakoff.*

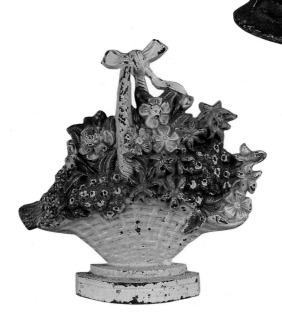

A colorful basket of flowers, 7.25" x 7.25". Marked "475" on back. *Courtesy of Sheila and Edward Malakoff.*

White basket of flowers with handle, 8" x 6". *Courtesy of Sheila and Edward Malakoff.*

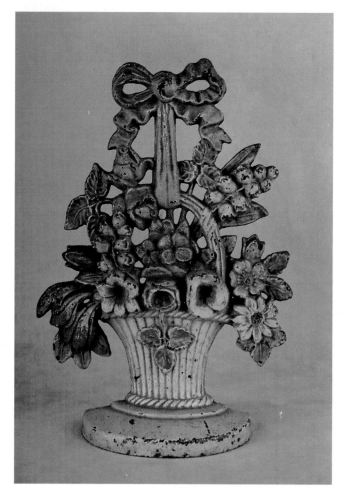

An ornate basket of flowers, 10.50" x 7.50". *Courtesy of Edward Malakoff.*

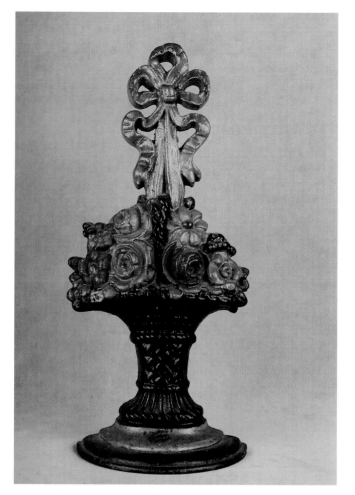

Nicely painted basket of flowers, 16" x 7.50". *Courtesy of Edward Malakoff.*

A nice curve marks this basket filled with flowers. 10" x 7". *Courtesy of Edward Malakoff.*

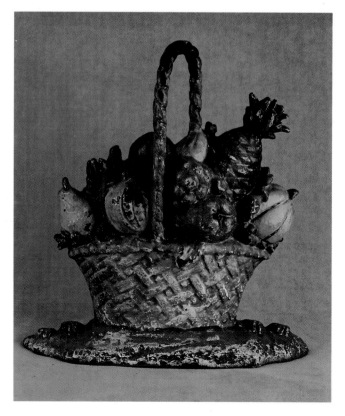

Basket of fruit, 12" x 9". *Courtesy of Frank Whitson.*

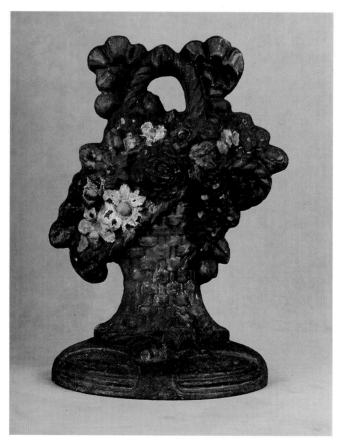

IN POTS

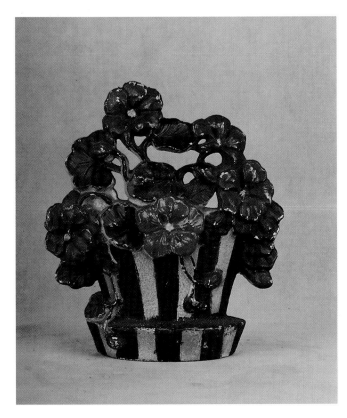

Striped pot of flowers, 5.50" x 4.75". *Courtesy of Sheila and Edward Malakoff.*

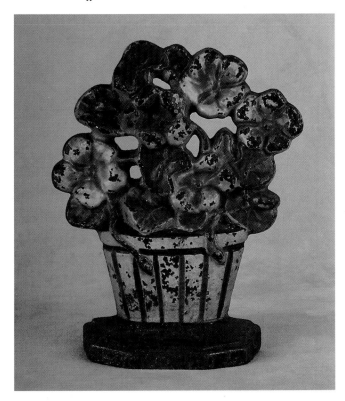

Fluted pot of flowers, 7" x 6". *Courtesy of Sheila and Edward Malakoff.*

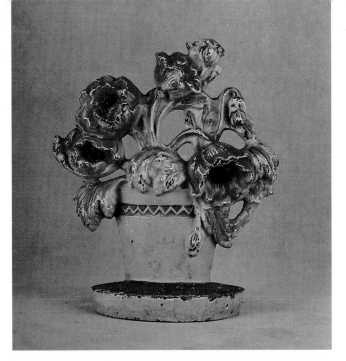

Hubley flower pot, 7" x 6". Marked "330".

IN VASES

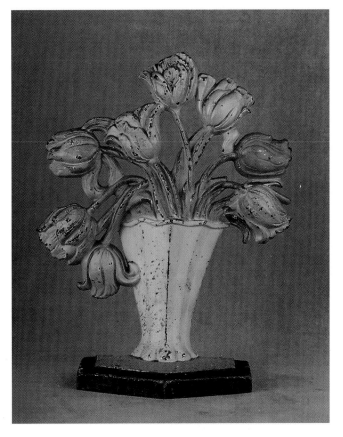

Tulips in white vase, 10" x 8". *Courtesy of Sheila and Edward Malakoff.*

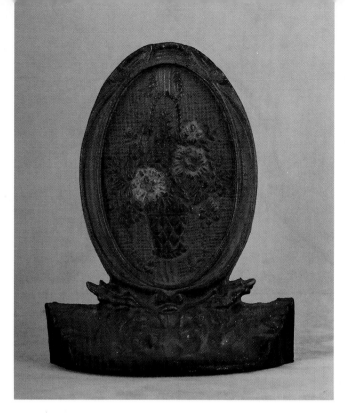

Flowers in oval, 7.25" x 61/4". Marked "Long Chain Lodge, Blue Ridge Mts., PA".

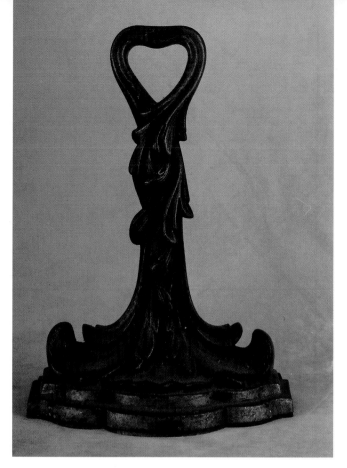

Foliage door porter, 13.25" x 10". *Courtesy of Sheila and Edward Malakoff.*

Flowers in footed vase, 10.75" x 8". *Courtesy of Sheila and Edward Malakoff.*

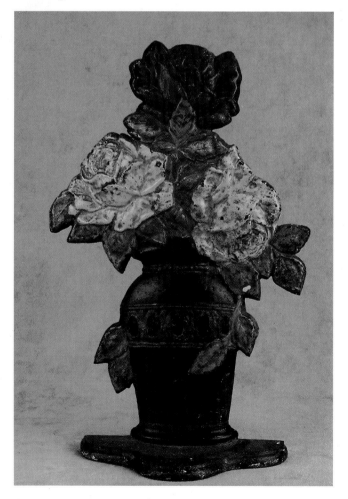

Roses in decorative vase, 10.75" x 5.75". *Courtesy of Frank Whitson.*

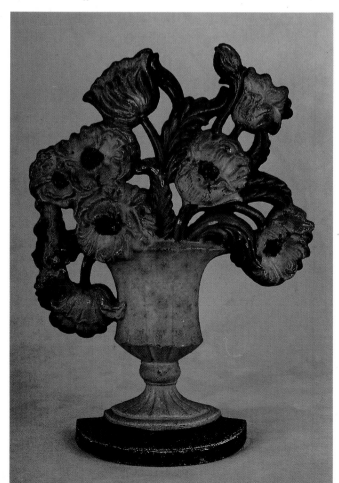

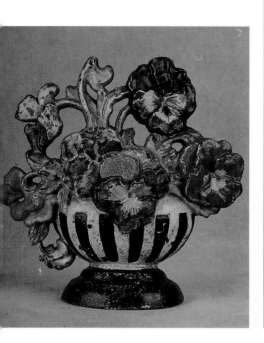

Pansies in striped vase, 7" x 7". *Courtesy of Sheila and Edward Malakoff.*

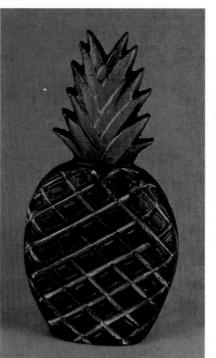

Pineapple, 8.75" x 4.50". Marked "Taiwan, CEM 16, 8071". *Courtesy of Frank Whitson.*

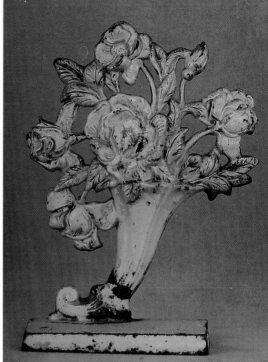

Roses in curved vase, 10" x 8". *Courtesy of Sheila and Edward Malakoff.*

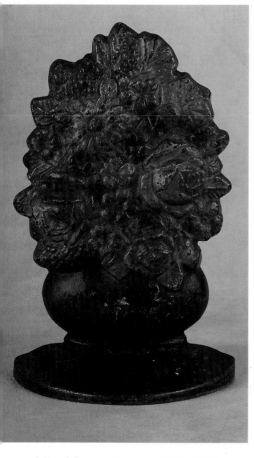

Mixed flowers in vase, 8.50" x 5.50". *Courtesy of Sheila and Edward Malakoff.*

Representational foliage, 14" x 6.50". Albany Foundry Company, Number 110. *Courtesy of Frank Whitson.*

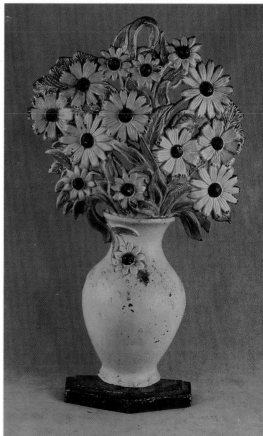

Black-eyed Susans in white vase, 18" x 10". Marked "456". *Courtesy of Frank Whitson.*

Jack, 6" x 7.50". *Courtesy of Frank Whitson.*

Lady's slipper, 4" x 9". *Courtesy of Frank Whitson.*

Two-piece high buttoned shoe, 8.50" x 9.75". *Courtesy of Frank*

Indian with spear on horseback, 9.50" x 6.75". *Courtesy of Sheila and Edward Malakoff.*

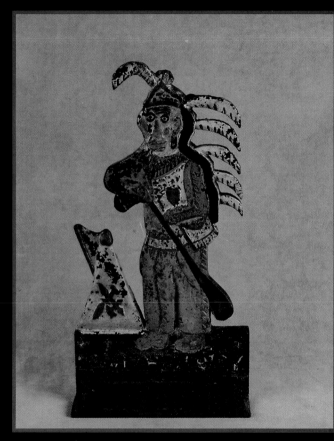

Primitive Indian with tepee, 13" x 7". Marked "Lewis Hellick (?)" on back. *Courtesy of Frank Whitson.*

"The End of the Trail," 9.50" x 9.50". *Courtesy of Frank Whitson.*

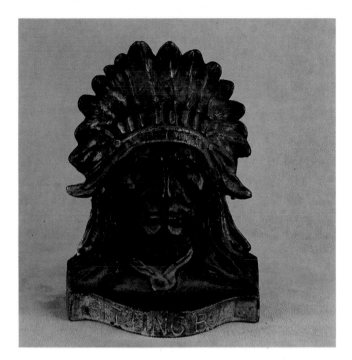

"Sitting Bull" bust, 6.75" x 5". *Courtesy of Frank Whitson.*

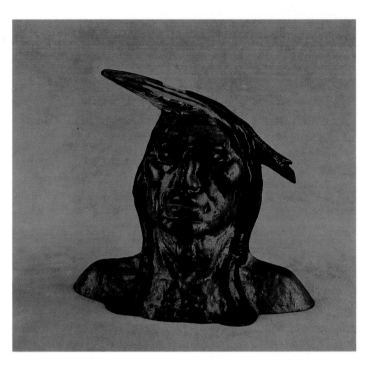

Indian bust with feather, 6.50" x 7". *Courtesy of Frank Whitson.*

Indian with decorative headdress, 5.25" x 7". *Courtesy of Frank Whitson.*

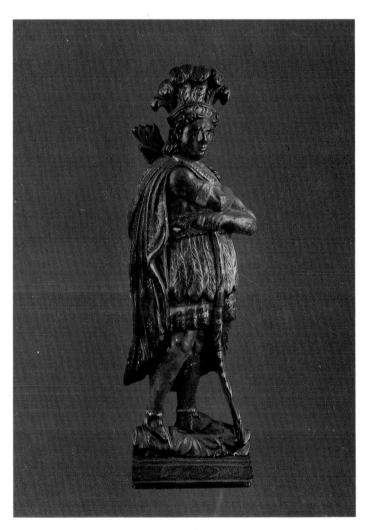

The Noble Savage, classical view of the American Indian, 12.75" x 4". *Courtesy of Frank Whitson.*

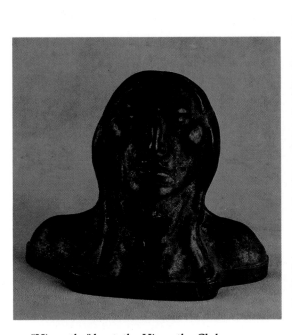

"Hiawatha" bust, the Hiawatha Club, 1903. 6" x 7.50". *Courtesy of Frank Whitson.*

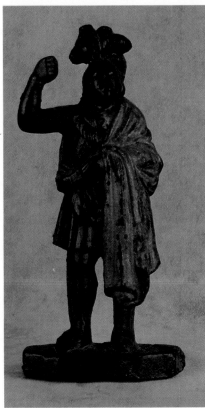

Indian warrior, 9" x 4.25". *Courtesy of Frank Whitson.*

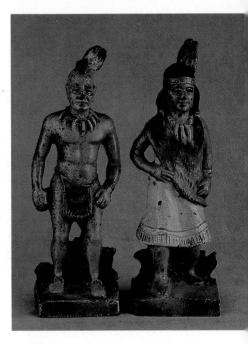

Indian brave and squaw doorstops, three dimensional, 8.75" x 3". *Courtesy of Frank Whitson.*

FISH CREATIONS

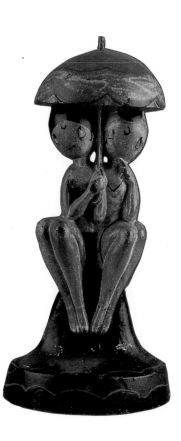

Bathing Girls, No. 250, 11" x 5". *Courtesy of Frank Whitson.*

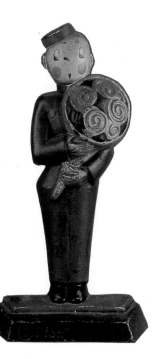

Messenger Boy with flowers, No. 249, 10" x 5". *Courtesy of Frank Whitson.*

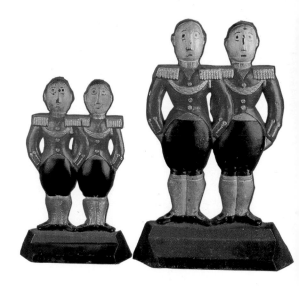

Footmen in two sizes. The taller, No. 248, is 12" x 8.25"; the shorter, No. 272, is 9" x 6". *Courtesy of Frank Whitson.*

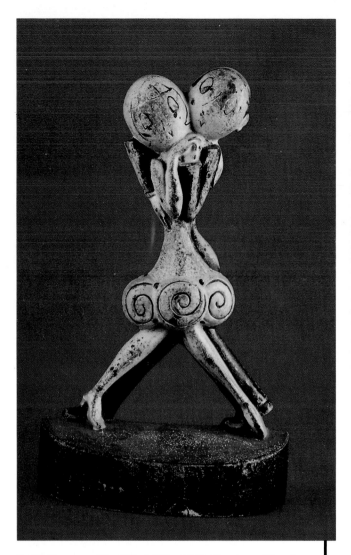

Fish's Dancers, No. 270, 8.75" x 5.25". *Courtesy of Frank Whitson.*

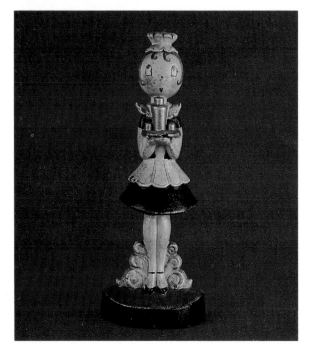

Maid, No. 268, 9.25" x 3.50". *Courtesy of Frank Whitson.*

ASIAN IMAGES

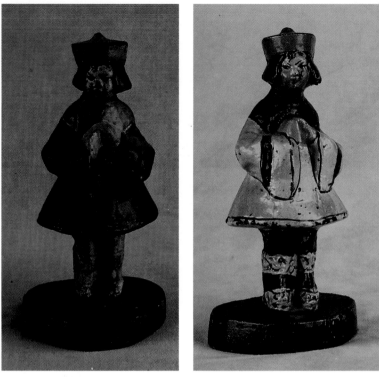

Asian figures, 8" x 4". *Courtesy of Frank Whitson, and of Sheila and Edwara Malakoff.*

Japanese child in kimono, 10.50" x 5". *Courtesy of Frank Whitson.*

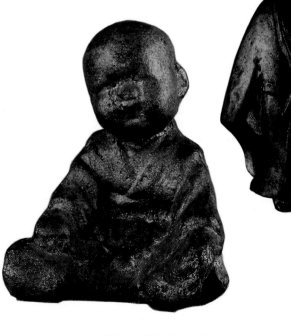

Asian baby, 4.75" x 3.75". Three dimensional. *Courtesy of Frank Whitson.*

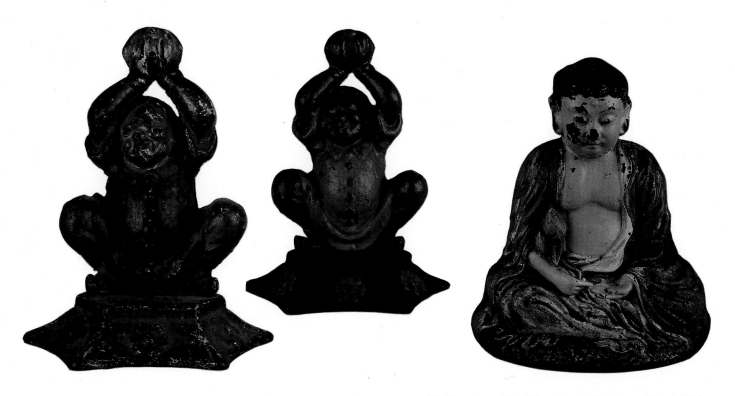

Asian figure on pedestal, 8.50" x 7". *Courtesy of Frank Whitson, and of Sheila and Edward Malakoff.*

Nicely painted Buddha, 9" x 8". *Courtesy of Frank Whitson.*

BABIES

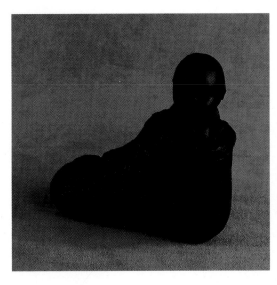

Baby in bootie, 5" x 5". *Courtesy of Frank Whitson.*

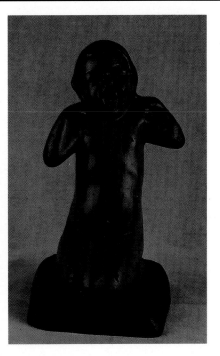

Yawning baby, ML Corporation, New York, 1931. Three dimensional, 9" x 5.50". *Courtesy of Frank Whitson.*

Reaching child, 17" x 7". *Courtesy of Frank Whitson.*

BLACK IMAGES: EXOTIC OR FICTIONAL

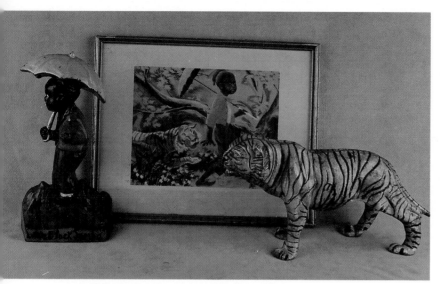

Sambo and a tiger. *Courtesy of Frank Whitson.*

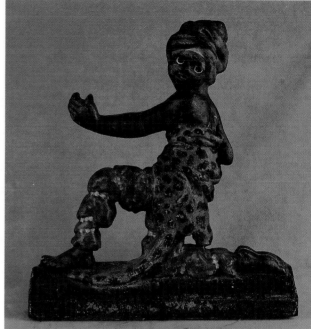

African figure in leopard skin, 12.75" x 12". *Courtesy of Frank Whitson.*

BLACK IMAGES: MALE FIGURES

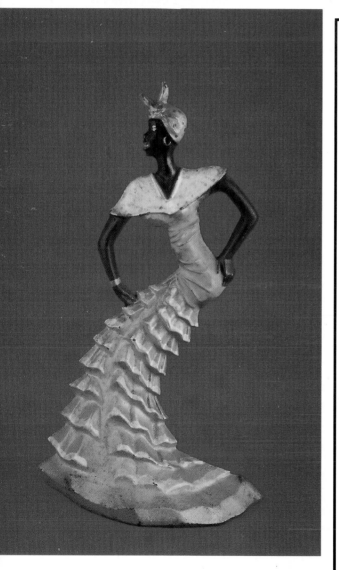

Caribbean dancer, 11" x 6.50". *Courtesy of Frank Whitson.*

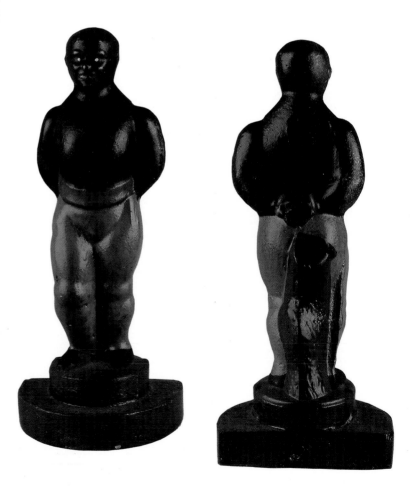

Black man dressed as boxer, 12" x 5". Three dimensional. *Courtesy of Frank Whitson.*

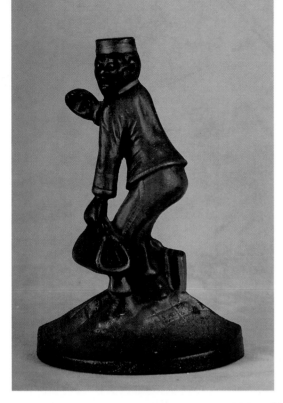

Bellboy, 7.50" x 5". *Courtesy of Sheila and Edward Malakoff.*

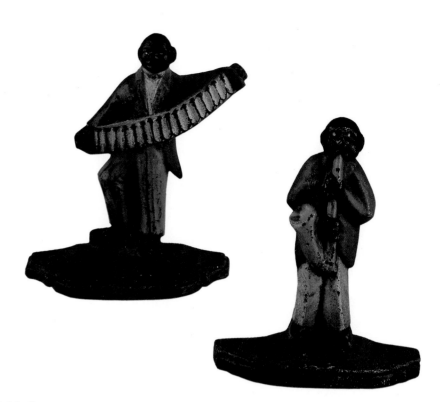

Accordion player, 6.75" x 6". *Courtesy of Frank Whitson.*

Saxophone player, 7" x 6". *Courtesy of Frank Whitson.*

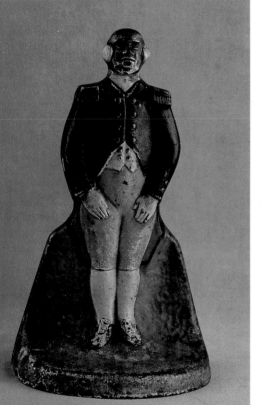

Servant, 8.50" x 5". *Courtesy of Frank Whitson.*

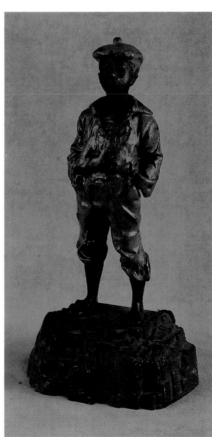

Whistler, Bradley & Hubbard, No. 429B. 10" x 5.50". *Courtesy of Frank Whitson.*

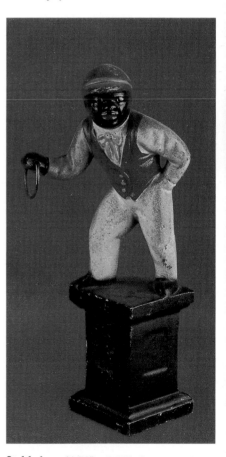

Stable boy, 11.50" x 5.50". *Courtesy of Frank Whitson.*

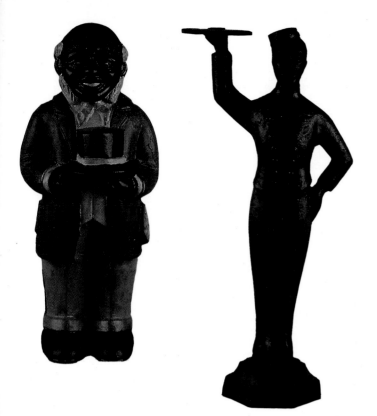

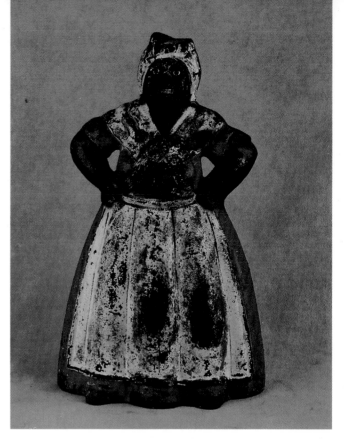

Uncle Mose bank/doorstop, premium from Aunt Jemima, 11" x 4.50". *Courtesy of Frank Whitson.*

Butler, 10.50" x 4". *Courtesy of Frank Whitson.*

Mammy, 13" x 8". *Courtesy of Frank Whitson.*

BLACK IMAGES: FEMALE FIGURES

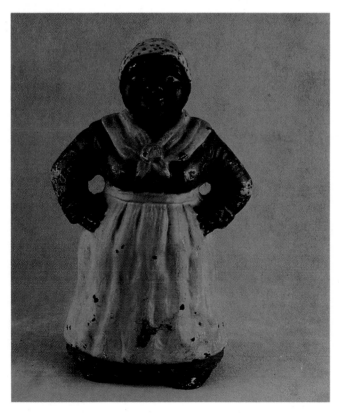

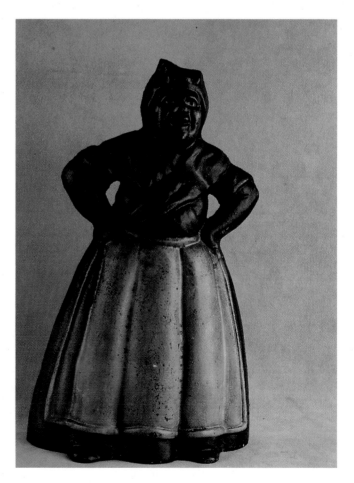

Mammy figure, 9" x 5.25". *Courtesy of Frank Whitson.*

Mammy, 12.75" x 8". Marked "CN". *Courtesy of Frank Whitson.*

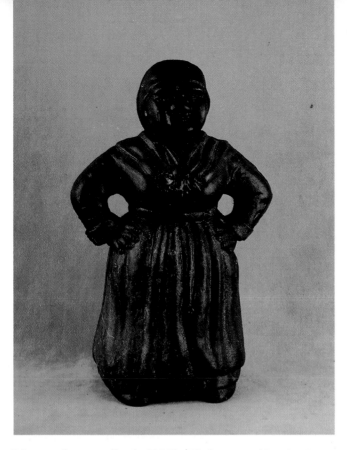

Mammy doorstop/bank, 11.25" x 7". *Courtesy of Frank Whitson.*

Black child, 6.25" x 3". *Courtesy of Sheila and Edward Malakoff.*

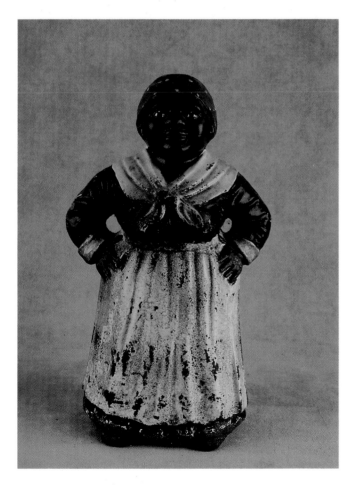

Aunt Jemima, 10.50" x 7". *Courtesy of Frank Whitson.*

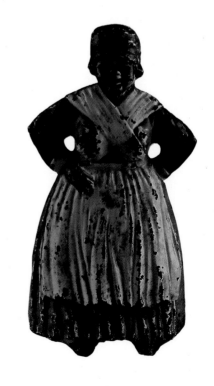

Mammy, 7.50" x 4". *Courtesy of Frank Whitson.*

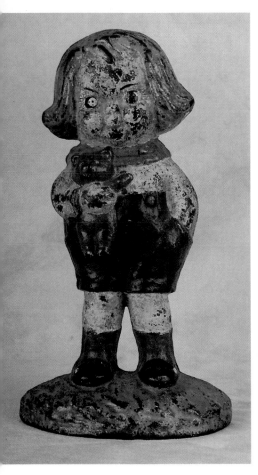

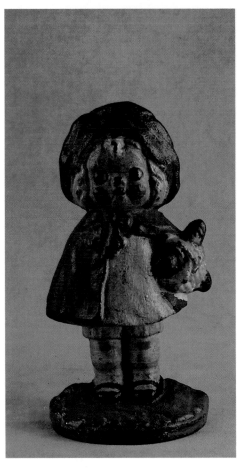

Little Red Riding Hood, 9.25" x 4.75". *Courtesy of Frank Whitson.*

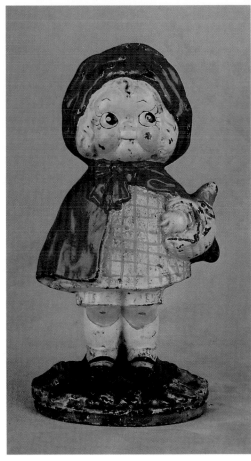

The eyes make a world of difference in this variation of Little Red Riding Hood, 9.25" x 4.75". *Courtesy of Sheila and Edward Malakoff.*

Bobby Blake, 9.25" x 5.25". *Courtesy of Sheila and Edward Malakoff.*

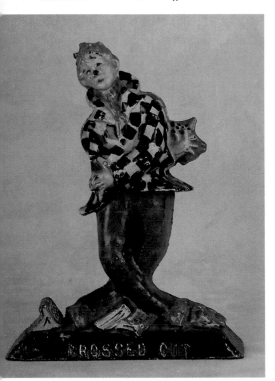

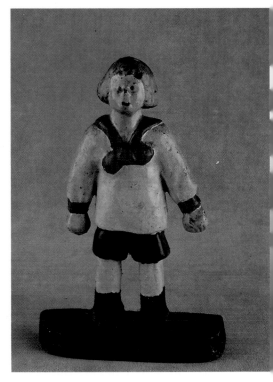

This school boy is "Crossed Out." 7.50" x 5.50". *Courtesy of Sheila and Edward Malakoff.*

Dutch boy doorstop/bank, 9" x 4". *Courtesy of Frank Whitson.*

Boy in shorts, 7.75" x 5.25". *Courtesy of Frank Whitson.*

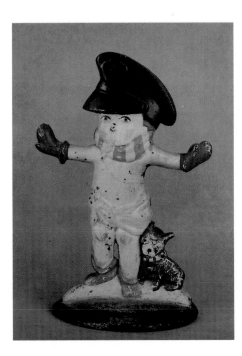

This traffic cop is slightly out of uniform, 10.50" x 7.75". *Courtesy of Sheila and Edward Malakoff.*

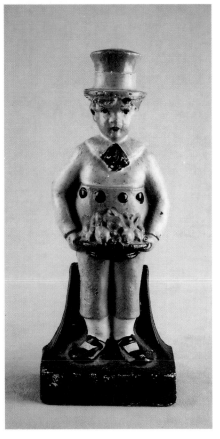

Boy in top hat holding fruit, 9" x 4". *Courtesy of Frank Whitson.*

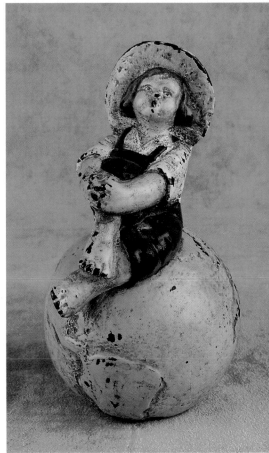

Boy on globe, 6" x 3.50". *Courtesy of Frank Whitson.*

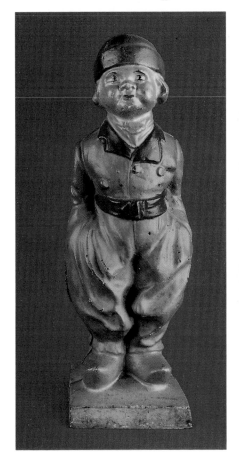

Dutch boy, 2 piece, 11.25" x 4". Paper label read "--ttco Products". *Courtesy of Frank Whitson.*

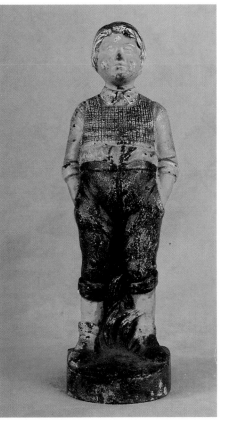

Vested boy, 11" x 3.50". *Courtesy of Sheila and Edward Malakoff.*

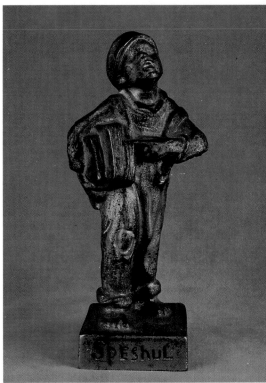

"Speshul," paperboy, 7" x 3.25". *Courtesy of Sheila and Edward Malakoff.*

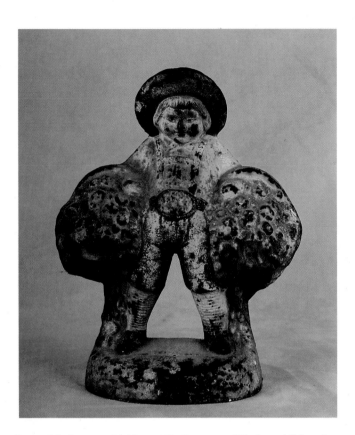

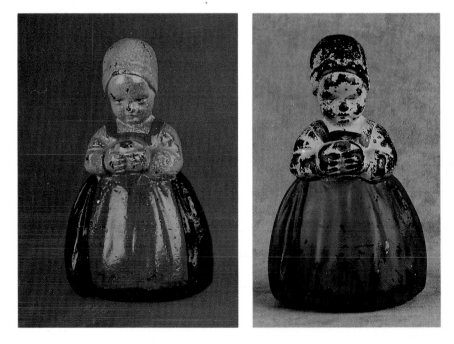

Dutch boy and girl kissing, 8.75" x 7.75". Marked "CN 84".
Courtesy of Frank Whitson.

Boy with flowers, 7.50" x 5.50". *Courtesy of Sheila and Edward Malakoff.*

Two examples of the little Dutch girl, 6.25" x 3.75". They are nicely hollowed out in the back. *Courtesy of Frank Whitson, and of Sheila and Edward Malakoff.*

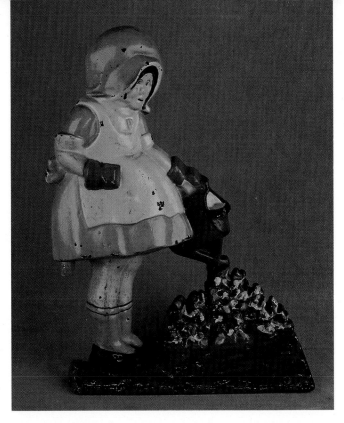

Girl watering flowers, 12" x 9". *Courtesy of Frank Whitson.*

Girl in beanie, 8.50" x 3.50". *Courtesy of Frank Whitson.*

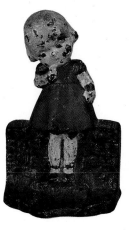

Girl in blue dress, 5.50" x 3.25". *Courtesy of Sheila and Edward Malakoff.*

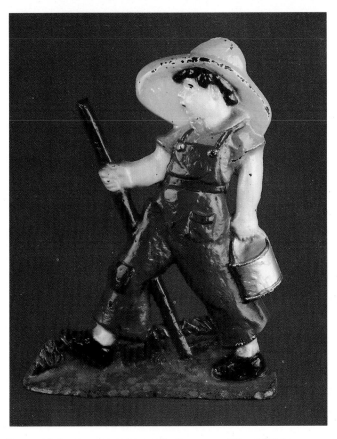

Boy with bucket, 12.50" x 9.25". *Courtesy of Frank Whitson.*

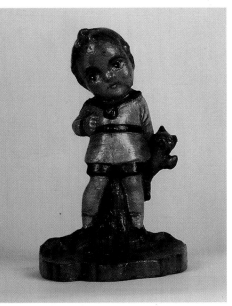

Child with teddy bear, marked 132 on back. 5.50" x 3.75". *Courtesy of Nancy and John Smith.*

Boy with flowers, 9.50" x 5.75". *Courtesy of Frank Whitson.*

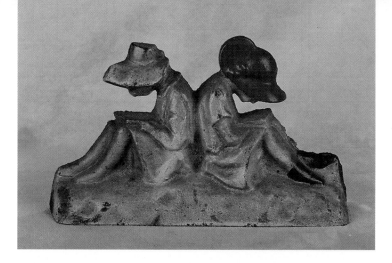

Girls reading, 5" x 8.50". *Courtesy of Sheila and Edward Malakoff.*

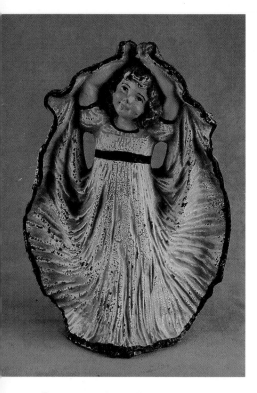

Dancing girl in yellow dress, 9.50" x 7". *Courtesy of Frank Whitson.*

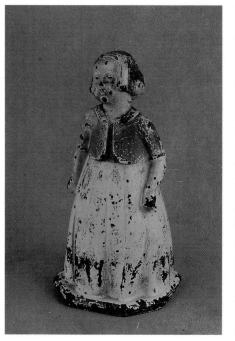

Girl, 7.25" x 3.50". *Courtesy of Frank Whitson.*

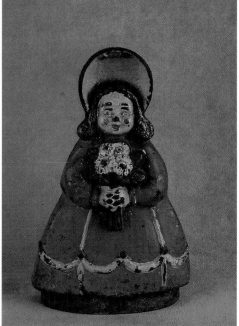

Girl holding flowers. Hollow, 7.50" x 3". *Courtesy of Frank Whitson.*

Girl with the cat that scratched her, 9" x 4.25". Marked "Cjo 1271" and signed O. Dioukly(?). To the left is a trade card with the same scene. *Courtesy of Frank Whitson.*

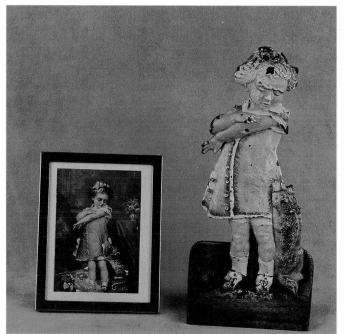

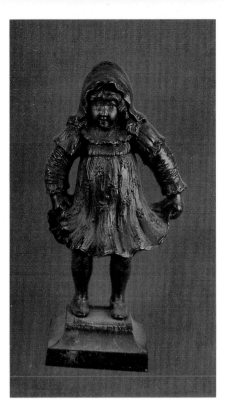

Bradley & Hubbard No. 7798, Girl on pedestal, 13" x 6.75". *Courtesy of Frank Whitson.*

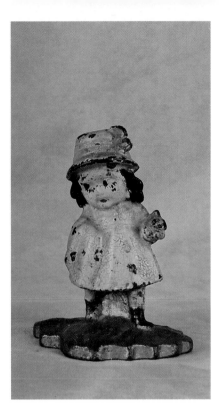

Girl in yellow, 5" x 4". *Courtesy of Sheila and Edward Malakoff.*

COMIC CHARACTERS

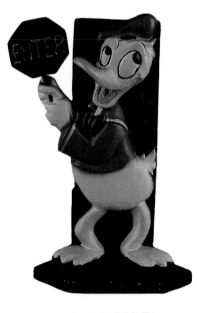

Donald Duck, 1971, Walt Disney Productions. The sign spins with "Stop" on one side and "Enter" on the other. 8.50" x 5". *Courtesy of Frank Whitson.*

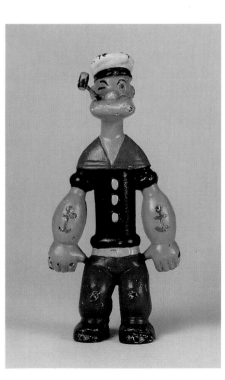

Rare Popeye doorstop, King Features, copyright 1929. 9" x 4.25". *Courtesy of Frank Whitson.*

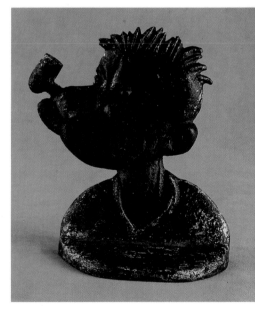

Popeye bust with pipe, 5.75" x 5". *Courtesy of Frank Whitson.*

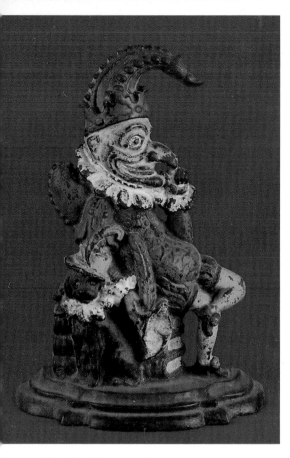

Punch and Judy, 11.50" x 8". *Courtesy of Frank Whitson.*

Punch, 12" x 7.25". *Courtesy of Frank Whitson.*

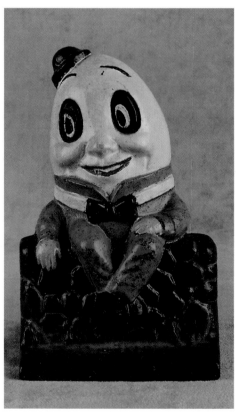

Humpty Dumpty doorstop/bank. 5.50" x 3.50". *Courtesy of Frank Whitson.*

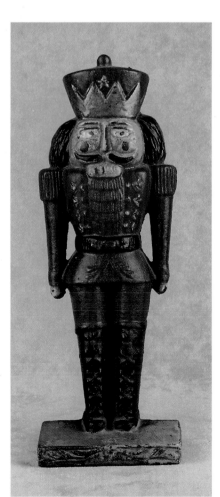

Judy, 12.25" x 8". *Courtesy of Frank Whitson.*

Hollow back Nutcracker, 10" x 4". *Courtesy of Frank Whitson.*

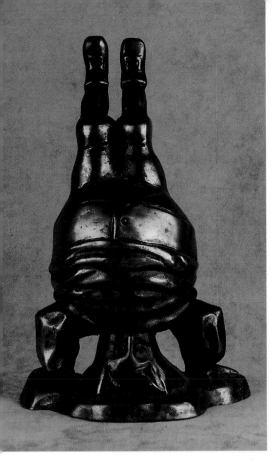

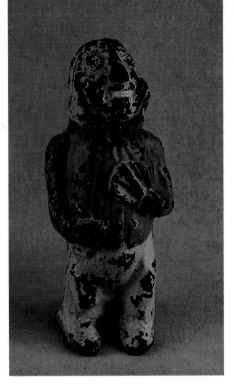

The March Hare, 8.50" x 4". *Courtesy of Frank Whitson.*

The Mad Hatter, 7" x 4". *Courtesy of Frank Whitson.*

Handstand, electroplated, 12.25" x 8". Marked "EB". *Courtesy of Frank Whitson.*

ELVES & GNOMES

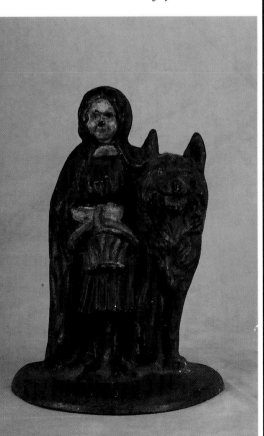

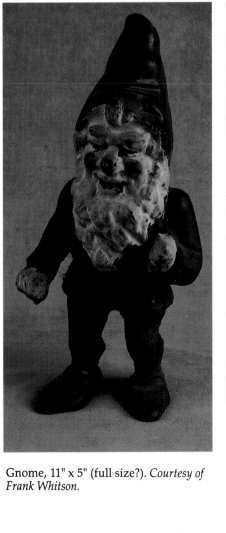

Gnome with walking stick, 13" x 5.50". *Courtesy of Frank Whitson.*

Red Riding Hood, 7.50" x 5.50". *Courtesy of Sheila and Edward Malakoff.*

Gnome, 11" x 5" (full size?). *Courtesy of Frank Whitson.*

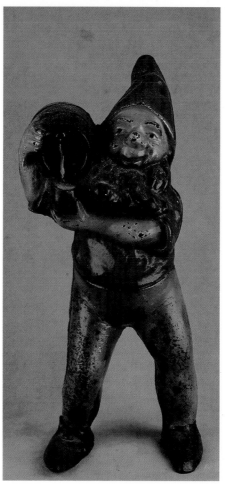

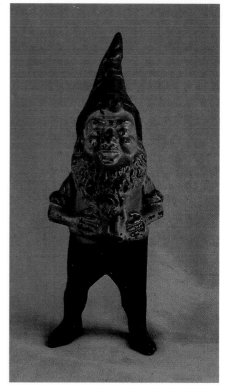

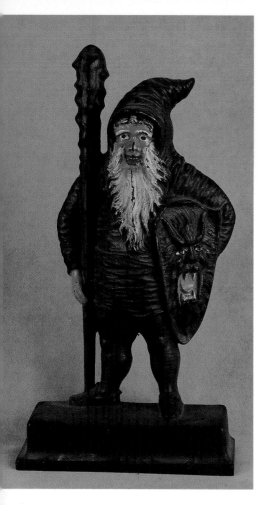

Elf, 10.50" x 4.25". *Courtesy of Frank Whitson.*

Elfin warrior with mask shield and club, 13.50" x 7.25". Marked "B & H/ 7995". *Courtesy of Frank Whitson.*

Elf with cask of ale, 15" x 6". *Courtesy of Frank Whitson.*

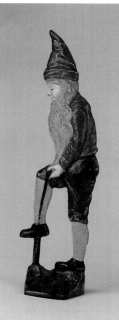

Two sided gnome, Spencer. 13" x 3.50". *Courtesy of Nancy and John Smith.*

Gnome carrying barrel, 7.75" x 7.25". Hollow back marked "JPR" (?). *Courtesy of Frank Whitson.*

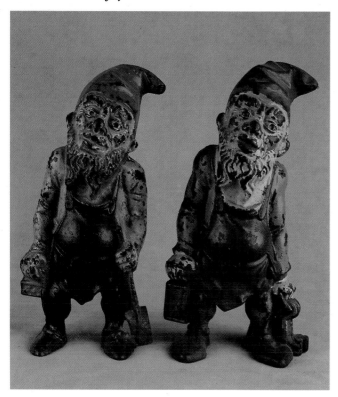

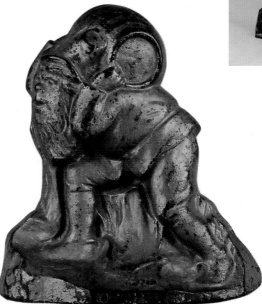

Two working elves, 10" x 5". *Courtesy of Frank Whitson.*

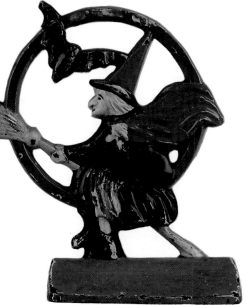

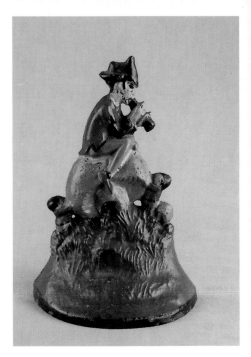

Witch on a broom, 6.50" x 6". *Courtesy of Frank Whitson.*

Pan, 7.25" x 5". Marked "120". *Courtesy of Frank Whitson.*

Thumbelina, 7.75" x 5". *Courtesy of Frank Whitson.*

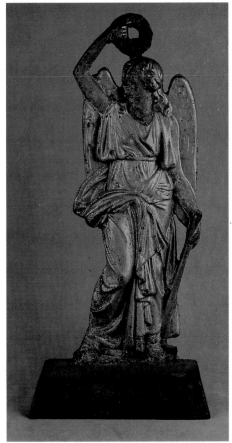

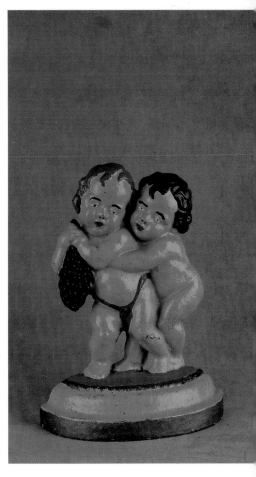

The Man in the Moon, 6.50" x 4". *Courtesy of Frank Whitson.*

Winged Victory, 16.50" x 8". *Courtesy of Frank Whitson.*

Children with grapes, 9.75" x 7.50". *Courtesy of Frank Whitson.*

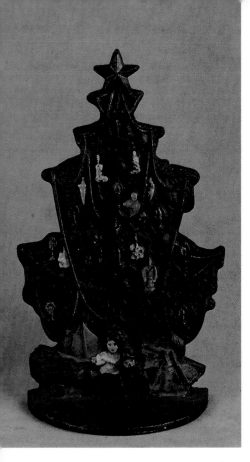

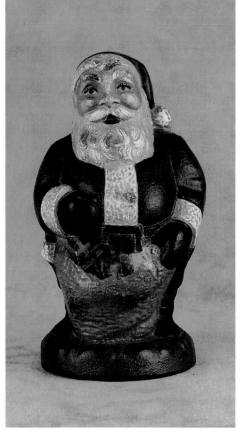

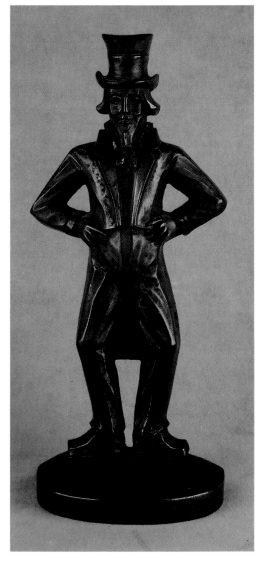

Christmas tree, 11" x 6". *Courtesy of Frank Whitson.*

Santa Claus with sack, hollow back, 7.25" x 4". *Courtesy of Frank Whitson.*

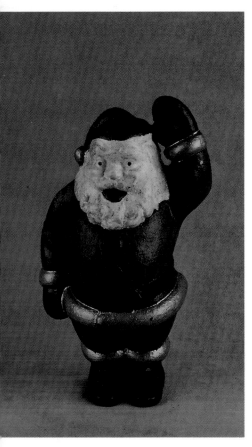

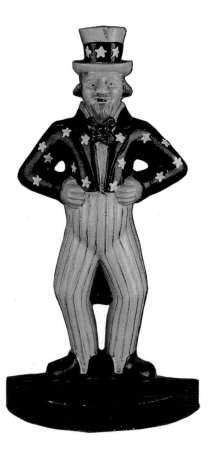

Electroplated Uncle Sam, 12" x 5.25". *Courtesy of Frank Whitson.*

Waving Santa Claus, 11" x 6". *Courtesy of Frank Whitson.*

Round-faced Uncle Sam, 16" x 8.50". *Courtesy of Frank Whitson.*

CLOWNS & MINSTRELS

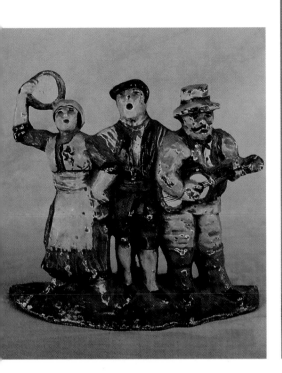

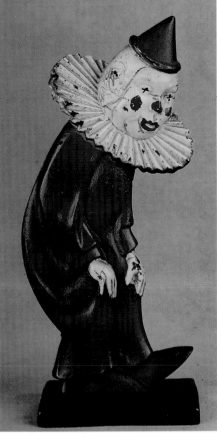

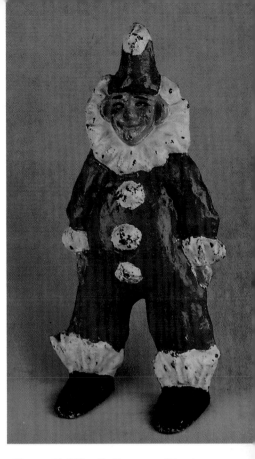

Three Gypsy troubadours, 6.50" x 7.50". *Courtesy of Sheila and Edward Malakoff.*

Clown, 10" x 4.25". *Courtesy of Sheila and Edward Malakoff.*

Clown, 11.50" x 6". *Courtesy of Frank Whitson.*

FISHERMEN

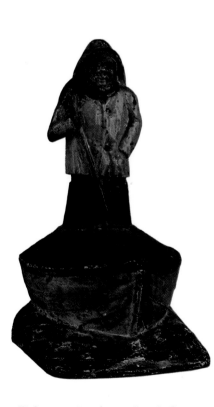

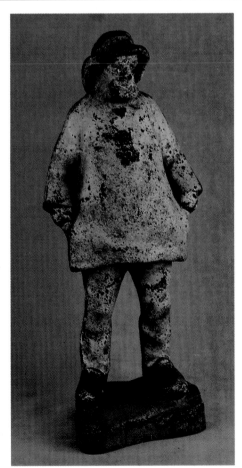

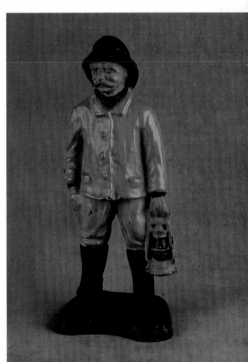

Three dimensional fisherman with a lantern, 9" x 3.75". *Courtesy of Frank Whitson.*

Fisherman made by the Eastern Specialty Co., 15" x 5.50". *Courtesy of Frank Whitson.*

Fisherman in a boat, 7" x 4". *Courtesy of Frank Whitson.*

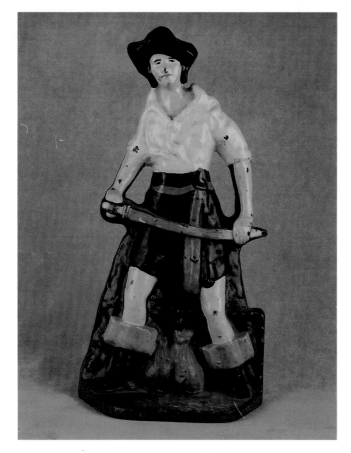

Female pirate, 13.50" x 7". *Courtesy of Frank Whitson.*

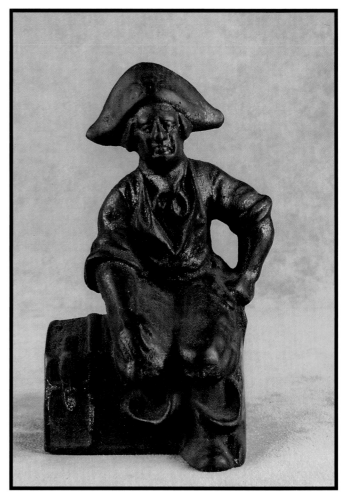

Pirate sitting on a treasure chest, 6" x 3.25". Hollow base.
Courtesy of Frank Whitson.

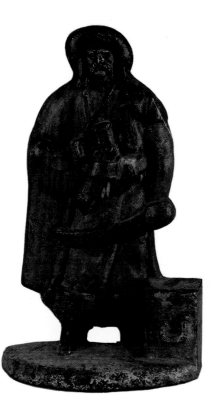

Buccaneer with cutlass, 9.75" x 6". *Courtesy of Frank Whitson.*

MILITARY FIGURES

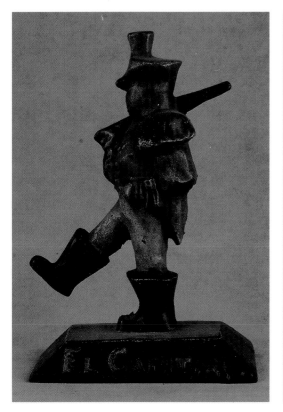

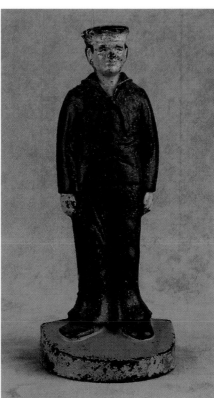

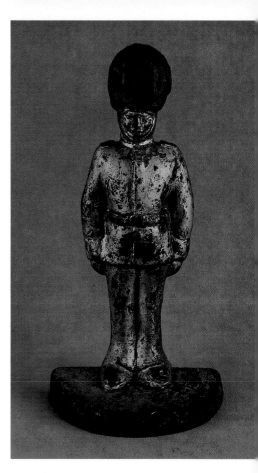

"El Capitan," three dimensional, 8" x 5". *Courtesy of Frank Whitson.*

Twentieth century sailor, 8.75" x 3.50". *Courtesy of Frank Whitson.*

English guard, 11.25" x 6". *Courtesy of Frank Whitson.*

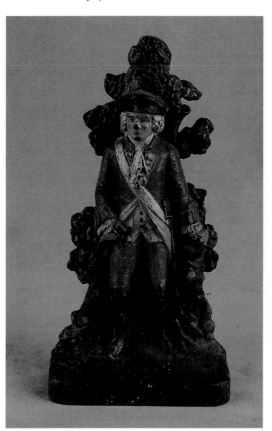

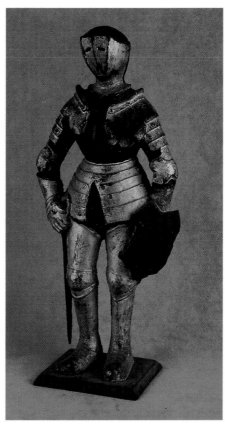

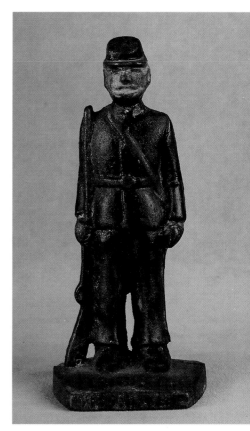

"Red Coat," Albany Foundry Co., No. 34, 9.50" x 5". *Courtesy of Frank Whitson.*

Knight in shining armor, 14" x 6". Marked LVL. *Courtesy of Frank Whitson.*

Civil War infantryman, 7" x 3.25". *Courtesy of Frank Whitson.*

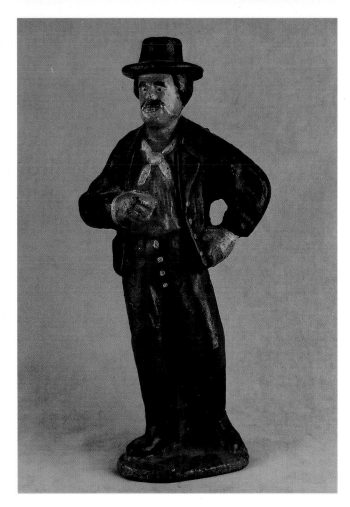

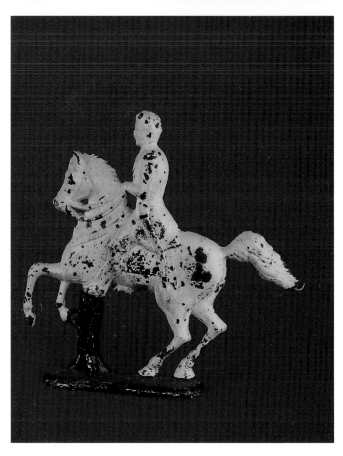

Soldier on a horse, 12.50" x 13". *Courtesy of Frank Whitson.*

Nineteenth century sailor, 16" x 5". *Courtesy of Frank Whitson.*

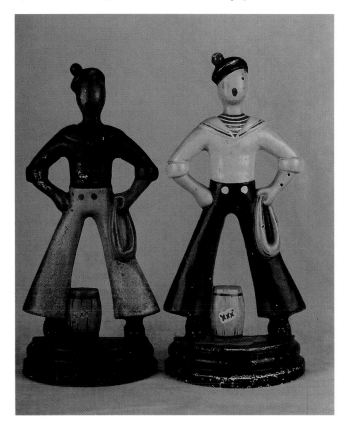

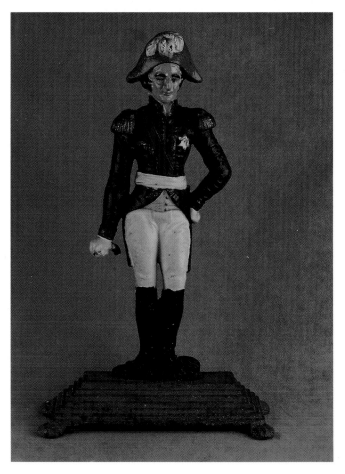

Sailors, 11.75" x 5.25". *Courtesy of Sheila and Edward Malakoff.*

French soldier, 16" x 10". *Courtesy of Frank Whitson.*

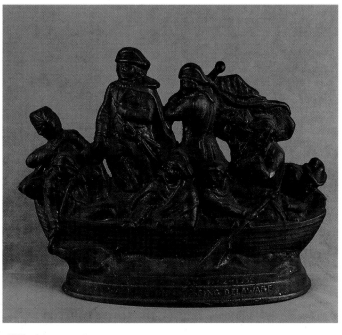

"Washington Crossing the Delaware," 8.75" x 11". *Courtesy of Frank Whitson.*

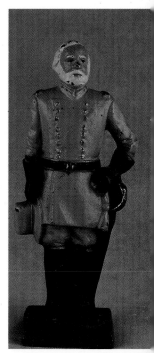

Robert E. Lee, three dimensional, 7.50" x 3". *Courtesy of Frank Whitson.*

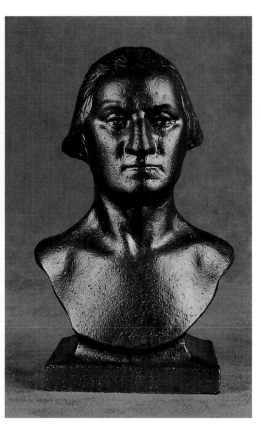

Bust of George Washington, 6" x 4.25". *Courtesy of Frank Whitson.*

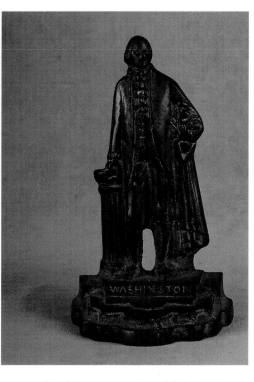

Washington standing, 6.25" x 3.25". *Courtesy of Sheila and Edward Malakoff.*

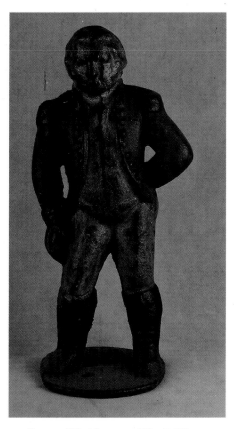

George Washington, 15" x 5.50". *Courtesy of Frank Whitson.*

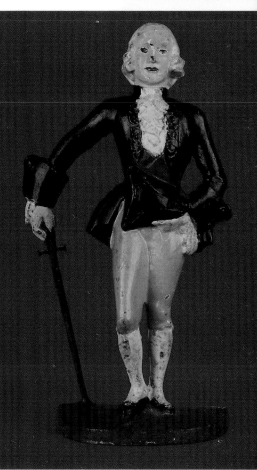

Lafayette, 11.50" x 6". *Courtesy of Sheila and Edward Malakoff.*

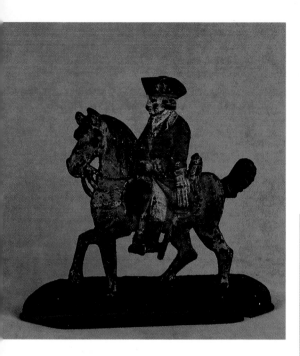

Paul Revere, 8" x 9". *Courtesy of Frank Whitson.*

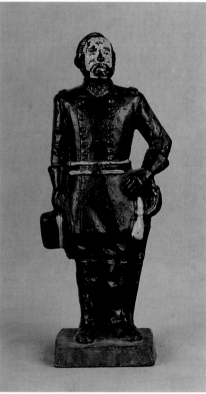

U.S. Grant, three dimensional, 7.50" x 3". *Courtesy of Sheila and Edward Malakoff.*

George Bernard Shaw, 8" x 4.50". *Courtesy of Frank Whitson.*

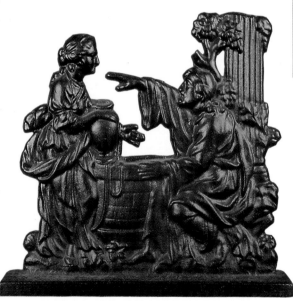

Jesus and the Woman of Samaria, after a painting of that name by Mignard. Also called Rebecca at the Well. Coalbrookdale Co. of Shropshire, England. 10.25" x 11". *Courtesy of Sheila and Edward Malakoff.*

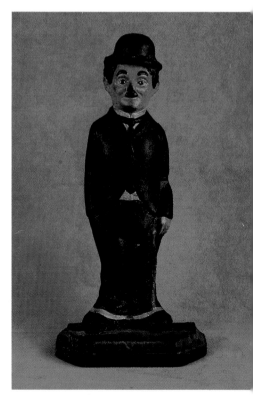

Charlie Chaplin as the "Little Tramp," 9.75" x 4.75". *Courtesy of Frank Whitson.*

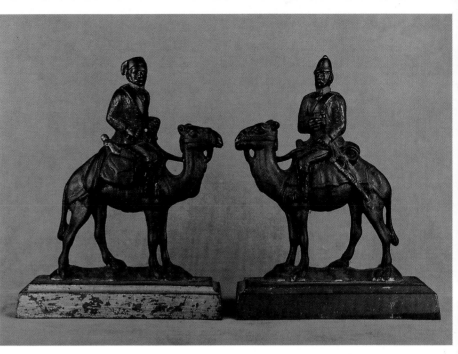

Knute Rockne, with facsimile signature in the casting, copyright Oct. 10, 1930. *Courtesy of Sheila and Edward Malakoff.*

Mantel pieces, General Charles George Gordon and General Garnet Joseph Wolseley on camels, 12" x 8". *Courtesy of Sheila and Edward Malakoff.*

MUSICIANS

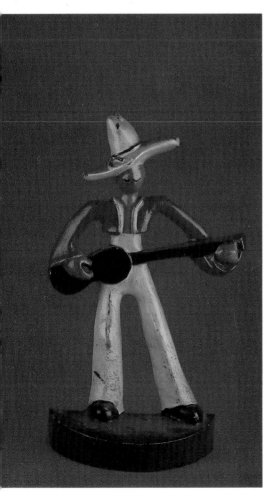

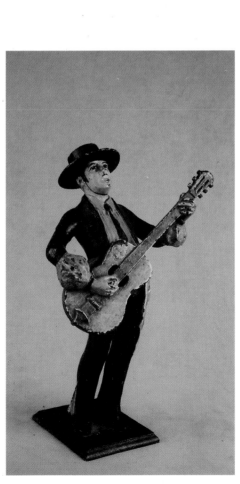

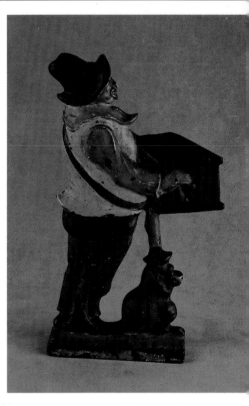

Two-sided organ grinder, 10" x 5.50". *Courtesy of Sheila and Edward Malakoff.*

Guitar player, 12" x 6.25". *Courtesy of Frank Whitson.*

Spanish guitar player, 11.25" x 6.25". *Courtesy of Frank Whitson.*

SCOTSMEN

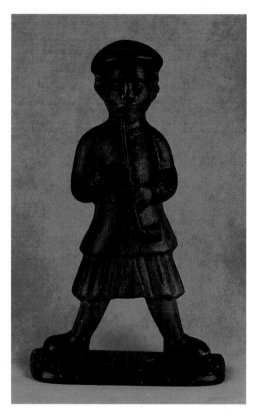

Scotsman in kilt, 12" x 7.50". *Courtesy of Frank Whitson.*

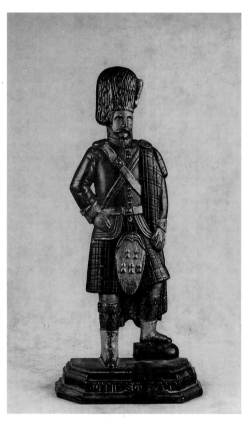

"Bonnie Scotland," a Scottish highlander on a pedestal. 12" x 5.50". *Courtesy of Frank Whitson.*

POLICEMEN

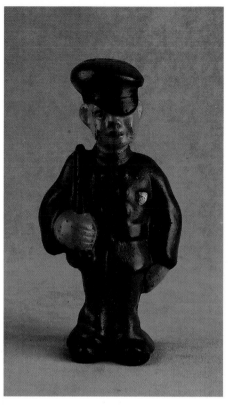

Policeman, LeMur Lgt Co., 8" x 4". *Courtesy of Frank Whitson.*

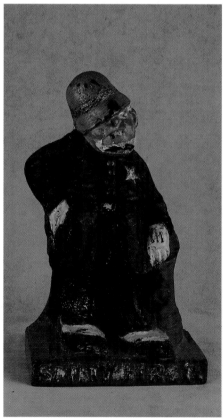

"Safety First" cop, 9.50" x 5.50". *Courtesy of Frank Whitson.*

OTHER MALE FIGURES

Patriot, 8.75" X 5.50". *Courtesy of Frank Whitson.*

Butler, 10" x 3.25". *Courtesy of Nancy and John Smith.*

Bellhop, 9" x 5". *Courtesy of Sheila and Edward Malakoff.*

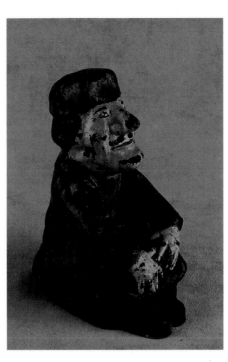

Turkish man, three dimensional, 6" x 3". Marked "665". *Courtesy of Frank Whitson.*

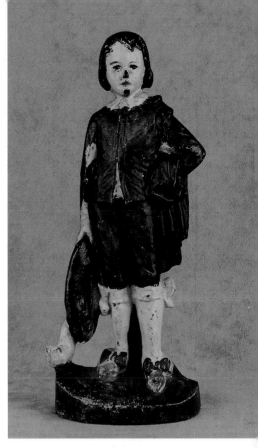

The Blue Boy after a painting by Gainsborough, 10.50" x 4.25". Hand-signed on bottom, "Miss Grace Lockridge.". *Courtesy of Frank Whitson.*

The Snooper, 13.50" x 4.50". *Courtesy of Frank Whitson.*

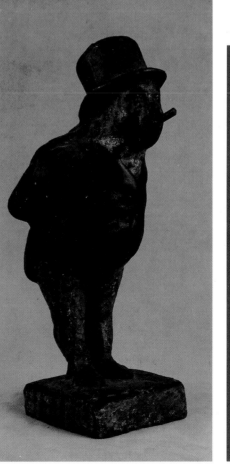

Man smoking a cigar, three dimensional, 9" x 4". *Courtesy of Frank Whitson.*

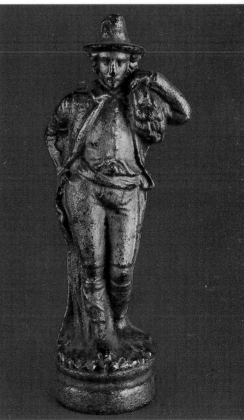

Farmer, 12" x 5". *Courtesy of Frank Whitson.*

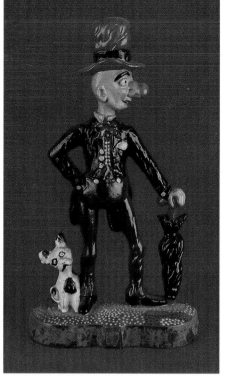

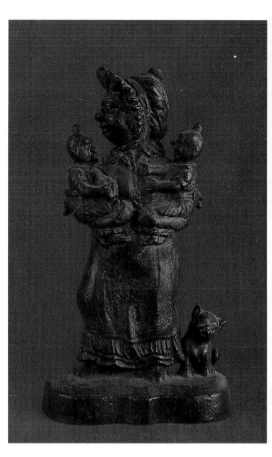

Ally Sloper, 11.25" x 6.50". Ally Sloper was an early comic character, first appearing in the English paper *Judy* in the 1870s. The early crude drawings of Sloper were done by Marie Duval. When the paper changed hands, Sloper began to be drawn by its chief cartoonist, W.G. Baxter. Immensely popular, it has been said that Ally Sloper was to his generation what Mickey Mouse was to later times. The dog, by the way, is named Snatcher. *Courtesy of Frank Whitson.*

Mrs. Sloper and children, 11.50" x 6.50". *Courtesy of Frank Whitson.*

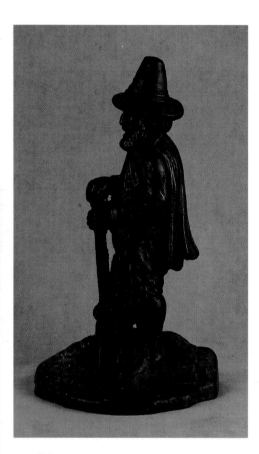

Pilgrim, 10.25" x 6". *Courtesy of Frank Whitson.*

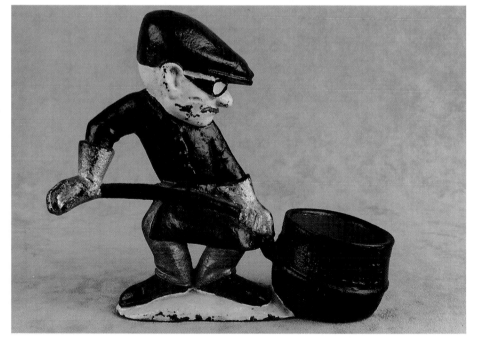

Iron worker, 6.50" x 7.75". Marked "Hill Clutch" on pot. *Courtesy of Frank Whitson.*

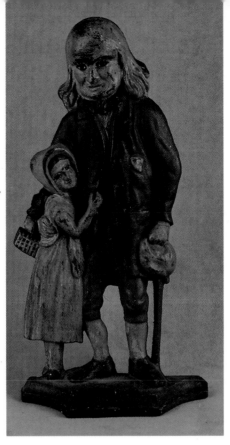

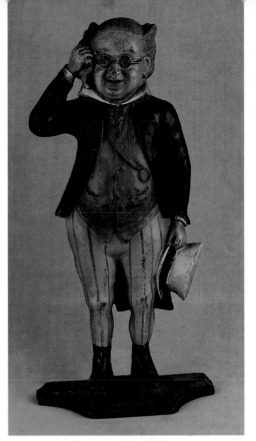

Dandy with cane, 8.50" x 5". *Courtesy of Sheila and Edward Malakoff.*

Probably Mr. Peggotty and Little Agnes, from Phiz's illustration in Dicken's *David Copperfield*. 14" x 7.25". Marked "CN". *Courtesy of Frank Whitson.*

Mr. Pickwick from Dicken's *Pickwick Papers*, 15" x 7.5". *Courtesy of Frank Whitson.*

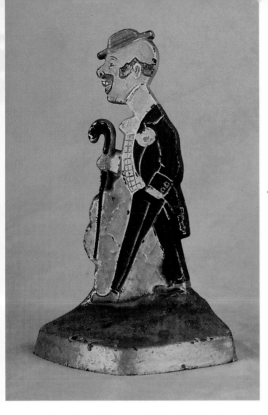

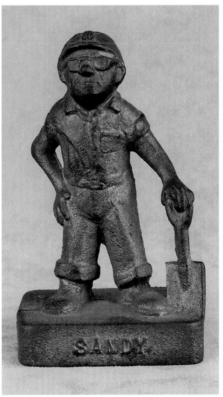

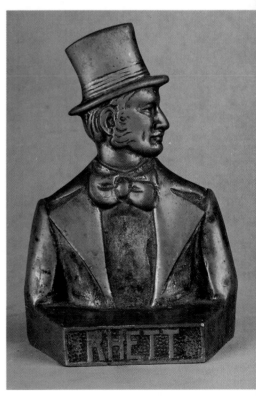

Shepherd with lamb, 13.50" x 9". *Courtesy of Sheila and Edward Malakoff.*

Worker with shovel, 5.75" x 3.50". Manufactured by the Midwest Foundry, it is marked "Sandy" on the front. *Courtesy of Frank Whitson.*

"Rhett," 8" x 5.50". While it is difficult to confirm, the costume of the character and the date of the doorstop lead one to assume that this is Rhett Butler from the novel *Gone with the Wind*, by Margaret Mitchell.

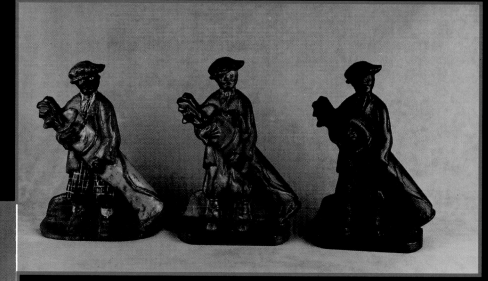

Left: black caddie, 8" x 6"; middle: copper toned caddie, Production Pattern & Foundry Co., Chicopee, Massachusetts, 1960; right: Production Pattern & Foundry Co., caddie.

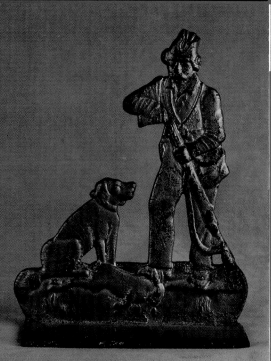

Hunter and dog, 10" x 8". *Courtesy of Frank Whitson.*

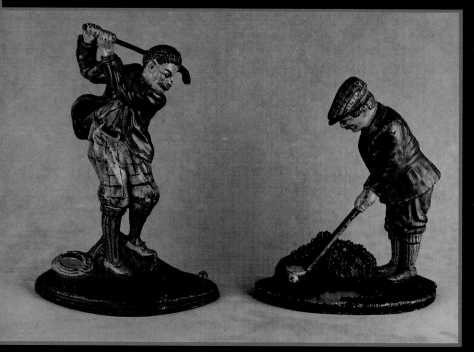

Golfers, Hubley. Left: No. 238, 10.25" x 7"; right: No. 34, 8.25" x 7". *Courtesy of Frank Whitson.*

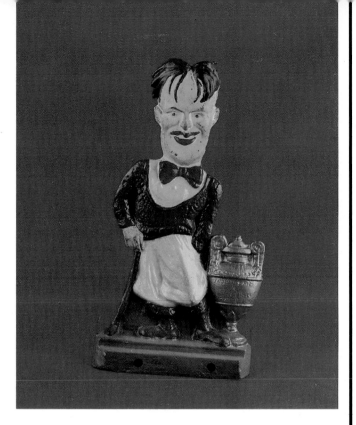

Golfer with trophy, 12" x 6". *Courtesy of Frank Whitson.*

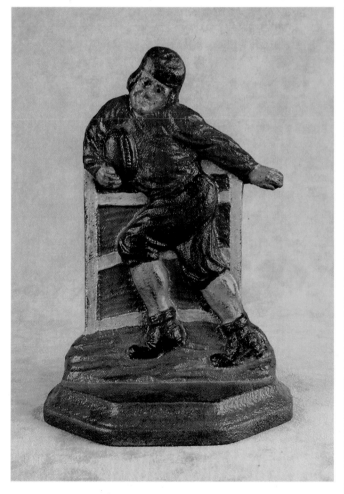

Football player, Hubley, 1937, 7.25" x 5". *Courtesy of Frank Whitson.*

FEMALE FIGURES

ARTISTIC REPRESENTATIONS

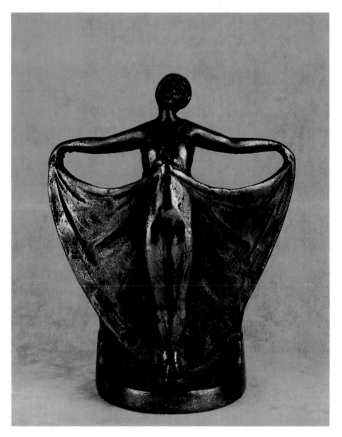

Dancer with outstretched dress, copper-plated, 9" x 7". *Courtesy of Frank Whitson.*

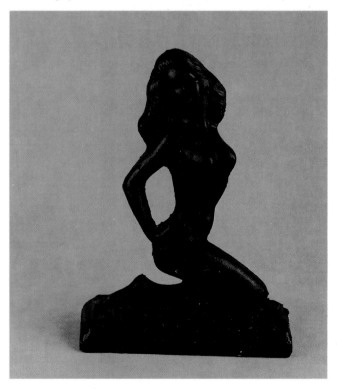

Kneeling nude, 9.25" x 7". *Courtesy of Frank Whitson.*

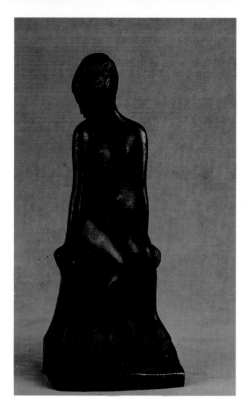

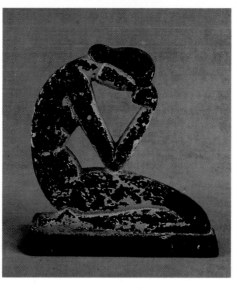

Mourning woman, 6" x 5.75". *Courtesy of Frank Whitson.*

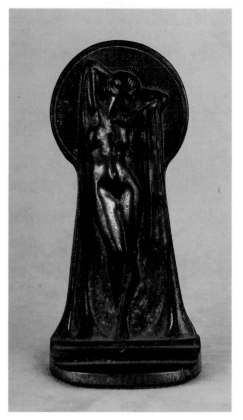

Seated nude, 8.25" x 3.50". Hubley, No. 322. *Courtesy of Frank Whitson.*

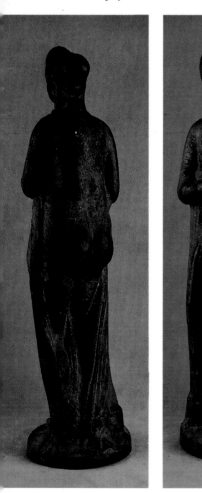

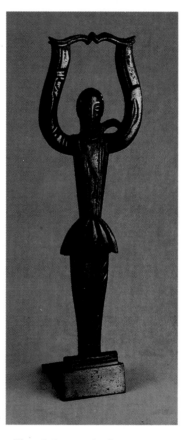

Standing nude, 7.75" x 3.75". *Courtesy of Sheila and Edward Malakoff.*

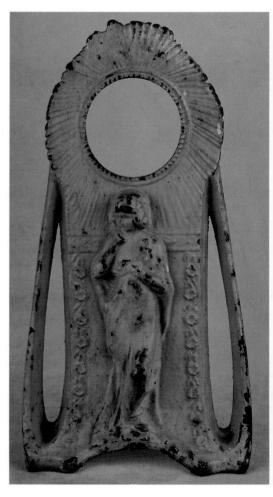

Plated deco-style doorporter, 14" x 2.25". *Courtesy of Frank Whitson.*

Columbia, 16.50" x 4.50". *Courtesy of Frank Whitson.*

Woman against pierced background, 13/50" x 7.25". *Courtesy of Sheila and Edward Malakoff.*

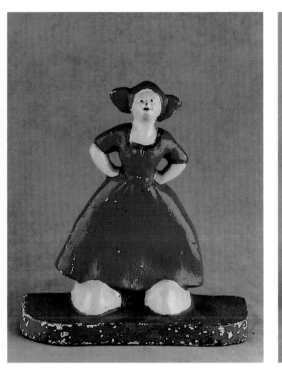

Dutch maiden, 9.50" x 9". *Courtesy of Frank Whitson.*

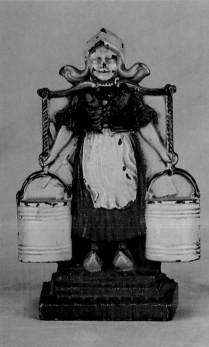

Dutch girl with buckets, 6.50" x 4.50". *Courtesy of Sheila and Edward Malakoff.*

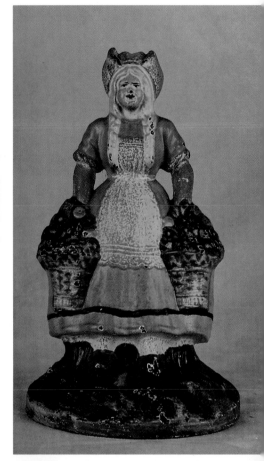

Dutch girl carrying baskets of flowers, 9.50" x 6". *Courtesy of Sheila and Edward Malakoff.*

Dutch girl with buckets, 13" x 9.75". *Courtesy of Frank Whitson.*

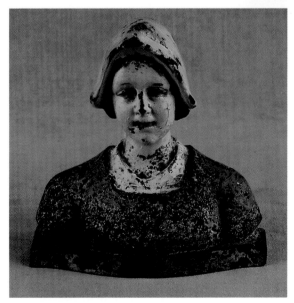

Beautiful bust of a Dutch woman, 5.75" x 6". *Courtesy of Frank Whitson.*

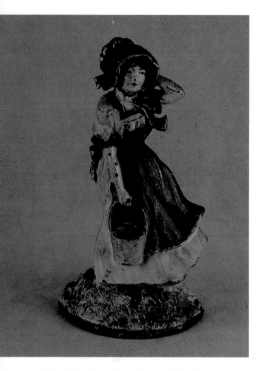

"Jill," Hubley No. 226, 8.75" x 5".
Courtesy of Frank Whitson.

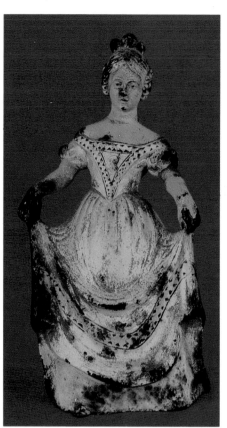

Curtsying woman, 9" x 5". *Courtesy of Sheila and Edward Malakoff.*

Woman with flowers and fan, 9.50" x 5.50". *Courtesy of Sheila and Edward Malakoff.*

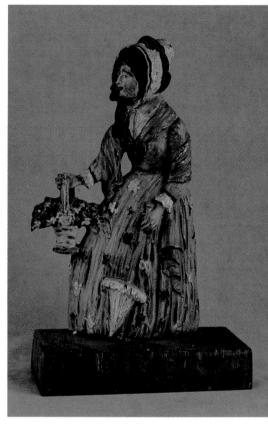

Woman with flower basket, Bradley & Hubbard No. 7796, 11" x 7". *Courtesy of Frank Whitson.*

Woman with purse, 9.50" x 6.25". *Courtesy of Frank Whitson.*

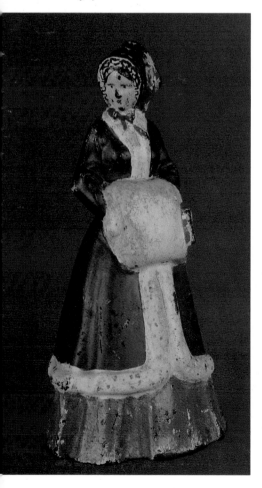

Woman with hand muff, 9.50" x 5".
Courtesy of Sheila and Edward Malakoff.

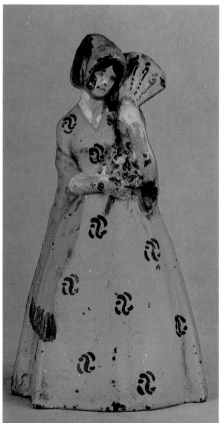

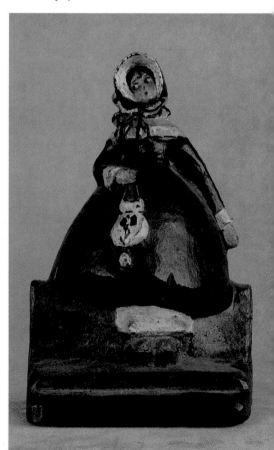

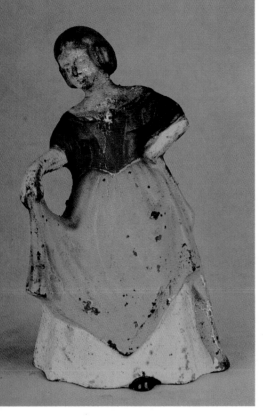

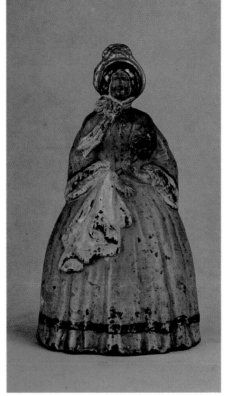

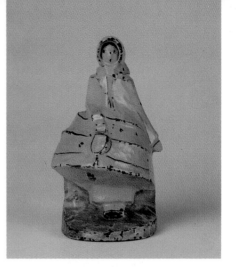

The old-fashioned lady, Hubley. 8.75" x 4". *Courtesy of Nancy and John Smith.*

Woman lifting skirt, 8.50" x 4.50". *Courtesy of Sheila and Edward Malakoff.*

Woman with flowers and handkerchief, 8" x 4.50". *Courtesy of Sheila and Edward Malakoff.*

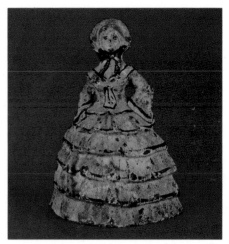

Small figure in layered dress, 4.75" x 3.50". *Courtesy of Sheila and Edward Malakoff.*

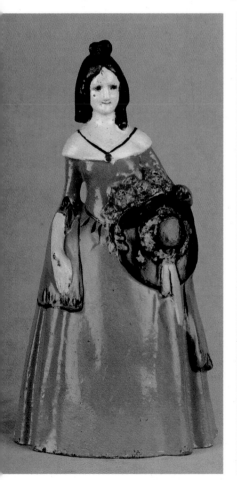

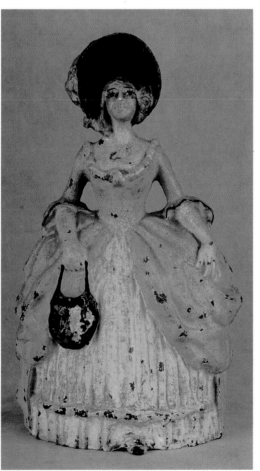

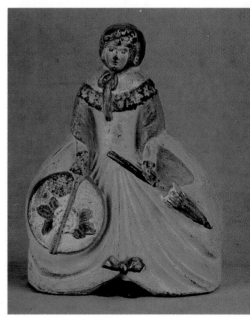

Woman holding hat, 11.50" x 6". *Courtesy of Sheila and Edward Malakoff.*

Woman in bonnet holding handbag, 10.50" x 6". *Courtesy of Sheila and Edward Malakoff.*

Woman with parasol, Albany Foundry Co., 7" x 5.50". *Courtesy of Sheila and Edward Malakoff.*

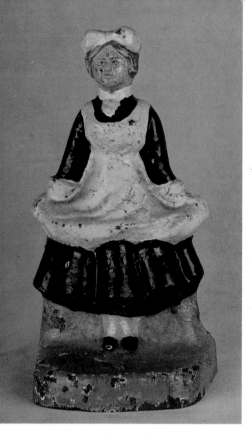

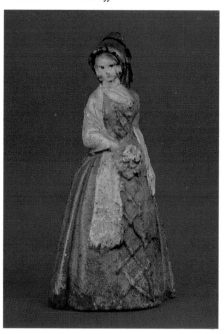

Right and center right photos:
Paint variations can give the doorstop quite a different personality, as in these two ladies. 8.25" x 6". *Courtesy of Sheila and Edward Malakoff.*

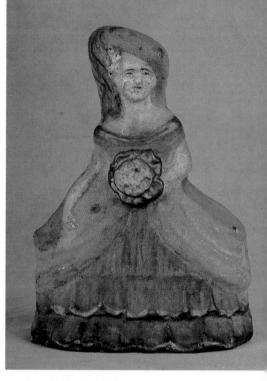

Maid doing curtsy, 9" x 4.75". *Courtesy of Sheila and Edward Malakoff.*

Woman in shawl with flowers, 6.75" x 3.50". *Courtesy of Sheila and Edward Malakoff.*

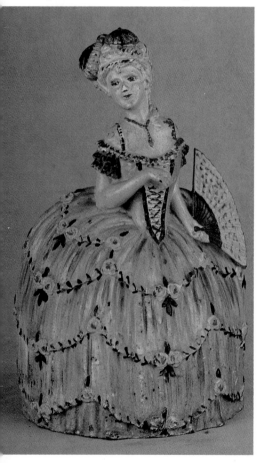

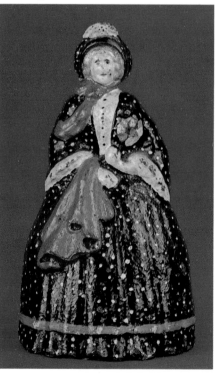

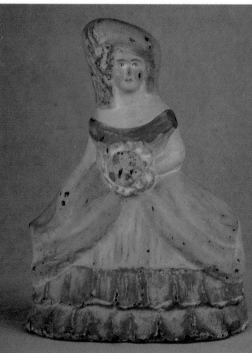

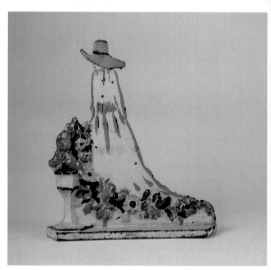

Lady with fan, 9.50" x 6". Marked "WS" in triangle. *Courtesy of Sheila and Edward Malakoff.*

Woman with flowers and handkerchief from page 103, with different paint. *Courtesy of Sheila and Edward Malakoff.*

The bridesmaid, Albany Foundry Co. 11.25" x 10". *Courtesy of Nancy and John Smith.*

20th CENTURY WOMEN

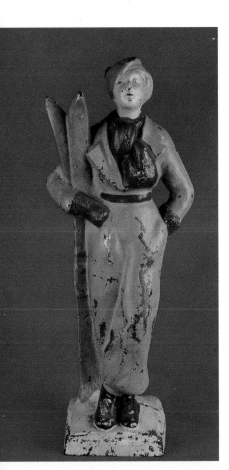

Skier, 12.75" x 5". *Courtesy of Frank Whitson.*

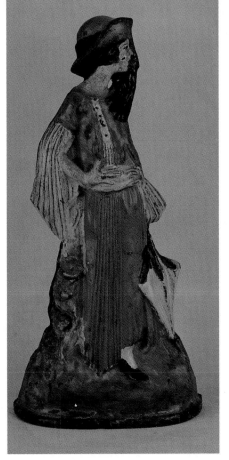

Twenties woman, 9.50" x 4.75". *Courtesy of Sheila and Edward Malakoff.*

Lady in garden, 11.75" x 7". *Courtesy of Sheila and Edward Malakoff.*

Bradley & Hubbard Art Deco styled woman, 17" x 7". *Courtesy of Frank Whitson.*

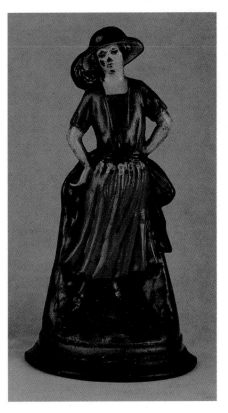

Twenties costumed woman, 12" x 6.50". Marked EGW Co., Toledo, Ohio. *Courtesy of Frank Whitson.*

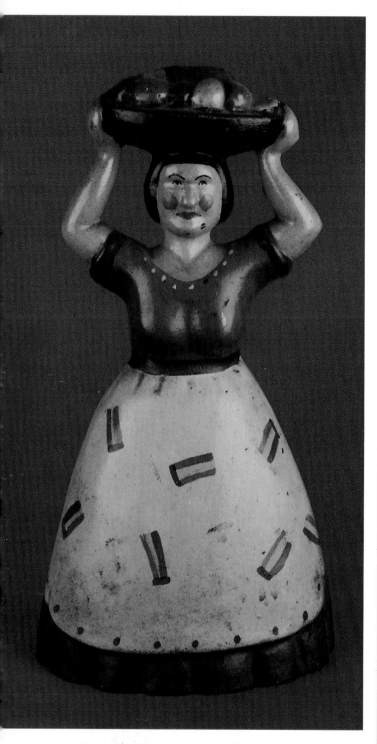

Lady with fruit, 4.50" x 6". *Courtesy of Frank Whitson.*

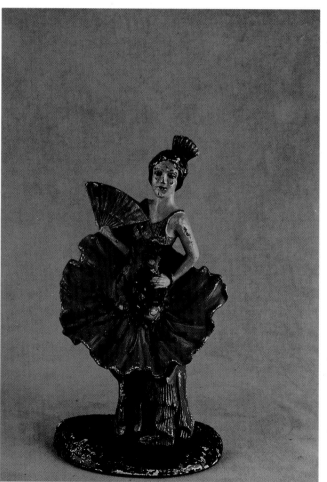

Spanish dancer, 9.50" x 5.50". *Courtesy of Frank Whitson.*

TRANSPORTATION:

Coaches

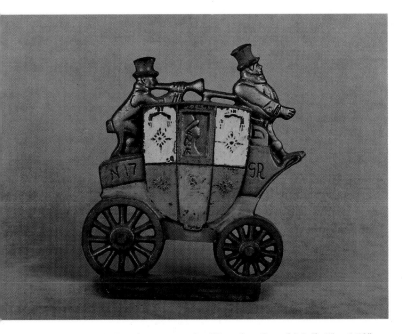

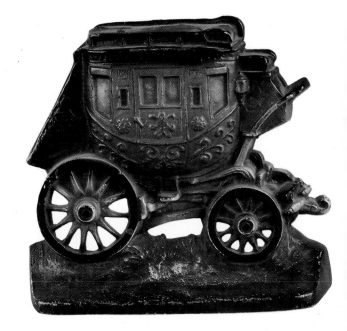

Coach and Coachmen, marked London Royal Mail, 7" x 6.50". *Courtesy of Sheila and Edward Malakoff.*

Coach, copyright 1930, 7.25" x 8". *Courtesy of Frank Whitson.*

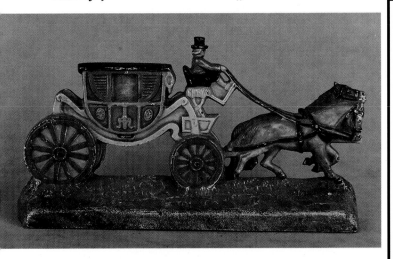

Airships

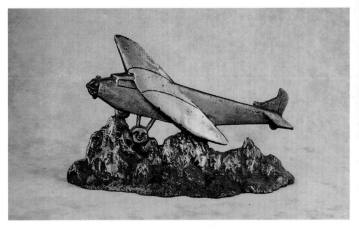

Coach and horses, Hubley No. 376/2, 6" x 11". *Courtesy of Sheila and Edward Malakoff.*

Conestoga wagon, Hubley, 375/1, 5" x 9". *Courtesy of Sheila and Edward Malakoff.*

Airplane, probably the Spirit of St. Louis, marked "LVL". 6" x 9.50". *Courtesy of Frank Whitson.*

Graf Zeppelin, 8" x 13.50". *Courtesy of Frank Whitson.*

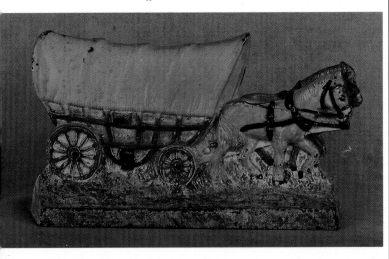

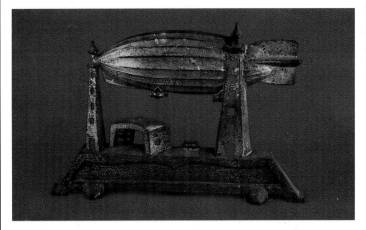

Three-masted sailing ship, 11" x 10". *Courtesy of Sheila and Edward Malakoff.*

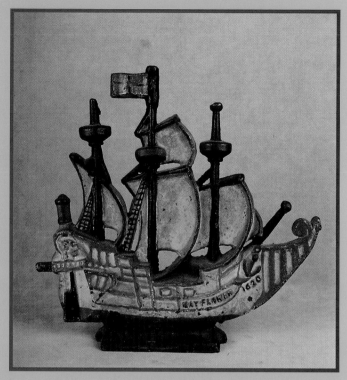

The Mayflower, 1620, by W.F. Tremary, 13" x 13". *Courtesy of Sheila and Edward Malakoff.*

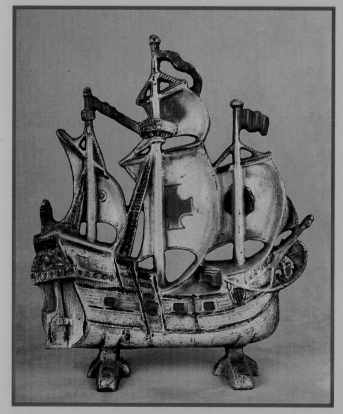

Nicely detailed ship, 12" x 10". *Courtesy of Sheila and Edward Malakoff.*

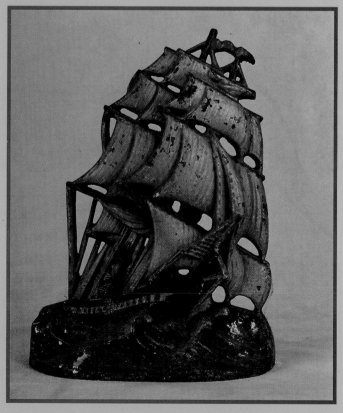

Dramatic sailing ship, A.M. Greenblatt Studios, Boston, 8.50" x 6.50". *Courtesy of Sheila and Edward Malakoff.*

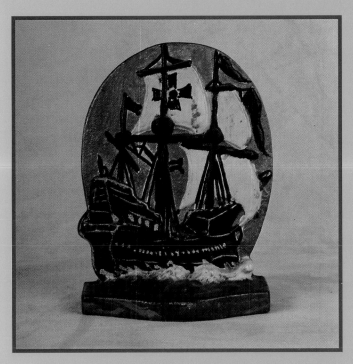

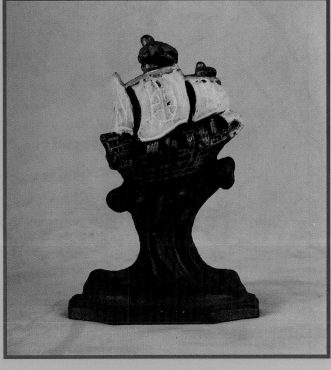

Ship cast high by a pedestal of waves, 6.50" x 4.75". *Courtesy of Sheila and Edward Malakoff.*

Ship in silhouette, 6.25" x 4.25". *Courtesy of Sheila and Edward Malakoff.*

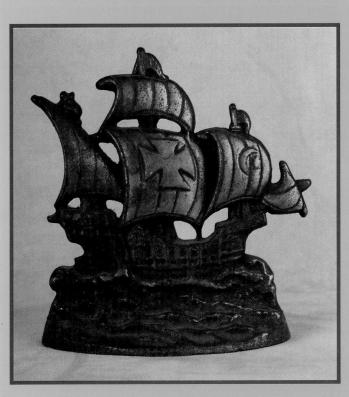

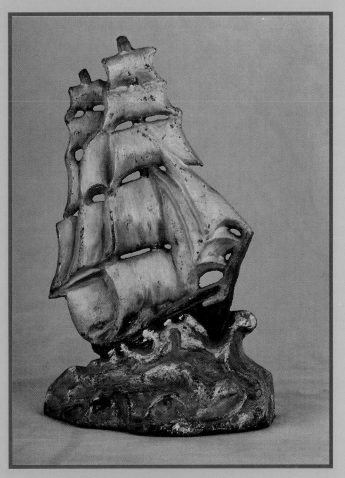

Ship on the sea, 8" x 7". *Courtesy of Sheila and Edward Malakoff.*

Ship in a storm, 9.25" x 6". *Courtesy of Sheila and Edward Malakoff.*

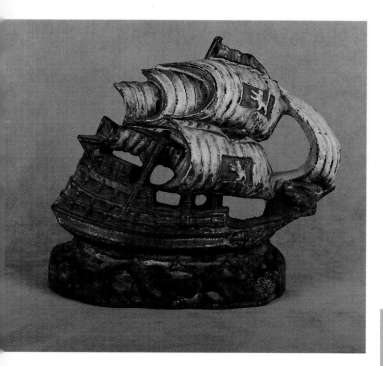

Ship in a strong wind, 8" x 9". *Courtesy of Sheila and Edward Malakoff.*

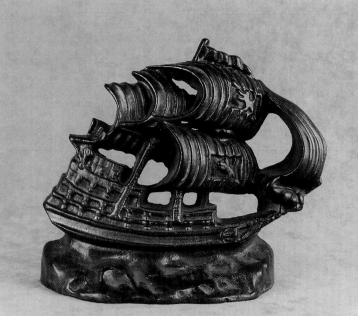

The same ship in a copper finish. *Courtesy of Frank Whitson.*

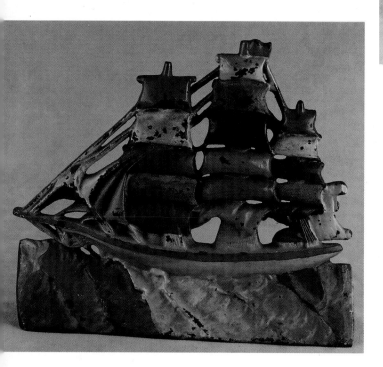

Wildly painted schooner, National Foundry, 9.50" x 11.50". *Courtesy of Frank Whitson.*

BOOKENDS

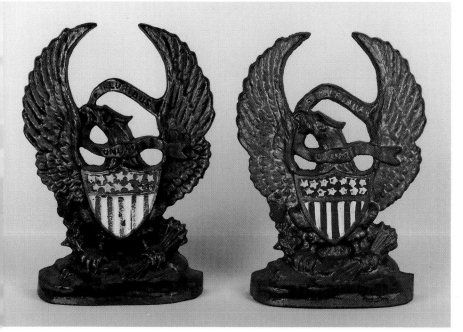

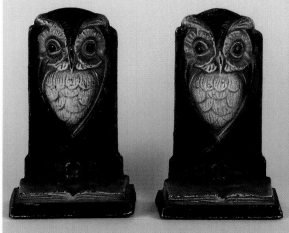

Owls with book, 5.25" x 3.5". *Courtesy of Barbara and Bob Lauver.*

Eagle with shield, 7" x 5.25". Marked 665. *Courtesy of Barbara and Bob Lauver.*

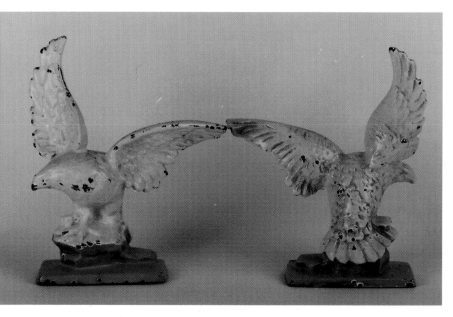

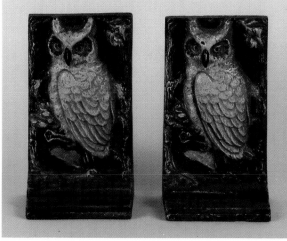

Owls, 5" x 3". Marked "47". *Courtesy of Barbara and Bob Lauver.*

Full-figure eagle, 2.5" x 5". *Courtesy of Barbara and Bob Lauver.*

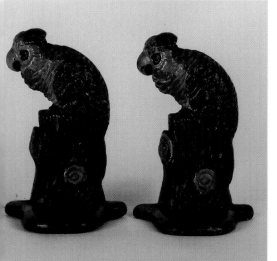

Parrots, 5" x 3/5". *Courtesy of Barbara and Bob Lauver.*

Parrots, 6.5" x 3.25". Marked 1922. *Courtesy of Barbara and Bob Lauver.*

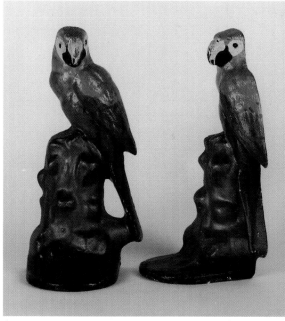

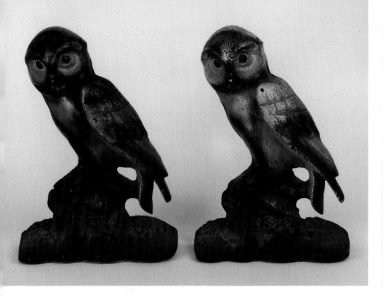

Owls, 6" x 4.25". *Courtesy of Barbara and Bob Lauver.*

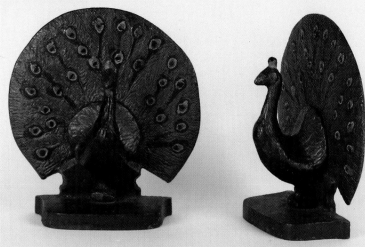

Peacocks, two-piece construction, 5.5" x 5.25". *Courtesy of Barbara and Bob Lauver.*

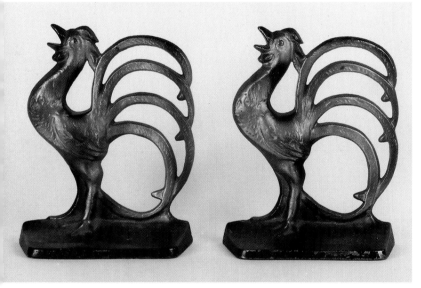

Decorative roosters, 6" x 5". *Courtesy of Barbara and Bob Lauver.*

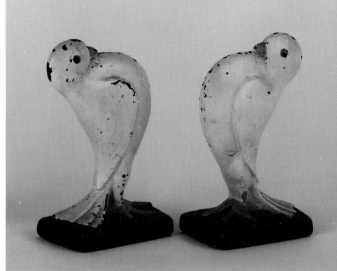

Fan-tailed pigeons, 5.25" x 3". *Courtesy of Barbara and Bob Lauver.*

Hubley "Quail," 5.75" x 5.25". Designed by Fred Everett. *Courtesy of Barbara and Bob Lauver.*

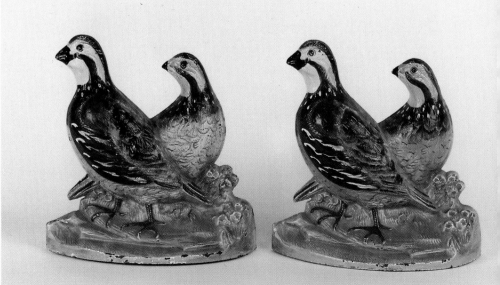

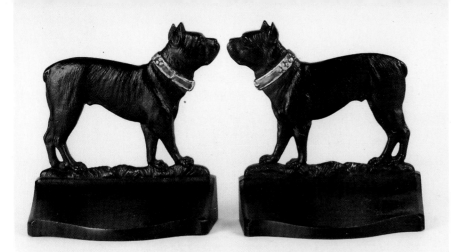

Bull dogs, Bradley & Hubbard, 5.25" x 5". *Courtesy of Barbara and Bob Lauver.*

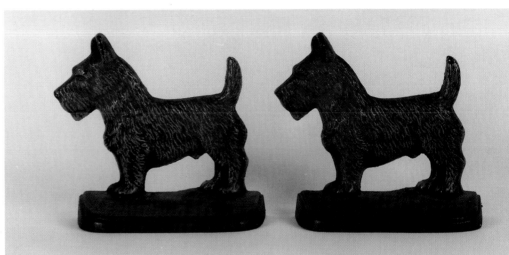

Scotties, Hubley No. S217. 5" x 5". *Courtesy of Barbara and Bob Lauver.*

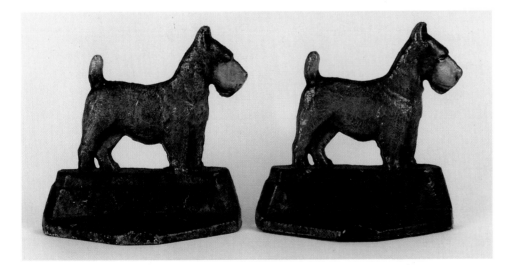

Scotties, 5.25" x 5.25". Marked with triangle inside a circle. *Courtesy of Barbara and Bob Lauver.*

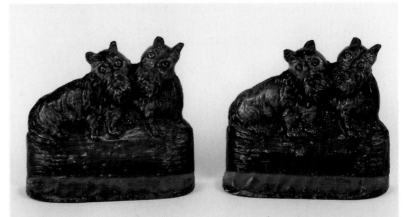

Scotties, 4" x 4.5". *Courtesy of Barbara and Bob Lauver.*

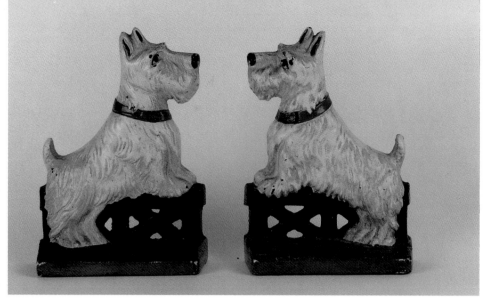

Scotties at the fence, c. 1940, Kenco, Littletown, Pennsylvania, 6.5" x 4.5". *Courtesy of Barbara and Bob Lauver.*

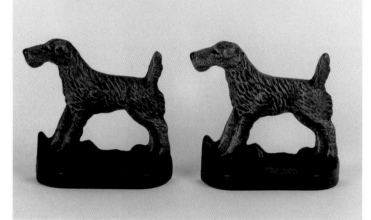

Small Wirehaired Terriers, possibly for children's books, 3.75" x 4.5". *Courtesy of Barbara and Bob Lauver.*

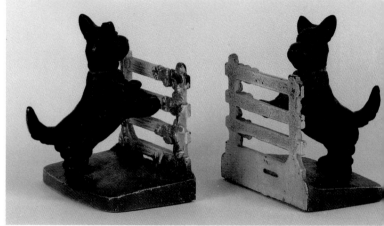

"Scotty" at the fence, Hubley No. 430. Full-figured, 5" x 4.5". *Courtesy of Barbara and Bob Lauver.*

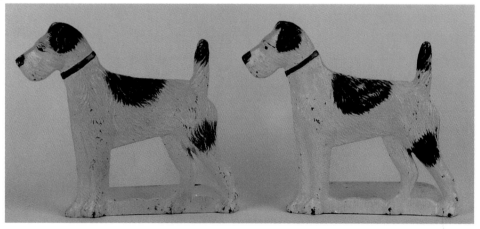

Terriers by Spencer, 5.5" x 6". *Courtesy of Barbara and Bob Lauver.*

Terrier bookends, 5" x 5.5". *Courtesy of Brooke Smith.*

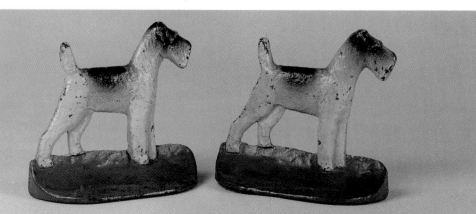

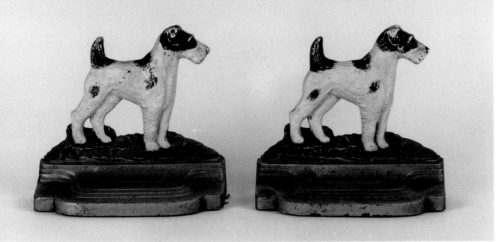

Terriers, Bradley & Hubbard, 4.5" x 5".
Courtesy of Barbara and Bob Lauver.

Terriers, Hubley, 294, 5.25" x 5.5".
Courtesy of Barbara and Bob Lauver.

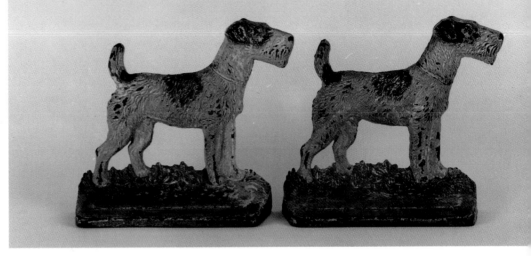

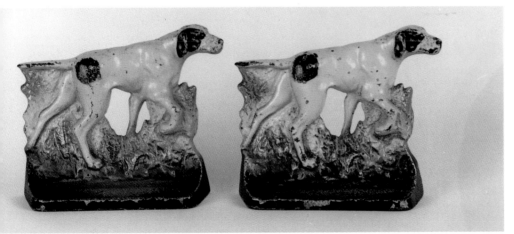

Pointers, 4.5" x 5.25". *Courtesy of Barbara and Bob Lauver.*

Pointers, Hubley, 303. 4" x 8". *Courtesy of Barbara and Bob Lauver.*

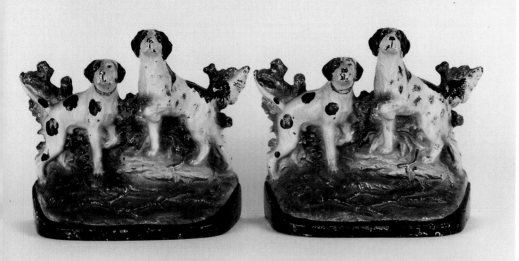

Setters, Hubley, 291, 5.25" x 6.25".
Courtesy of Barbara and Bob Lauver.

"Setter." Full-figure English setters
pointing, Hubley, No. 363. 5" x 8".
Courtesy of Barbara and Bob Lauver.

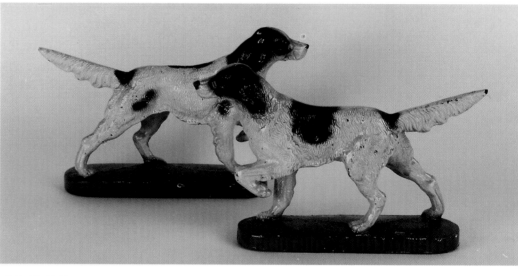

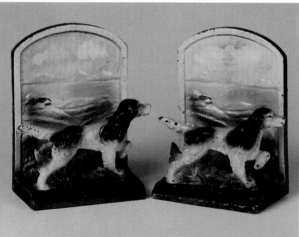

Bookend with bottle opener dog. The
dog could be unscrewed for use, or
used as it stands. 5.25" x 3.75". *Courtesy
of Brooke Smith.*

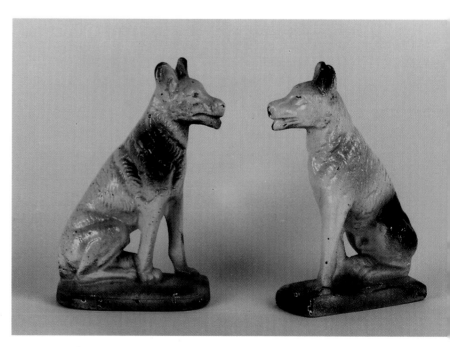

Sitting German shepherds, 6.5" x 4.25". *Courtesy of Barbara and
Bob Lauver.*

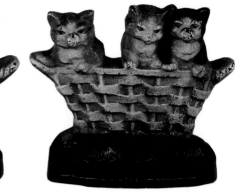

Three kittens in a basket, 4.75" x 5.75". *Courtesy of Barbara and Bob Lauver.*

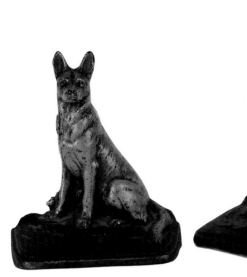

German shepherd, Hubley, 5.5" x 4.75". *Courtesy of Barbara and Bob Lauver.*

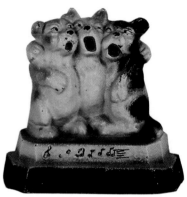

Singing dogs, Hubley, 4.75" x 5". *Courtesy of Barbara and Bob Lauver.*

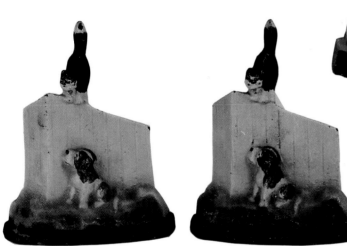

Dog with cat on fence, Hubley, 5.75" x 4.75". *Courtesy of Barbara and Bob Lauver.*

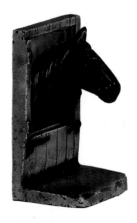

Horse at the stable door. Two pieces, 4.75" x 3.25". *Courtesy of Barbara and Bob Lauver.*

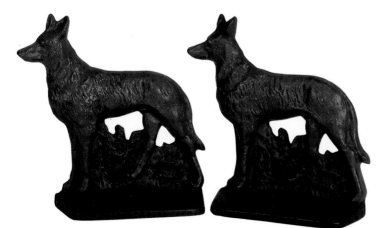

Coyote bookends, 6" x 6". *Courtesy of Nancy and John Smith.*

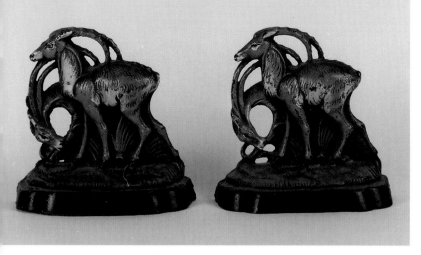

Ibexes, Hubley, 417. 5" x 5". *Courtesy of Barbara and Bob Lauver.*

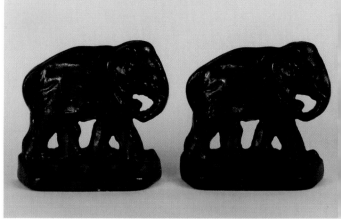

Small elephants, 3.5" x 4". *Courtesy of Barbara and Bob Lauver.*

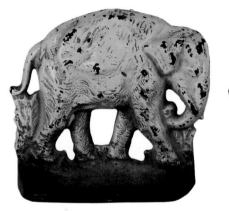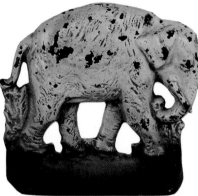

Elephants, 4.75" x 5.25". *Courtesy of Barbara and Bob Lauver.*

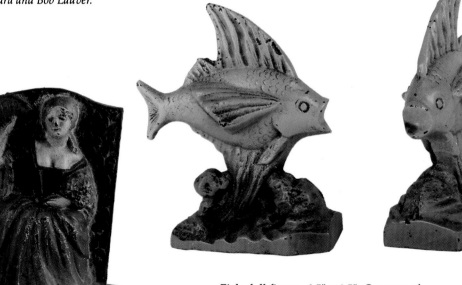

Pierrot and Lady with fan, 7.25" x 3.5". *Courtesy of Frank Whitson.*

Fish, full figure, 6.5" x 4.5". *Courtesy of Barbara and Bob Lauver.*

Blue and pink sunbonneted girls, Hubley, 6.25" x 4". Marked 72, and Cape Cod. *Courtesy of Barbara and Bob Lauver.*

"Dolly and Bobby," 4.25" x 5". Hubley, No. 498. *Courtesy of Barbara and Bob Lauver.*

Spirit of Freedom, 6" x 6". *Courtesy of Barbara and Bob Lauver.*

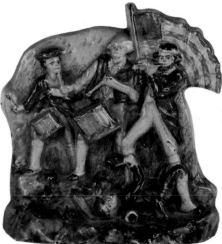

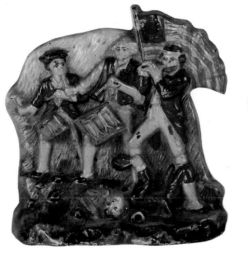

Angelus, after Millet's painting, 4.75" X 5". Marked 6 on back. *Courtesy of Barbara and Bob Lauver.*

Pirate Treasure, 5.25" x 5". *Courtesy of Barbara and Bob Lauver.*

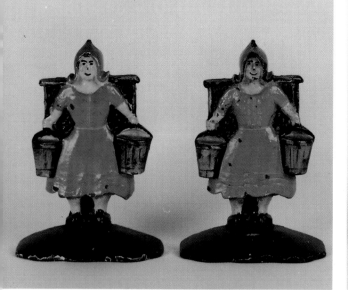

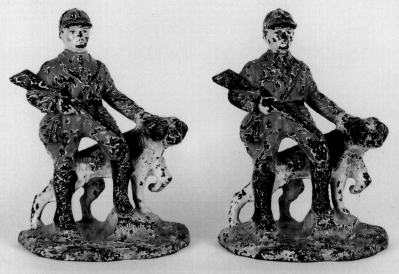

Dutch girl with pails. 5.5" x 4". *Courtesy of Barbara and Bob Lauver.*

Hunter with dog, full figured, Hubley, No. 428. 6.25" x 5". *Courtesy of Barbara and Bob Lauver.*

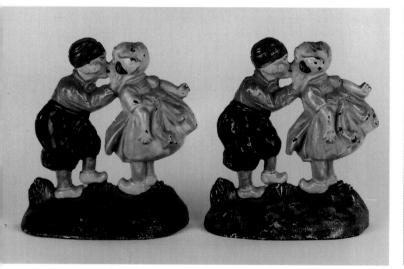

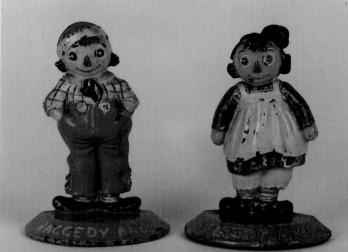

Kissing Dutch children, Hubley, No. 332. 4.75" x 4.5". *Courtesy of Barbara and Bob Lauver.*

Raggedy Ann & Andy, Copyright P.F. Volland & Co., 1931. 5.5" x 4". *Courtesy of Barbara and Bob Lauver.*

Full-figured hobos, 7" x 2.5". *Courtesy of Barbara and Bob Lauver.*

Pirate, full-figured, 7" x 4.25". *Courtesy of Barbara and Bob Lauver.*

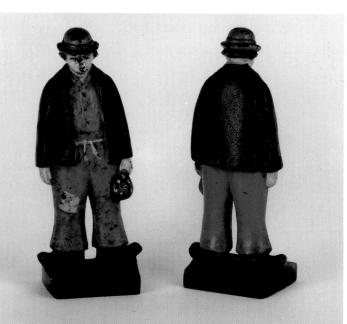

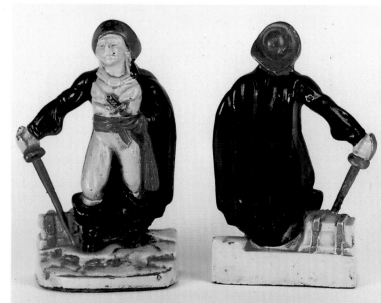

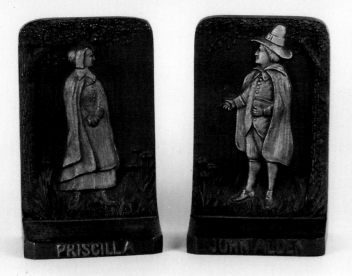

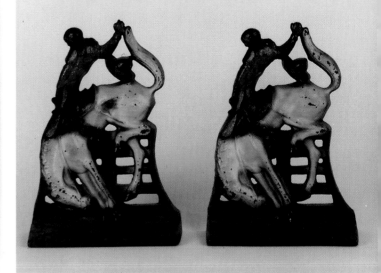

John Alden and Priscilla, Bradley & Hubbard, 6" x 3.75". These have a paper label on the bottom with a brief biography of this famous pair. *Courtesy of Barbara and Bob Lauver.*

Bronco Rider, 5.5" x 4.25". Marked "136" and copyright "A C". *Courtesy of Barbara and Bob Lauver.*

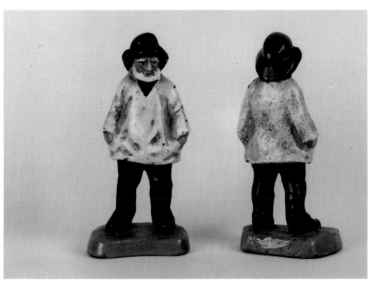

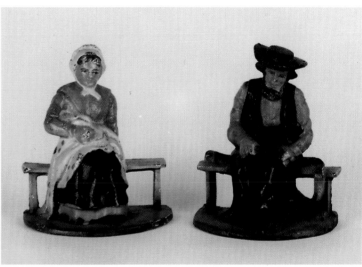

Maine fisherman, 6" x 2.75". *Courtesy of Barbara and Bob Lauver.*

Amish couple, 4.75" x 4". *Courtesy of Barbara and Bob Lauver.*

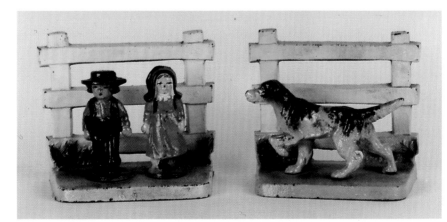

While the setting of these Hubley pieces are identical, they are not a matched set. They came from the home of a Hubley employee. Perhaps he brought home parts of two sets of bookends, or perhaps they are letter holders. 4" x 4.75". Two and three pieces. *Courtesy of Barbara and Bob Lauver.*

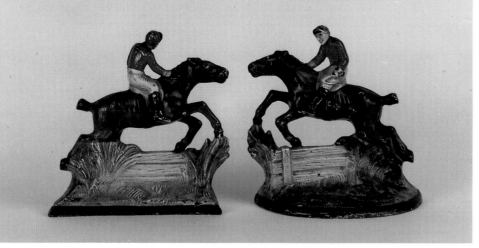

"Steeplechase," Hubley, No. 415. Full-figure, 5" x 5". *Courtesy of Barbara and Bob Lauver.*

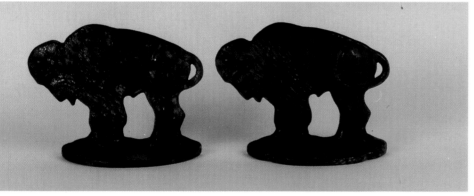

Round-up, 5" x 5.25". *Courtesy of Barbara and Bob Lauver.*

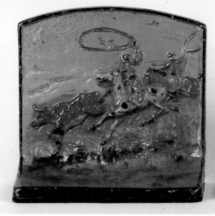
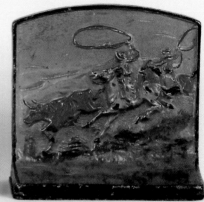

Buffalo, 3.5" x 5". *Courtesy of Barbara and Bob Lauver.*

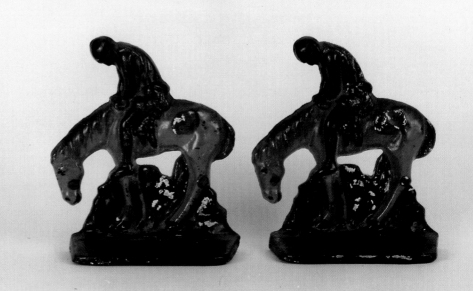

"End of the Trail," 5.75" x 5.25". *Courtesy of Barbara and Bob Lauver.*

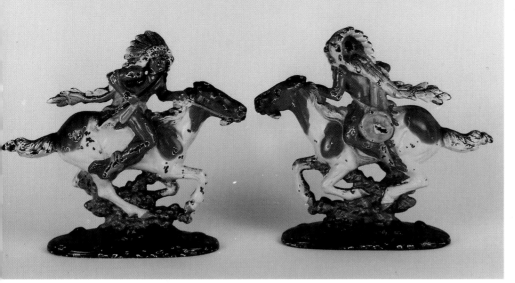

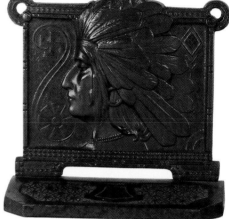

Nicely detailed "Indian Warrior," Hubley, No. 334. Full figure, 6" x 6.5". *Courtesy of Barbara and Bob Lauver.*

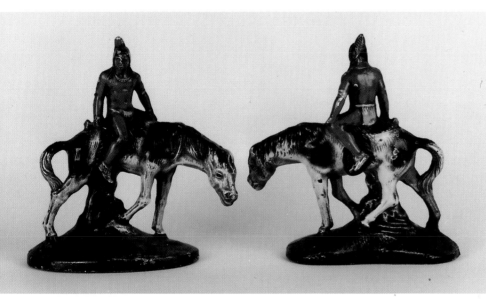

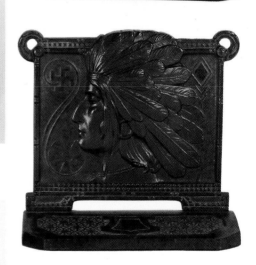

Full-figure Indian brave, 6" x 6". *Courtesy of Barbara and Bob Lauver.*

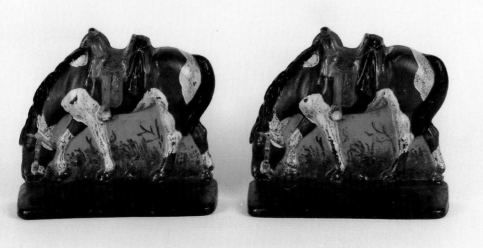

Indian relief, two-piece construction. Because of the swastika symbol (Indian sign of good fortune) these must be pre-World War II. Marked 9728 on back. 5.75" x 6" *Courtesy of Barbara and Bob Lauver.*

Common grazing horse in uncommon paint, Hubley, 118. 4.75" x 5". *Courtesy of Barbara and Bob Lauver.*

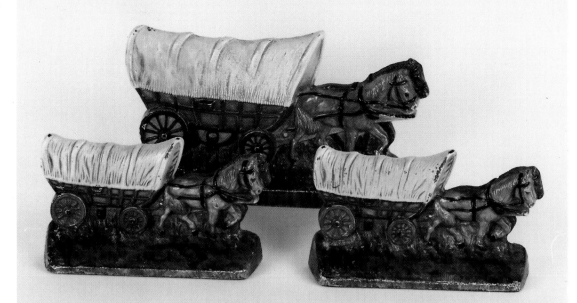

Hubley Conestoga wagon doorstop and bookends. The doorstop is number 375 and measures 5.25" x 9.5", while the bookends are number 378 and measure 3.75" x 6.5" *Courtesy of Barbara and Bob Lauver.*

Doorway bookends, Bradley & Hubbard. 5.75" x 4". *Courtesy of Nancy and John Smith.*

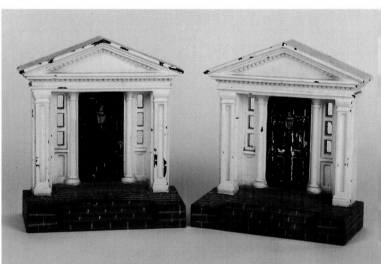

Front door bookends, 5.5" x 5". *Courtesy of Nancy and John Smith.*

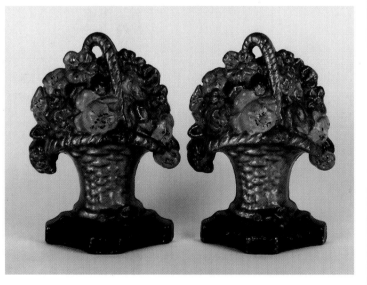

Basket of flowers, 5.75" x 4.25". Marked 4. *Courtesy of Barbara and Bob Lauver.*

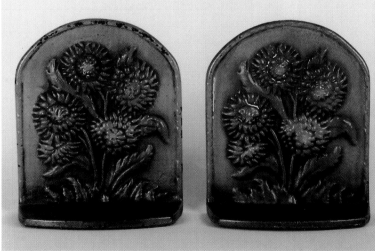

Asters, 5.25" x 4.5". *Courtesy of Barbara and Bob Lauver.*

Flowers on red background, 5.5" x 5". Marked 108. *Courtesy of Barbara and Bob Lauver.*

Flowers, 4.75" x 7". Marked 107. *Courtesy of Barbara and Bob Lauver.*

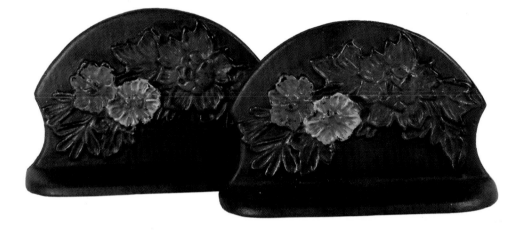

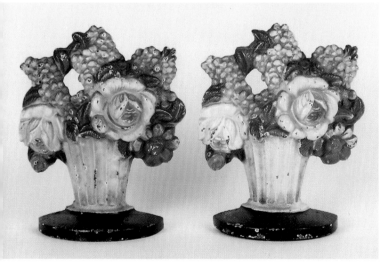

Mixed flowers in vase, 5.5" x 4.5". Marked 479. *Courtesy of Barbara and Bob Lauver.*

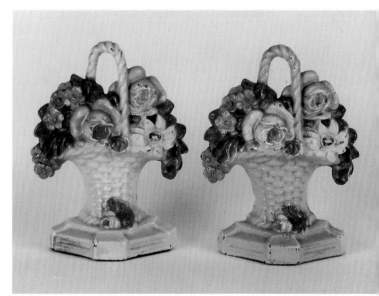

Flower baskets, 5.75" x 4.5". Marked 8. *Courtesy of Barbara and Bob Lauver.*

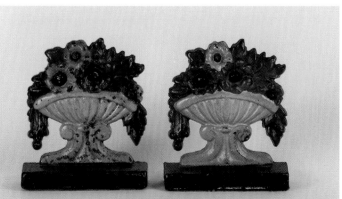

Flowers in vase, 4" x 3.5". *Courtesy of Barbara and Bob Lauver.*

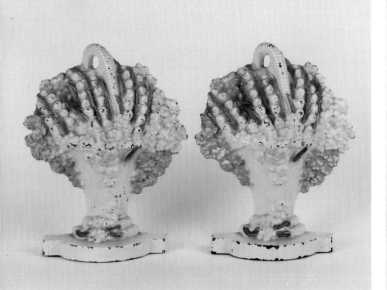

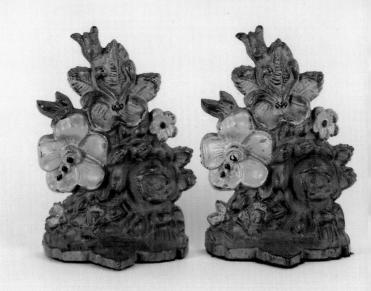

Flower baskets, 5.75" x 4.5". Marked 473. *Courtesy of Barbara and Bob Lauver.*

Flowers, 6" x 4.5". Marked 12511. *Courtesy of Barbara and Bob Lauver.*

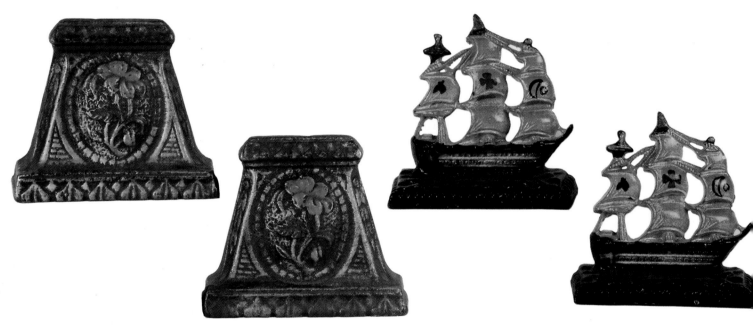

Flowers in shield, 4.75" x 5.75". *Courtesy of Barbara and Bob Lauver.*

Ships, marked 620, 5" x 5.25". *Courtesy of Barbara and Bob Lauver.*

Ships, 5.25" x 5". *Courtesy of Barbara and Bob Lauver.*

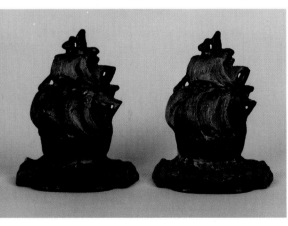

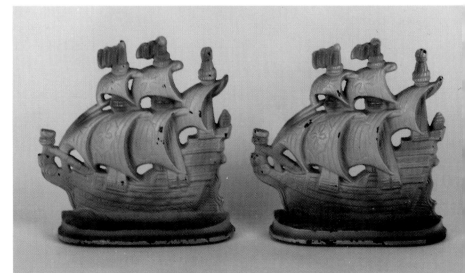

Small ships, marked 594, 4" x 3.25". *Courtesy of Barbara and Bob Lauver.*

126 Book Ends

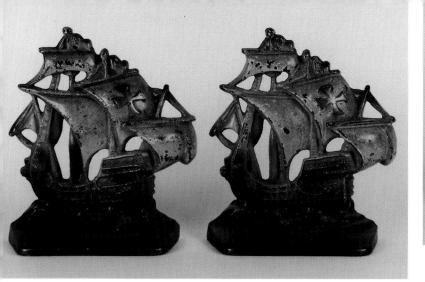

Ships, 5.75" x 5". *Courtesy of Barbara and Bob Lauver.*

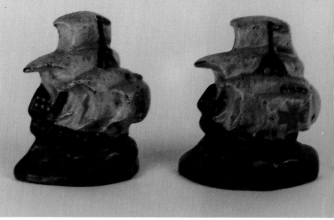

Ships, 4" x 4". *Courtesy of Barbara and Bob Lauver.*

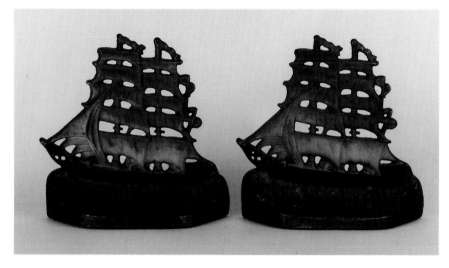

Schooners, 5" x 5". *Courtesy of Barbara and Bob Lauver.*

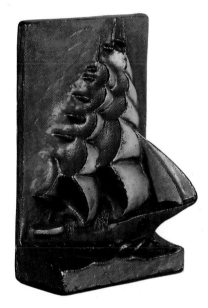

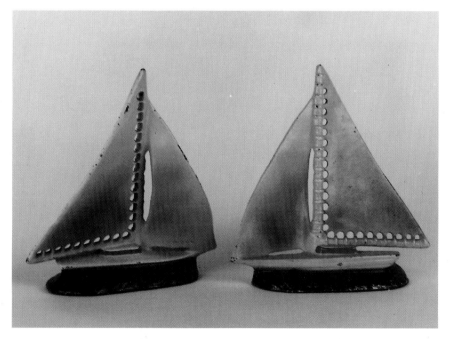

Hubley sailboats, No. 155. 6" x 5.5". *Courtesy of Barbara and Bob Lauver.*

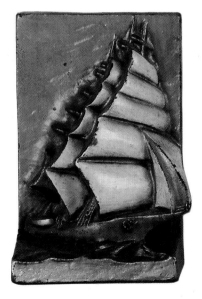

Hubley ships, No. 384, 7" x 4.5". *Courtesy of Barbara and Bob Lauver.*

BOTTLE OPENERS

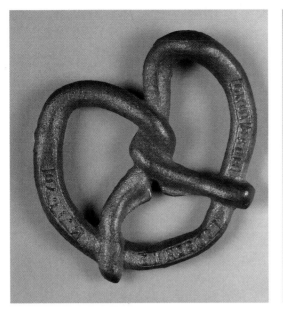

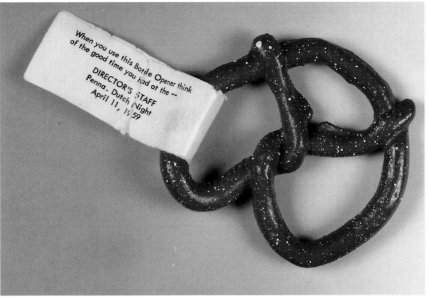

Pretzel bottle opener, marked "Grundsow Looshis, 4-17-70. 2.5" x 3". *Courtesy of Brooke Smith.*

Pretzel bottle opener, commemorating the Director's Staff, Penna. Dutch Night, April 11, 1959. *Courtesy of Brooke Smith.*

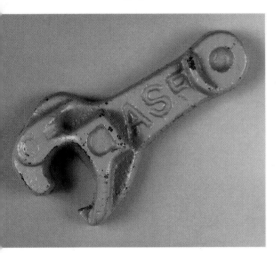

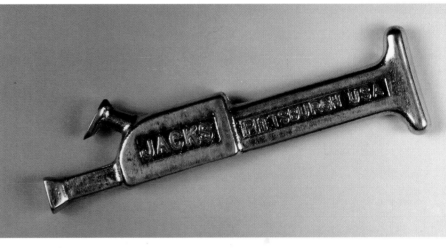

Railroad coupler paper weight marked CASE. 3.25" x 1.5". *Courtesy of Brooke Smith.*

Canvasback, 2.75" x 3". *Courtesy of Brooke Smith.*

Duff Norton Jacks, Pittsburgh, U.S.A., advertising bottle opener. 4.5" x 1.25". *Courtesy of Brooke Smith.*

Mallard, 2.75" x 3". *Courtesy of Brooke Smith.*

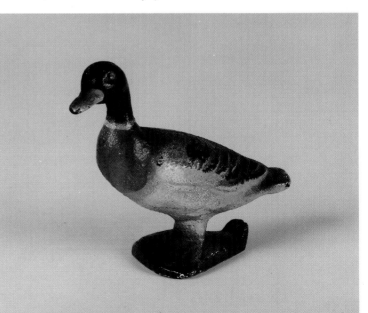

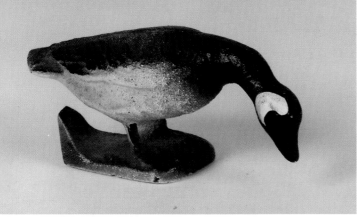

Canadian goose, 1.75" x 3.5". *Courtesy of Brooke Smith.*

Goose, 1.75" x 3.75". *Courtesy of Brooke Smith.*

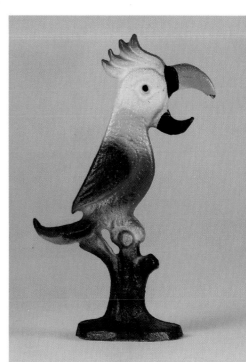

Standing bird. *Courtesy of Brooke Smith.*

Standing parrot. *Courtesy of Brooke Smith.*

Parrot with bottle opener in perch. 4.75" x 3". *Courtesy of Brooke Smith.*

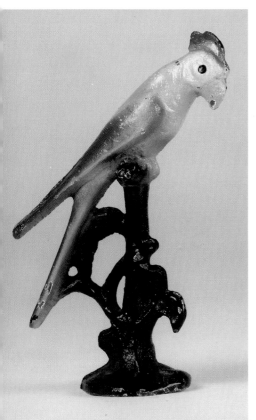

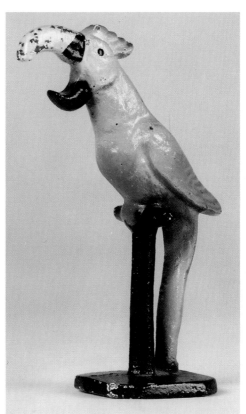

Parrot, two sided, but fairly flat, 5" x 3". This is a can opener (tail) and bottle opener (beak) in one. *Courtesy of Brooke Smith.*

Parrot on stand. *Courtesy of Brooke Smith.*

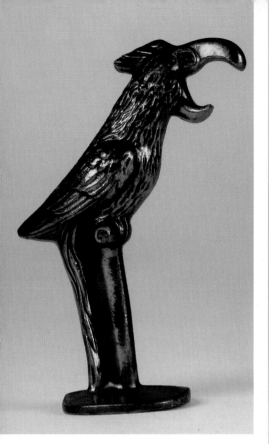

Copper electroplated parrot, 5" x 3". *Courtesy of Brooke Smith.*

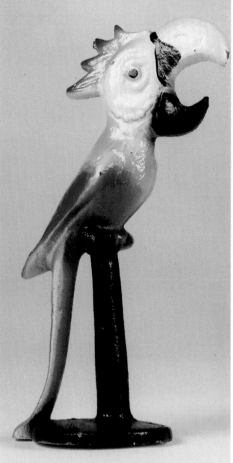

Parrot on stand. *Courtesy of Brooke Smith.*

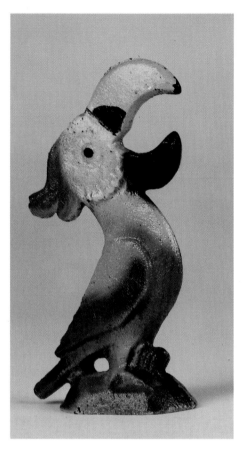

Parrot. *Courtesy of Brooke Smith.*

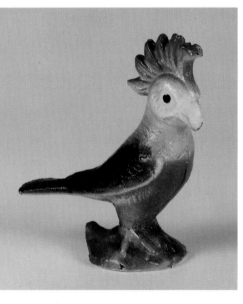

Standing cockatoo. *Courtesy of Brooke Smith.*

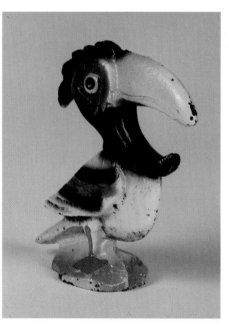

Standing toucan. *Courtesy of Brooke Smith.*

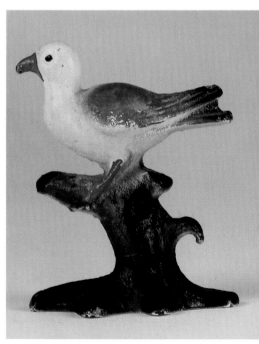

Seagull, 3.25" x 2.5". *Courtesy of Brooke Smith.*

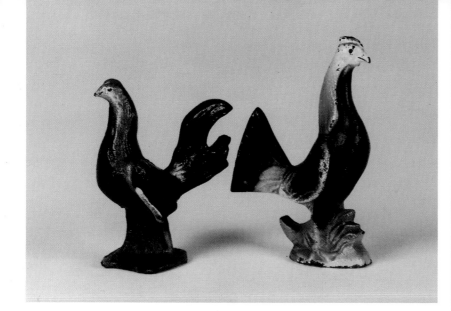

Gamecocks. *Courtesy of Brooke Smith.*

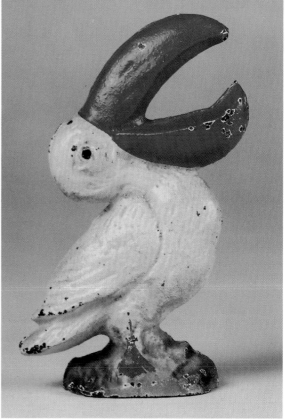

White pelican, 3.75" x 2.5". *Courtesy of Brooke Smith.*

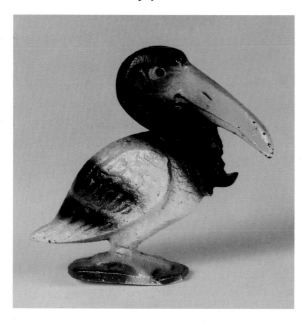

Pelican bottle opener. *Courtesy of Brooke Smith.*

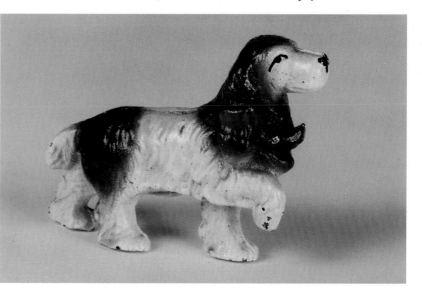

Springer spaniel. *Courtesy of Brooke Smith.*

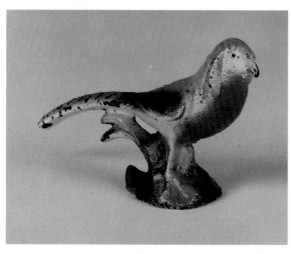

Golden pheasant, 2.25" x 4". *Courtesy of Brooke Smith.*

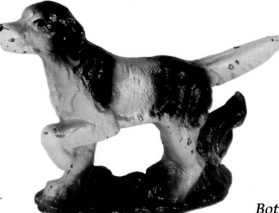

English setter. *Courtesy of Brooke Smith.*

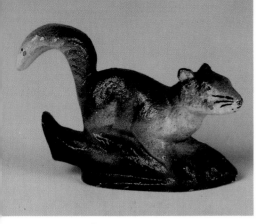

Squirrel, 3" x 4". *Courtesy of Brooke Smith.*

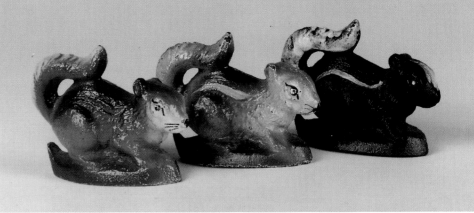

A little paint variation creates a skunk, a chipmunk, and a squirrel from the same mold. 2.25" x 3". *Courtesy of Brooke Smith.*

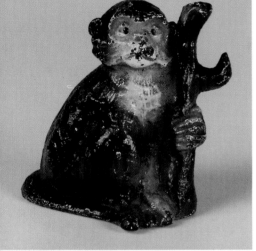

Monkey with branch. *Courtesy of Brooke Smith.*

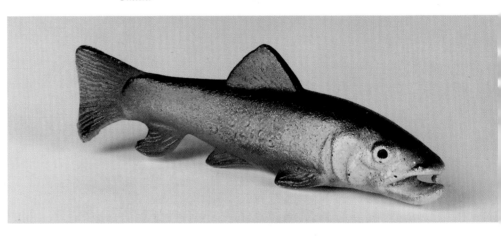

Trout, 1.5" x 4.75". *Courtesy of Brooke Smith.*

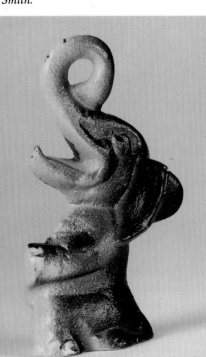

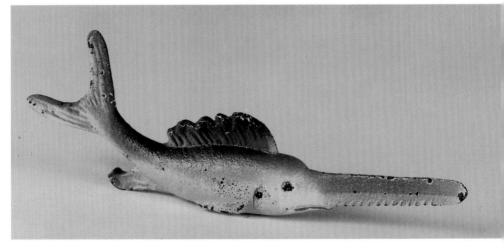

Sawfish, 2" x 5.75". *Courtesy of Brooke Smith.*

Sitting elephant, 3.5" x 2". *Courtesy of Brooke Smith.*

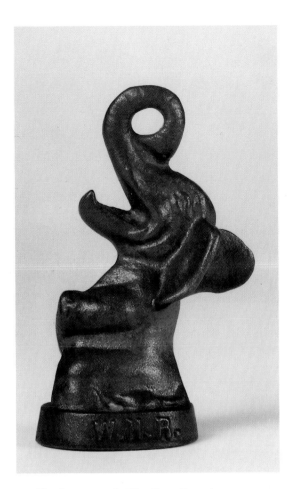

Elephant on tub, Hamilton Foundry, marked W.H.R. on base. 4" x 2.5". *Courtesy of Brooke Smith.*

Elephant, 2.5" x 3.5". *Courtesy of Brooke Smith.*

Two-sided, nearly flat elephant, 3" x 2". *Courtesy of Brooke Smith.*

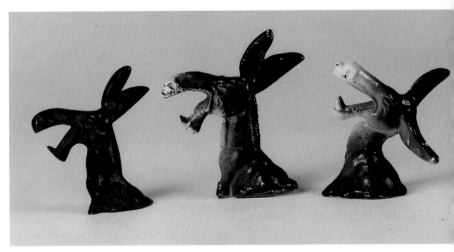

Sitting elephant, John Wright Foundry, 3" x 1.75". *Courtesy of Brooke Smith.*

Jackass bottle openers, left to right, 3.25" x 3", 3.75" x 3.5", 3" x 3". *Courtesy of Brooke Smith.*

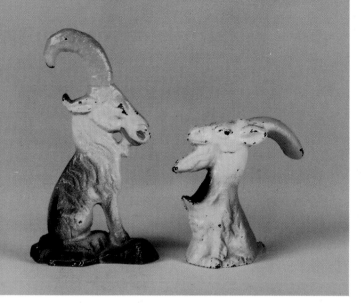

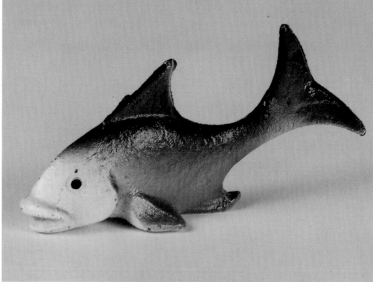

Left: Billy goat with bottle opener under its horn. 4.5" x 2.5".
Right: Billy goat with bottle opener below its beard, 2.75" x
2.5". *Courtesy of Brooke Smith.*

Fish with its tail up, 2.25" x 4.5". *Courtesy of Brooke Smith.*

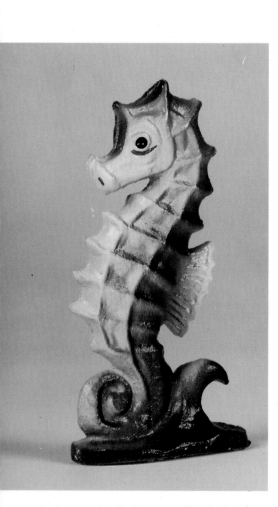

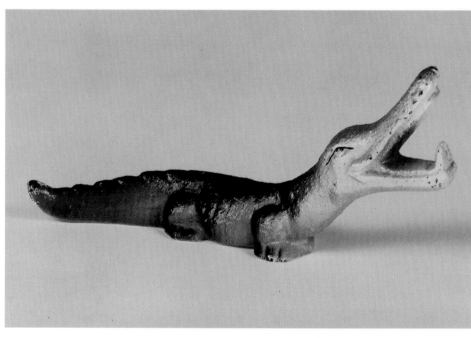

Alligator, 5.25" x 2.25". *Courtesy of Brooke Smith.*

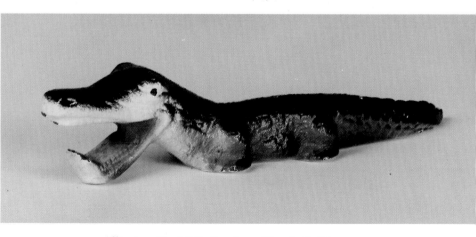

Seahorse, 4" x 2". *Courtesy of Brooke Smith.*

Alligator, 6" x 1.25". *Courtesy of Brooke Smith.*

Handy Hans, L&L Favors. 4.5" x 4".
Courtesy of Brooke Smith.

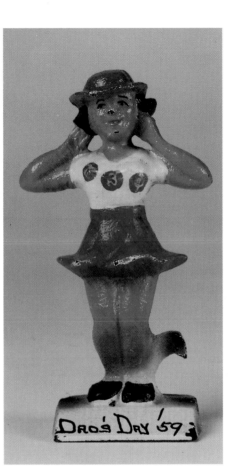

Patty Pep, L&L Favors. 4.25" x 1.5".
Courtesy of Brooke Smith.

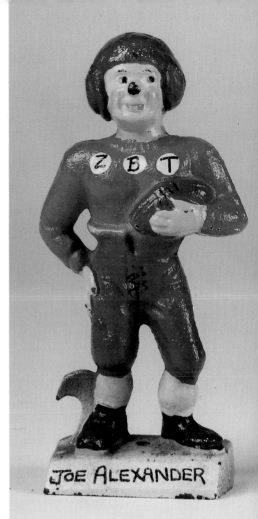

Football player bottle opener, L&L
Favors, 4.25" x 1.5". *Courtesy of Brooke
Smith.*

Freddy Frosh, 4" x 2". *Courtesy of Brooke
Smith.*

Amish boy bottle opener. The opener is
a lip on the base between his legs. 4" x
2". *Courtesy of Brooke Smith.*

A bottle opener in the form of a cast
iron iron caster, 4.25" x 2.75". *Courtesy of
Brooke Smith.*

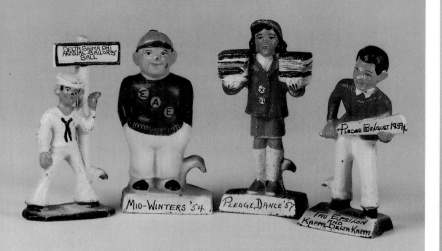

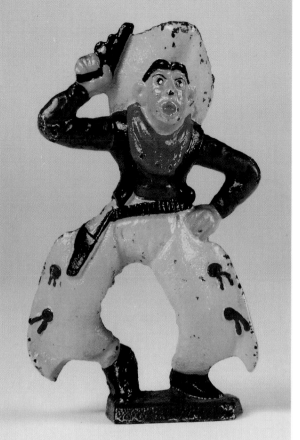

Cast iron bottle openers often served as party tokens for fraternity and other college dances and parties. All about 4" to all. *Courtesy of Brooke Smith.*

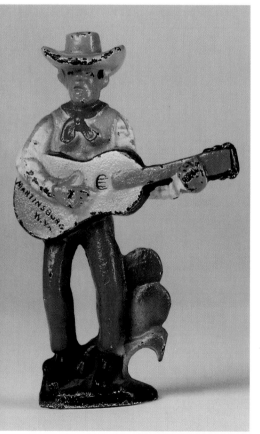

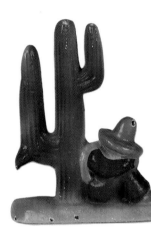

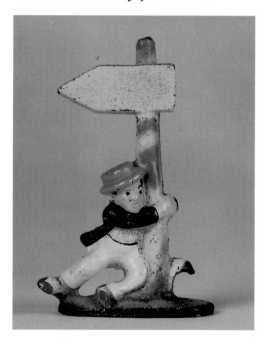

Six shooting cowboy bottle opener, 4.75" x 2.75". *Courtesy of Brooke Smith.*

Mexican next to a cactus, 3" x 2.25". *Courtesy of Brooke Smith.*

Man leaning on sign post. 4.25" x 2.75". *Courtesy of Brooke Smith.*

Guitar playing cowboy bottle opener, 5" x 3.75". *Courtesy of Brooke Smith.*

Three post hangers, Uncle Sam, Buckeye Beer, and lamppost. 4.25" x 2.5". *Courtesy of Brooke Smith.*

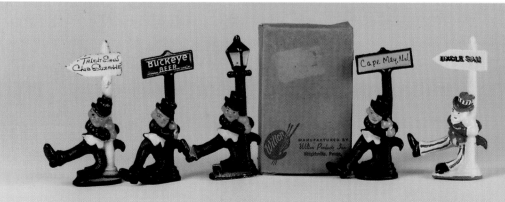

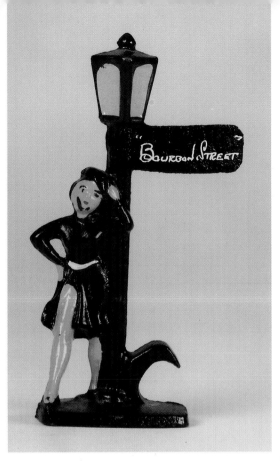

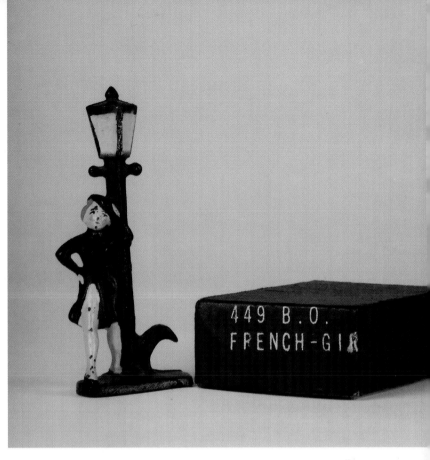

Woman at lamppost with sign, 4.5" x 2.5". *Courtesy of Brooke Smith.*

Box marked 449 B.O., French Girl. 4.5" x 2". *Courtesy of Brooke Smith.*

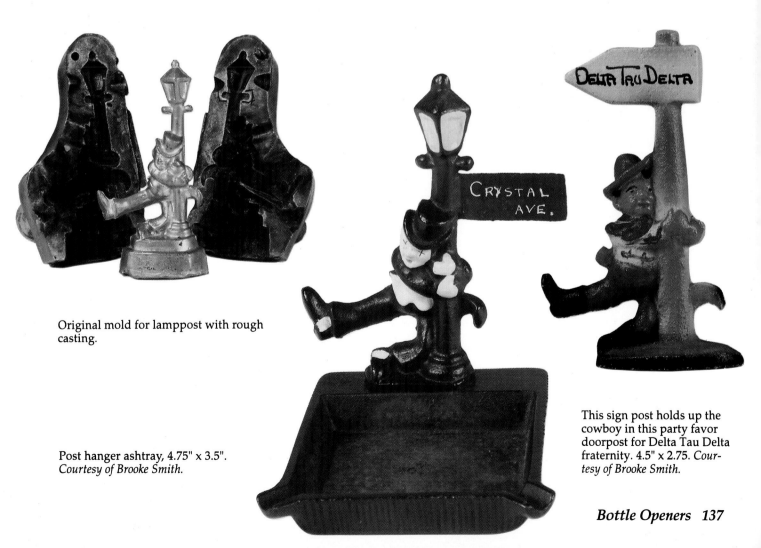

Original mold for lamppost with rough casting.

Post hanger ashtray, 4.75" x 3.5". *Courtesy of Brooke Smith.*

This sign post holds up the cowboy in this party favor doorpost for Delta Tau Delta fraternity. 4.5" x 2.75. *Courtesy of Brooke Smith.*

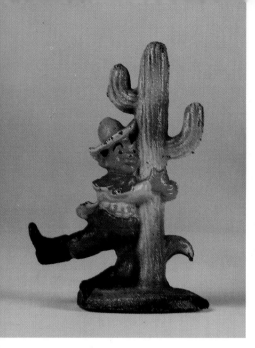

Cactus supports this cowboy and opens your bottle. 4" x 2.75". *Courtesy of Brooke Smith.*

The foliage at the bottom of this tree forms the bottle opener. L: 4" x 3", Right: 4.25" x 2". *Courtesy of Brooke Smith.*

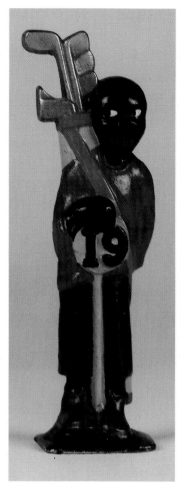

Golf caddie, 6" x 1.75". *Courtesy of Brooke Smith.*

Palm tree bottle opener, 4.5" x 2.75". *Courtesy of Brooke Smith.*

Grass skirt Greek favor ashtray, 5.75" x 4". *Courtesy of Brooke Smith.*

Black boys and alligators, 3" x 4.5". *Courtesy of Brooke Smith.*

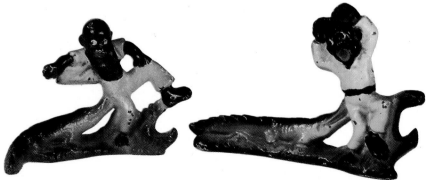

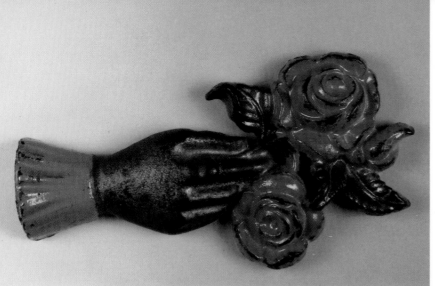

Hand with roses bottle opener, 4.75" x 2.5". *Courtesy of Brooke Smith.*

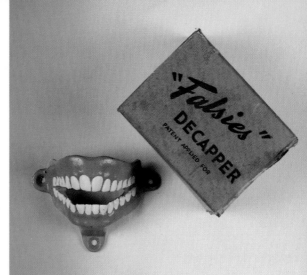

A "Dilly Denture," Falsies Decapper, Brian Shaffner Company, Salem Artisans, 3" x 3.5". *Courtesy of Brooke Smith.*

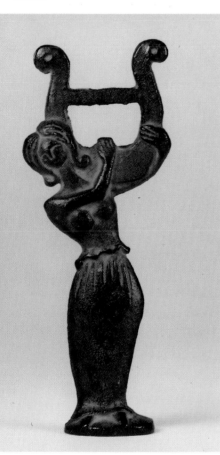

Lady with a harp bottle opener, 6.25" x 2.25". *Courtesy of Brooke Smith.*

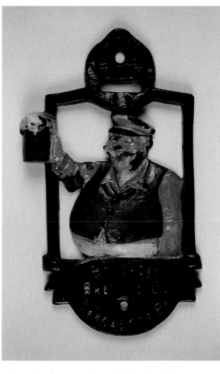

Bottle opener advertising the Sprenger Brewing Co., Lancaster, Pennsylvania. Marked M.P., Lanc. Pa. on back. 6.5" x 3.5". *Courtesy of Brooke Smith.*

Black face bottle opener, DJC Powers Co., Detroit, Michigan. 4" x 4.25". *Courtesy of Brooke Smith.*

Miss Black, 3.5" x 3.5". *Courtesy of Brooke Smith.*

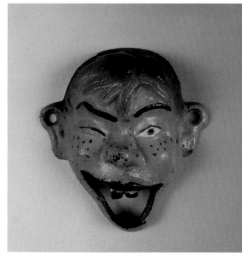

Winking Boy, Wilton Products, 3.75" x 3.5". *Courtesy of Brooke Smith.*

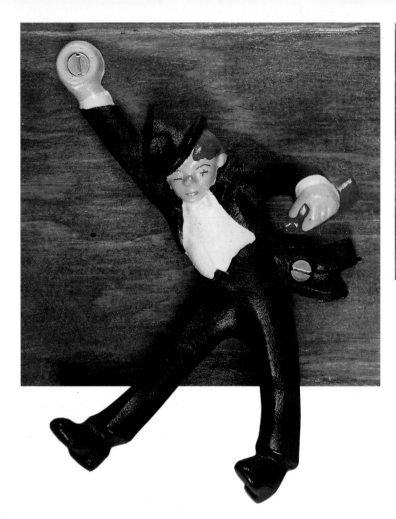

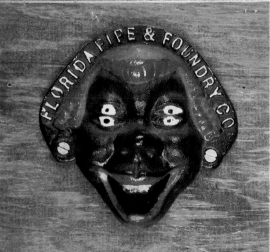

Florida Pipe and Foundry Company, 4.5" x 4.25". *Courtesy of Brooke Smith.*

Hanging drunk, 5" x 3.5". *Courtesy of Brooke Smith.*

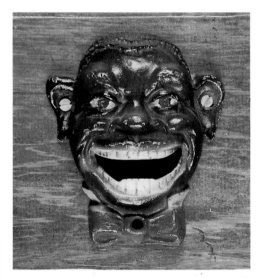

Black face with eye pupils indented, 4.5" x 3.75". *Courtesy of Brooke Smith.*

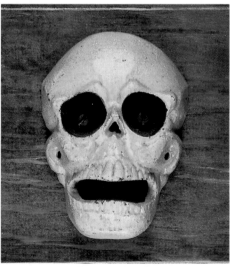

Skull, 3.5". *Courtesy of Brooke Smith.*

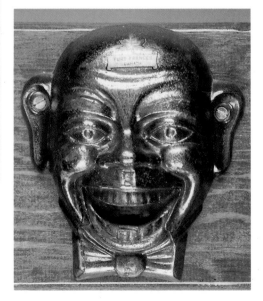

Clown, 4.5" x 4". *Courtesy of Brooke Smith.*

Black face, 5" x 4.5". *Courtesy of Brooke Smith.*

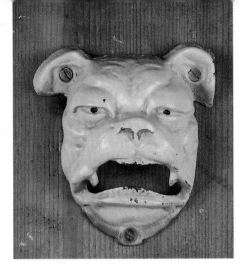

Bull Dog, 4" x 4". *Courtesy of Brooke Smith.*

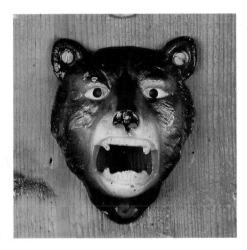

Bear, 3.5" x 3". *Courtesy of Brooke Smith.*

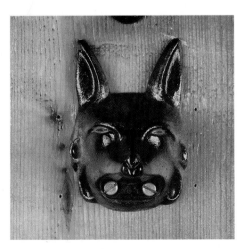

Coyote, 3.25" x 2.5". *Courtesy of Brooke Smith.*

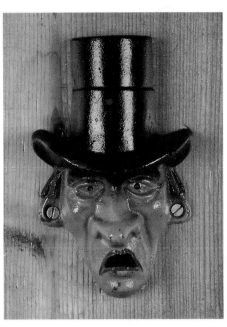

Mr. Dry, 5.25" x 3.5". *Courtesy of Brooke Smith.*

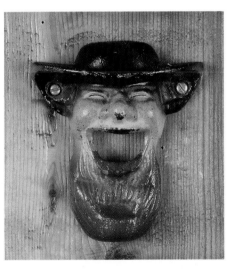

Amish Man, 4.25" x 3.5". *Courtesy of Brooke Smith.*

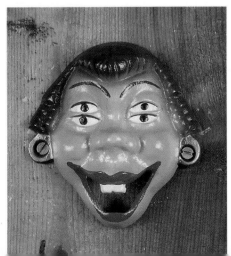

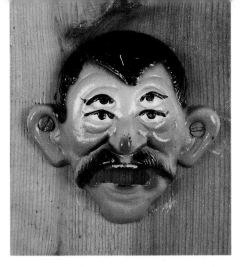

Four-Eyes man, 4" x 4". *Courtesy of Brooke Smith.*

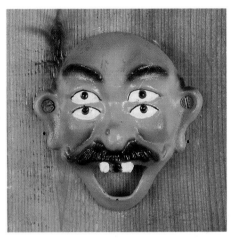

Doubled eyed man, 3.75" x 3.5". *Courtesy of Brooke Smith.*

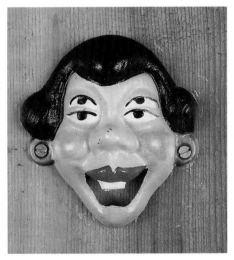

Four-eyed lady, 4" x 3.75". *Courtesy of Brooke Smith.*

Miss Four-Eyes, 4" x 3.75". *Courtesy of Brooke Smith.*

DOOR KNOCKERS

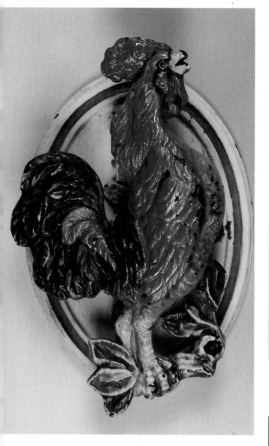

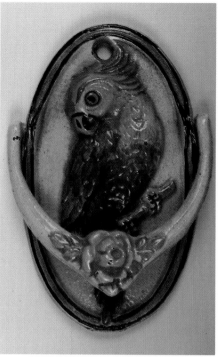

Parrot, 3.75" x 2.5". *Courtesy of Nancy and John Smith.*

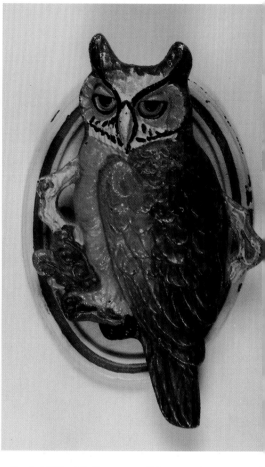

Rooster, 4.5" x 3". *Courtesy of Nancy and John Smith.*

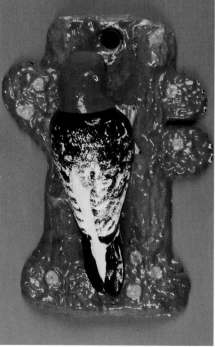

Owl, 4.75" x 3". *Courtesy of Nancy and John Smith.*

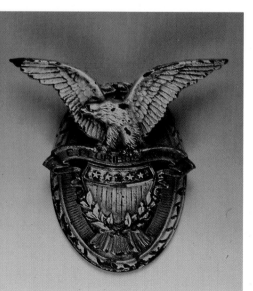

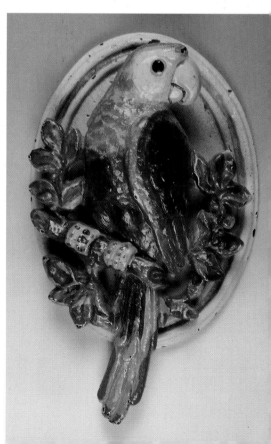

E. Pluribus Unum, 4.5" x 4.5". *Courtesy of Nancy and John Smith.*

Woodpecker door knocker, 3.75" x 2.5". *Courtesy of Brooke Smith.*

Oval door knocker with parrot, 4.75" x 2.75". *Courtesy of Brooke Smith.*

Art Deco parrot door knocker, 4" x 3".
Courtesy of Nancy and John Smith.

Butterfly door knocker, 3.5" x 2.5".
Courtesy of Nancy and John Smith.

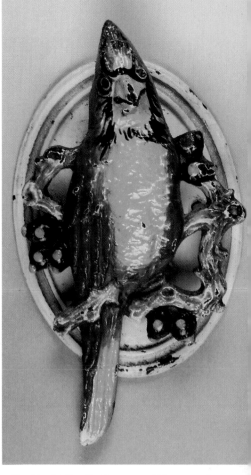

Cardinal, 5" x 3". *Courtesy of Nancy and John Smith.*

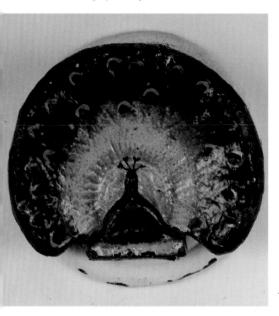

Peacock, 3" x 3". *Courtesy of Nancy and John Smith.*

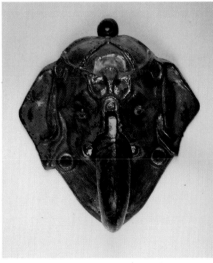

Circus elephant door knocker, 6" x 5.5".
Courtesy of Nancy and John Smith.

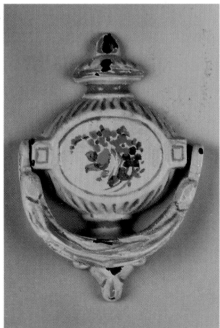

Door knocker, 3.25" x 2.25". *Courtesy of Brooke Smith.*

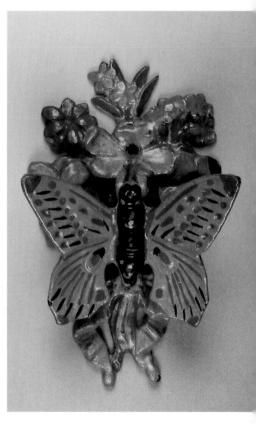

Butterfly door knocker, 4" x 2.5".
Courtesy of Nancy and John Smith.

Rose door knocker, 4.5" x 3". *Courtesy of Nancy and John Smith.*

Cherries door knocker, 3" x 3". *Courtesy of Nancy and John Smith.*

Poinsettia door knocker, 3" x 2.75". *Courtesy of Nancy and John Smith.*

Daisies, 5" x 3". *Courtesy of Nancy and John Smith.*

Door knocker with pear. 3.25" x 3". *Courtesy of Brooke Smith.*

Morning glory door knocker, 3" x 3". *Courtesy of Nancy and John Smith.*

Door knocker 3.25" x 2.25". *Courtesy of Nancy and John Smith.*

Door knocker with basket of flowers, 4" x 3". *Courtesy of Brooke Smith.*

Basket with swag, 7.5" x 3.75". *Courtesy of Nancy and John Smith.*

Door knocker with ribbon and flowers, marked 124. 4" x 2.5". *Courtesy of Brooke Smith.*

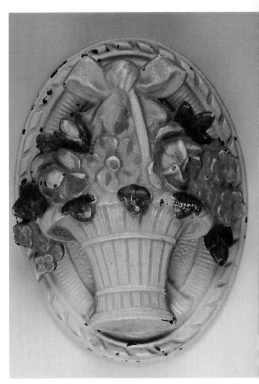

Ivy in basket, 4.25" x 2.5". Hubley, made in U.S.A. *Courtesy of Nancy and John Smith.*

Door knocker with basket, marked 205. 4" x 2".

Oval door knocker with basket of flowers, 4" x 3". *Courtesy of Brooke Smith.*

Bathing Beauty by Fish, 5" x 2.5".
Courtesy of Nancy and John Smith.

Door knocker with flowers, 4" x 1.75".
Marked 287. *Courtesy of Brooke Smith.*

Woman in bonnet, 4.5" x 3". *Courtesy of
Nancy and John Smith.*

Colonial man and woman, Waverly
Studio, Wilmette, Illinois, 4.5" x 2.5".
Courtesy of Nancy and John Smith.

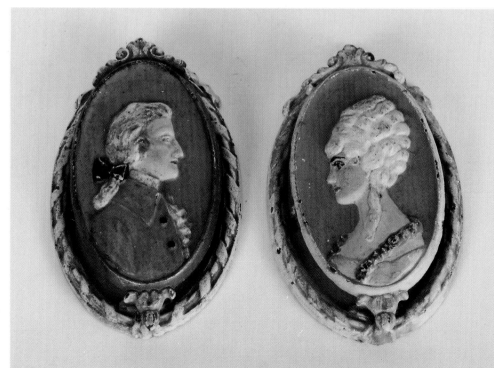

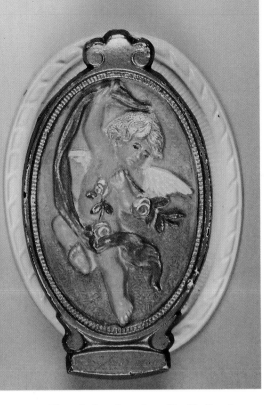

Cherub door knocker, 4" x 3". *Courtesy of Nancy and John Smith.*

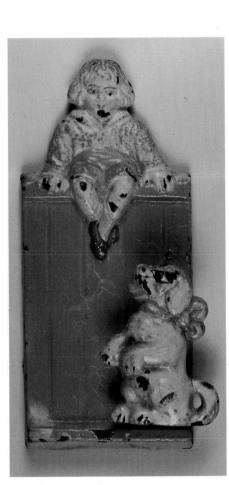

Buster Brown and Tige, marked no. 200. 4.75" x 2". *Courtesy of Nancy and John Smith.*

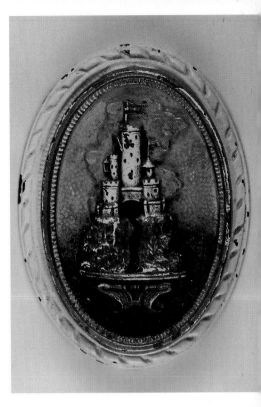

Castle, 4" x 3". *Courtesy of Nancy and John Smith.*

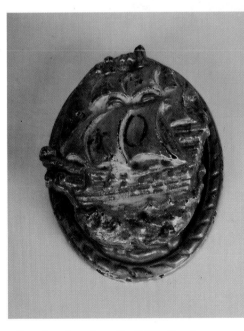

Ship door knocker, 4" x 2.75". *Courtesy of Nancy and John Smith.*

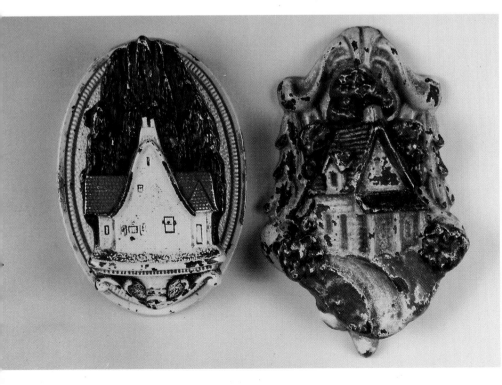

Two cottages, Left: 3.5" x 2.5"; right: 4" x 2.75". *Courtesy of Nancy and John Smith.*

Door Knockers 147

PAPER WEIGHTS

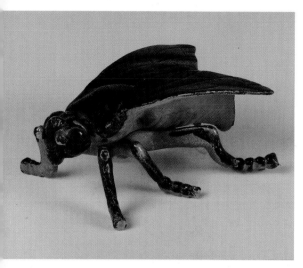

Fly, 1.50" x 4". *Courtesy of Brooke Smith.*

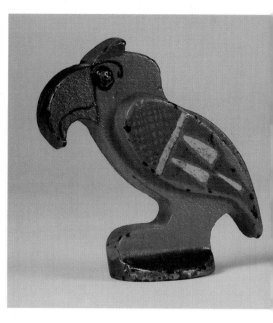

Angular parrot paperweight, 3.5" x 3.75". *Courtesy of Brooke Smith.*

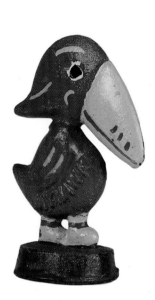

Kansas Jayhawk paperweight. Marked Kansas on one side and Jayhawk on the other. 3.75" x 2.5". *Courtesy of Brooke Smith.*

Hubley paper weight, Duffer Duck, 2.5" x 1.75". *Courtesy of Nancy and John Smith.*

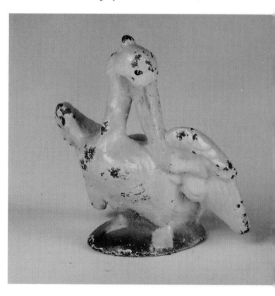

Hubley pelican, 2.75" x 2.5". *Courtesy of Brooke Smith.*

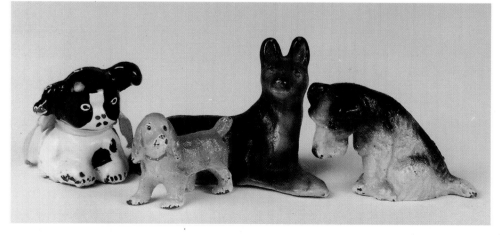

Puppy paperweights. 1" to 1.5". *Courtesy of Brooke Smith.*

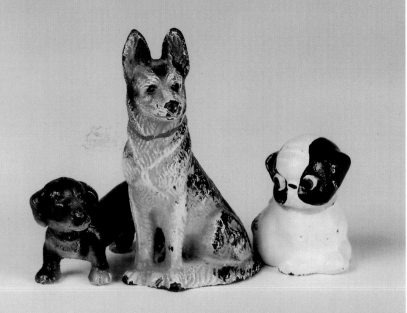

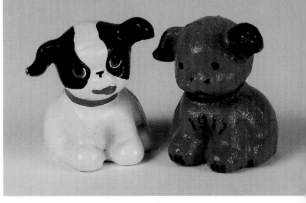

Puppies, 1.5". *Courtesy of Brooke Smith.*

Dog paperweights, German shepherd, 3", dachshund, 1.5" x 2.5", puppy with bee on hip, 1.5". *Courtesy of Brooke Smith.*

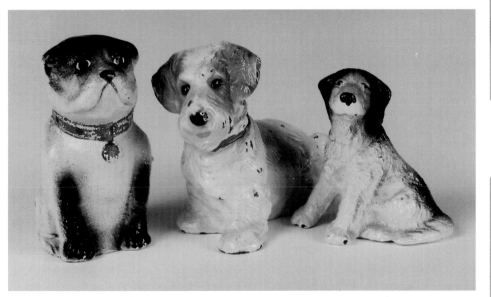

Puppy paperweight and pencil holder. The pencil was tied with a string to the puppy's tail. 1.75" x 2". *Courtesy of Brooke Smith.*

Dog paperweights. 2" to 2.5". *Courtesy of Brooke Smith.*

Elephant paper weight, 1.75" x 1.5". *Courtesy of Brooke Smith.*

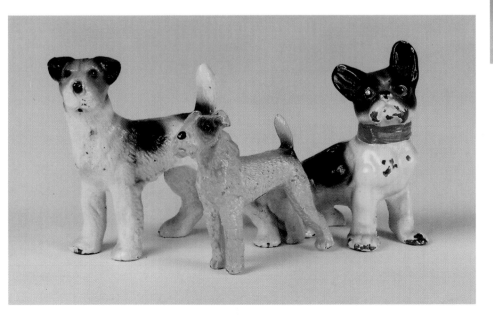

Dog paperweights, 2.5" to 3". *Courtesy of Brooke Smith.*

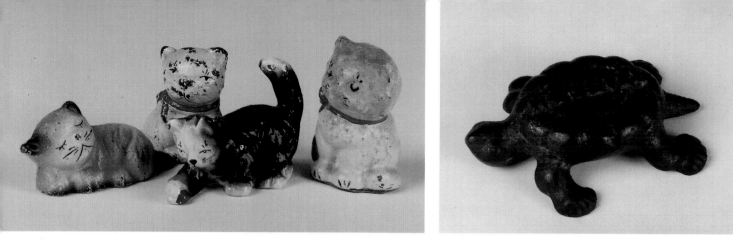

Kitten paperweights, 1" to 1.75". *Courtesy of Brooke Smith.*

Turtle paperweight, marked Hoosier on back. 1" x 3". *Courtesy of Brooke Smith.*

Elephant paperweight advertising the Independent Stove Co., Owosso, Michigan. The other side of the elephant reads "Renown Underfeed Stoves." 2" x 3.25". *Courtesy of Brooke Smith.*

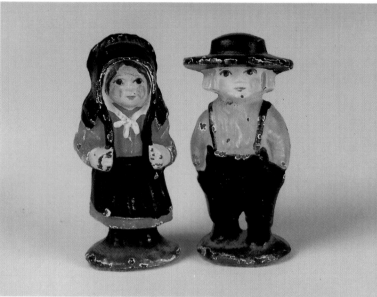

Amish kids, 2.5". *Courtesy of Brooke Smith.*

Three dimensional Amish couple paperweights, 4" x 1.5". *Courtesy of Brooke Smith.*

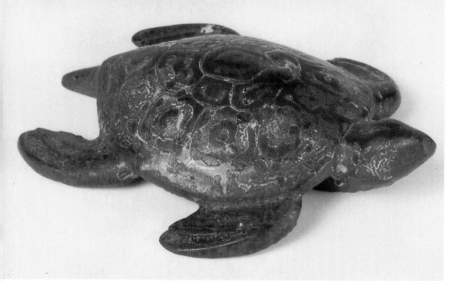

Sea turtle paperweight, 1" x 4.5". *Courtesy of Brooke Smith.*

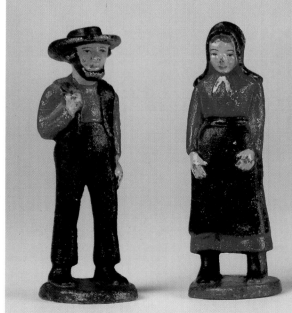

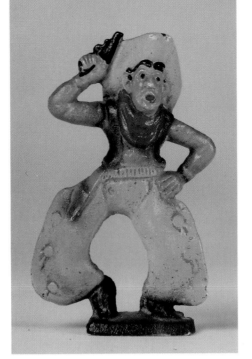

Cowboy paperweight, 4.25" x 3".
Courtesy of Brooke Smith.

Kissing children, 3.25" s 2.5". *Courtesy of Nancy and John Smith.*

Advertising paperweight turtles,
Courtesy of Brooke Smith.

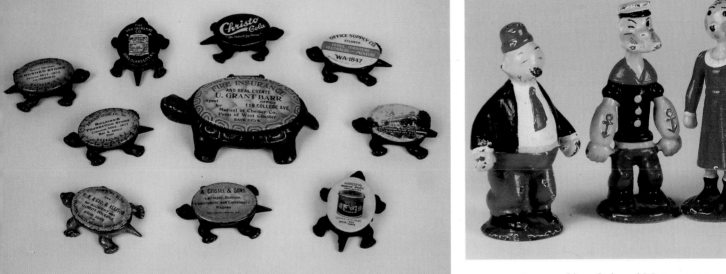

Popeye, Olive Oyl, and Wimpy paper-
weights by Hubley. 3" to 3.25" tall.

Black family of paperweights, 2" to
3.25" tall. *Courtesy of Brooke Smith.*

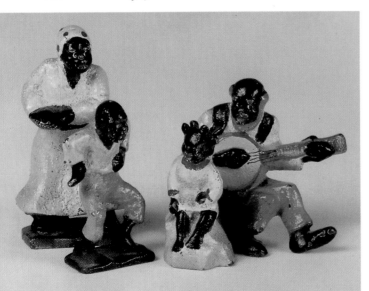

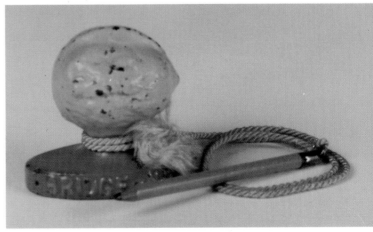

"Bridge Nut" paperweight with pencil for scoring bridge. 2" x
2". *Courtesy of Brooke Smith.*

Paper Weights **151**

PENCIL HOLDERS

Duck and duckling pencil holder, Hubley. 2" x 1.75". *Courtesy of Nancy and John Smith.*

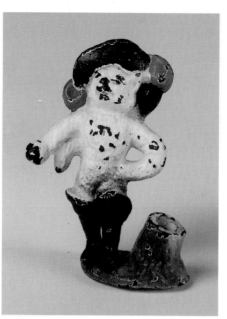

Puss 'n Boots, Hubley. 3" x 2". *Courtesy of Nancy and John Smith.*

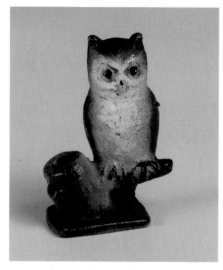

Owl pencil holder, Hubley. 2.25" x 1.5". *Courtesy of Nancy and John Smith.*

The Three Bears pencil holder, Hubley. 1.5" x 2.5". *Courtesy of Nancy and John Smith.*

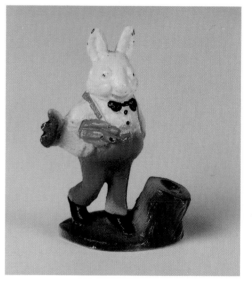

Peter Rabbit, Hubley. 2.75" x 2". *Courtesy of Nancy and John Smith.*

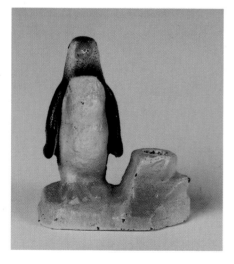

Penguin pencil holder, 2.25" x 2". *Courtesy of Brooke Smith.*

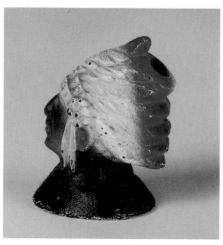

Indian head pencil holder, 2.25" x 1.5". *Courtesy of Brooke Smith.*

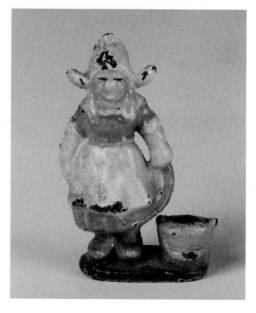

Dutch girl pencil holder, 2.75" x 1.75". *Courtesy of Brooke Smith.*

STRING HOLDERS

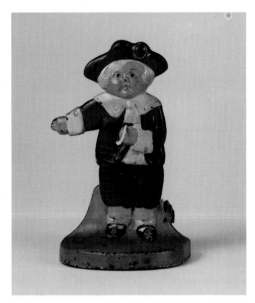

Pilgrim boy string holder, 9" x 5.5".
Courtesy of Nancy and John Smith.

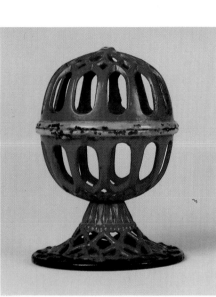

Pierced string holder, 6" x 4.25".
Courtesy of Nancy and John Smith.

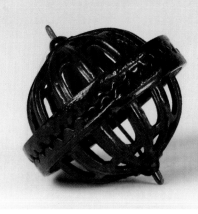

Hanging string holder. 2.5" x 2.75".
Courtesy of Nancy and John Smith.

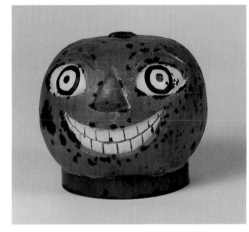

Jack-O-Lantern string holder, 4.5" x 5".
Courtesy of Nancy and John Smith.

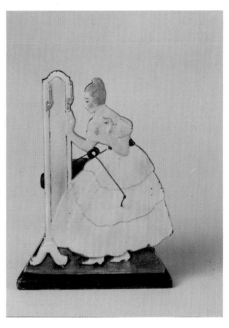

Woman at mirror string holder, 8" x
5.5". *Courtesy of Nancy and John Smith.*

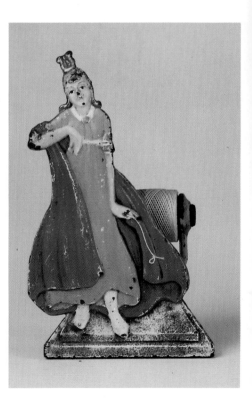

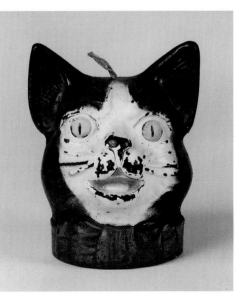

Cat string holder, 6" x 4.5". *Courtesy of
Nancy and John Smith.*

Woman, 8.5" x 5". *Courtesy of Nancy and
John Smith.*

BANKS

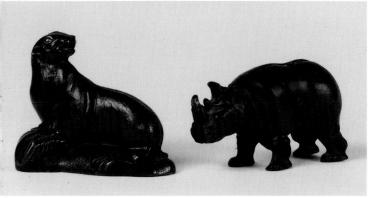

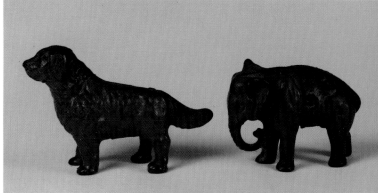

Rhinoceros and seal on rock banks, Arcade. Rhino, 2.5" x 5"; seal, 3.5" x 4.25". *Courtesy of Nancy and John Smith.*

Newfoundland and elephant still banks, each with original Arcade sticker. Dog, 3.75" x 5.25"; elephant, 2.75" x 4". *Courtesy of Nancy and John Smith.*

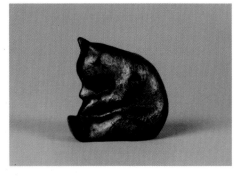

Honey bear bank, 2.5"x 2.5". *Courtesy of Nancy and John Smith.*

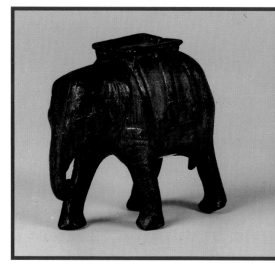

McKinley/Teddy Roosevelt Prosperity elephant bank, from their 1900 campaign. Harper?, 2.5" x 3.5". *Courtesy of Nancy and John Smith.*

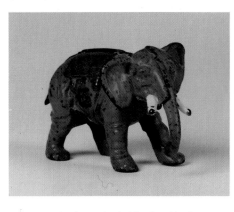

Circus elephant with blanket bank, Kenton. 3.25" x 5". *Courtesy of Nancy and John Smith.*

Sitting elephant, 4.25" x 2". *Courtesy of Nancy and John Smith.*

Stiff legged elephant, Harris Toy Co., 1904. 3.75" x 4.5". *Courtesy of Nancy and John Smith.*

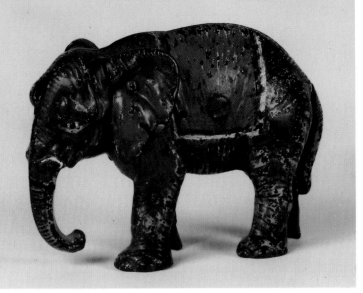

Circus elephant with blanket bank, Kenton. 3.25" x 5". *Courtesy of Nancy and John Smith.*

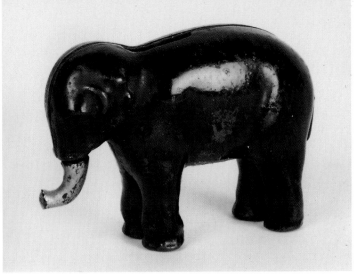

Elephant with swivel trunk, 2.5" x 3.5". *Courtesy of Nancy and John Smith.*

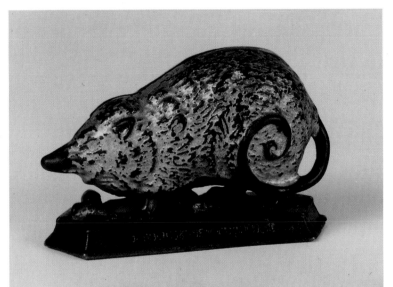

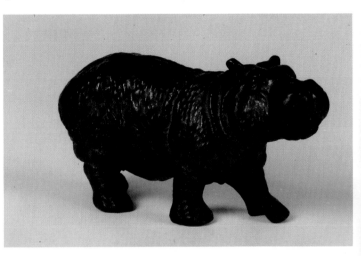

Very rare hippo, 2.5" x 5.25". *Courtesy of Nancy and John Smith.*

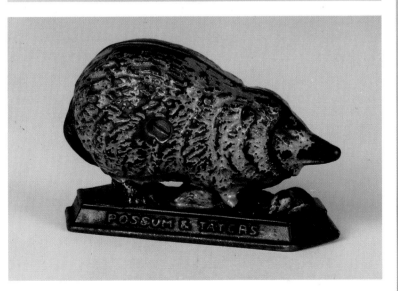

Billy Possum, Possum & Taters, a political take-off on William Taft, Copyright 1909, by Harpers. 3" x 4.75". *Courtesy of Nancy and John Smith.*

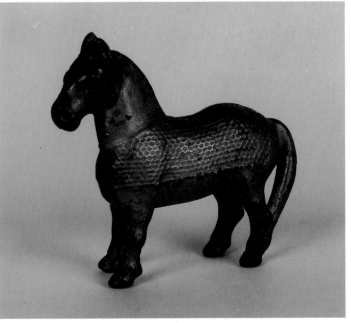

Horse with fly net, 4" x 4.5". *Courtesy of Nancy and John Smith.*

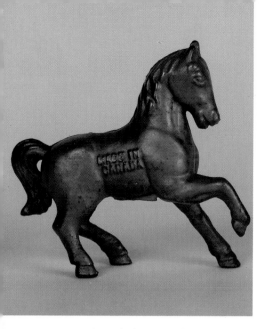

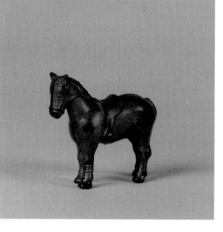

Pony bank, A.C. Williams. 2.75" x 3.25". *Courtesy of Nancy and John Smith.*

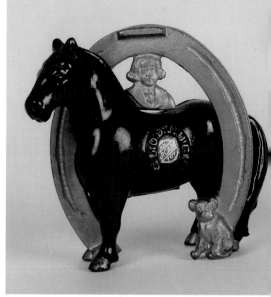

Made in Canada horse bank, 4.25" x 4.75". *Courtesy of Nancy and John Smith.*

Buster Brown and Tige grace the horse shoe on this Arcade bank. The Arcade sticker is inside the smaller horse shoe on the horse's side. 4.5" x 5". *Courtesy of Nancy and John Smith.*

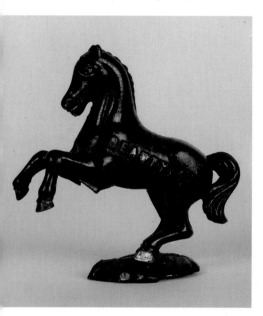

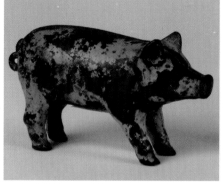

Pig bank, 2.25" x 4". *Courtesy of Nancy and John Smith.*

Beauty rearing, 5" X 4.5". *Courtesy of Nancy and John Smith.*

Pig bank, by Arcade, 1910-1932. Very similar to the earlier Harper pig. 2" x 4". *Courtesy of Nancy and John Smith.*

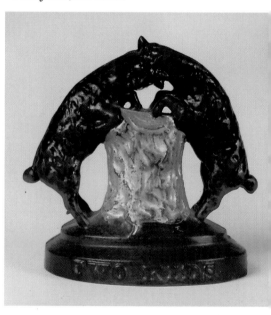

"Two Kids", Harper?, still bank, 4.75" x 4.5". *Courtesy of Nancy and John Smith.*

Pig bank by Shimmer Toy Co., 5.25" x 3.25". *Courtesy of Nancy and John Smith.*

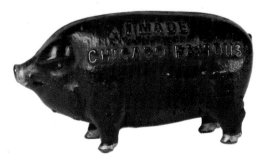

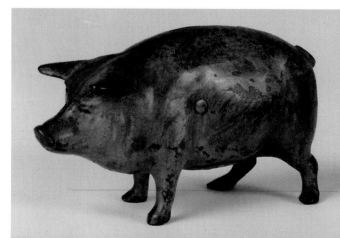

"I made Chicago famous" bank, J.M. Harper, Copyright 1902. 2" x 4". *Courtesy of Nancy and John Smith.*

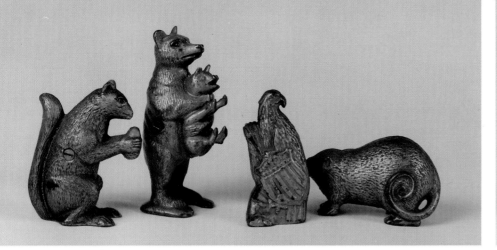

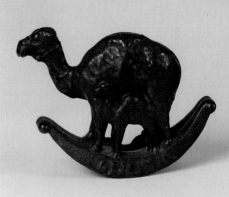

Animal still banks: eagle with shield, 4", possum (Arcade), 2.75" x 4.5", bear stealing pig, 5.5" x 2.75", squirrel, 4" x 3.25". *Courtesy of Nancy and John Smith.*

"Oriental" rocking camel, still bank, 4.5" x 5.75". *Courtesy of Nancy and John Smith.*

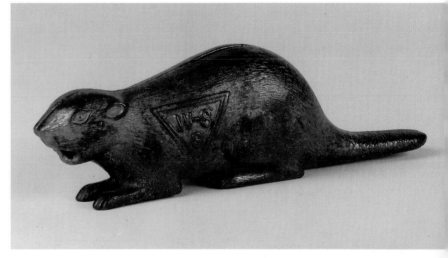

Cow, A.C. Williams, 3.5" x 5.25". *Courtesy of Nancy and John Smith.*

Beaver, W-S S, 2.25" x 7.5". *Courtesy of Nancy and John Smith.*

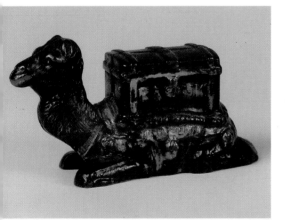

Resting camel, Kaiser & Rex, 1899. 2.5" x 5".

Turtle, marked "Turtle Bank" on the bottom. Head pivots to reveal slot. 1.25" x 3.5". *Courtesy of Nancy and John Smith.*

Basset hound, 3" x 4". *Courtesy of Nancy and John Smith.*

Roosting hens. The one on the left has the slot on the back, the other has its slot on the bottom of the piece. 3.25" x 3.25". *Courtesy of Nancy and John Smith.*

IFC fish bank, 2.25" x 7". *Courtesy of Nancy and John Smith.*

Kitten with bow, Gray Iron Casting Co., 4.5" x 7". *Courtesy of Nancy and John Smith.*

The quilted lion, 3.75" x 5". *Courtesy of Nancy and John Smith.*

Spitz, 4.25" x 4.5". *Courtesy of Nancy and John Smith.*

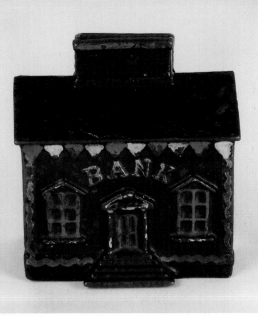

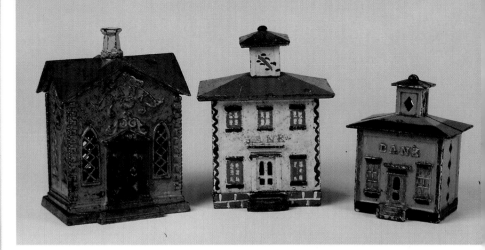

House banks: Villa Bank, Kaiser & Rex, 1894, 5.5" x 4", Cupola bank, J & E Stevens, 1869, 5.5" x 4.5"; small cupola, J & E Stevens, 1872, 4.25" x 3". *Courtesy of Nancy and John Smith.*

Chimney Bank, 3" x 2.75". *Courtesy of Nancy and John Smith.*

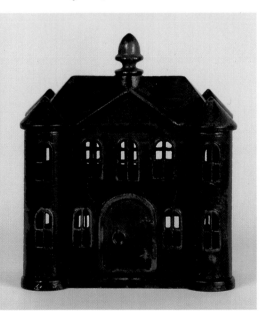

Tower building bank, 1886. 5.5" x 4.75". *Courtesy of Nancy and John Smith.*

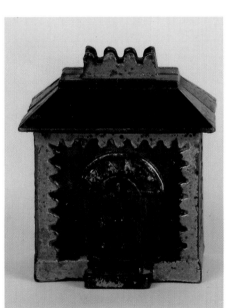

Bank building, 3.5" x 3". *Courtesy of Nancy and John Smith.*

Oriental building bank, Keyser & Rex, 3" x 2.75". *Courtesy of Nancy and John*

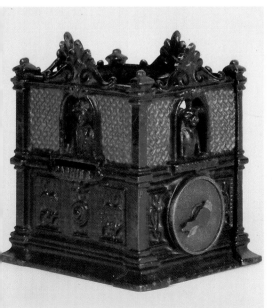

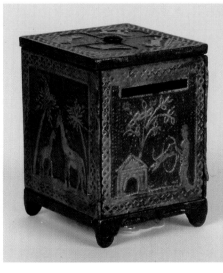

The Fidelity safe has Buster Brown appearing at one window and Tige at the other three. Buster's window identifies him as Cashier. Tige's windows identify him variously as Fidelity, Security, and Paying Teller. There is a combination lock. 5" x 4.5". *Courtesy of Nancy and John Smith.*

"Sport" safe, patent January 8, 1882. *Courtesy of Nancy and John Smith.*

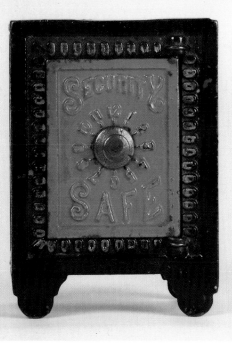

Security safe with combination lock, 4.5" x 3.25". *Courtesy of Nancy and John Smith.*

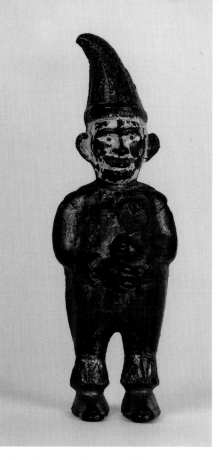

The Clown with the Crooked Hat, 7" x 2.25". *Courtesy of Nancy and John Smith.*

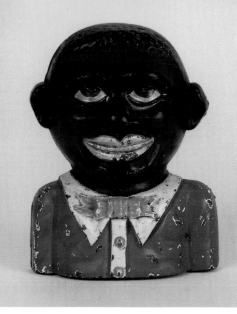

Young negro, Racer Product, 4.5" x 3.75". *Courtesy of Nancy and John Smith.*

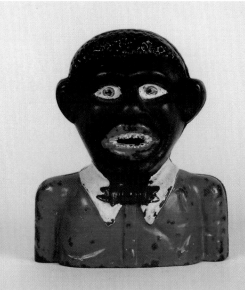

Pickaninny Money Bank, No. 3000, 5.25" x 4.25". *Courtesy of Nancy and John Smith.*

Man on bale of cotton still bank, U.S. Hardware Company. 5" x 4". *Courtesy of Nancy and John Smith.*

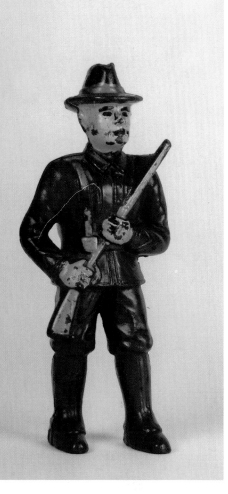

The soldier, 6" x 2.5". *Courtesy of Nancy and John Smith.*

Billy Bounce bank, 5" x 2.5". *Courtesy of Nancy and John Smith.*

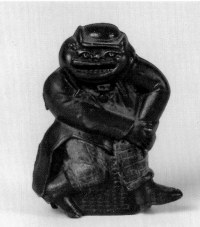

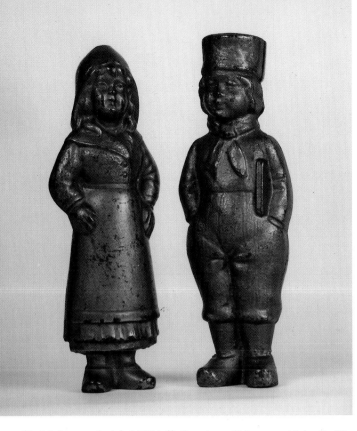

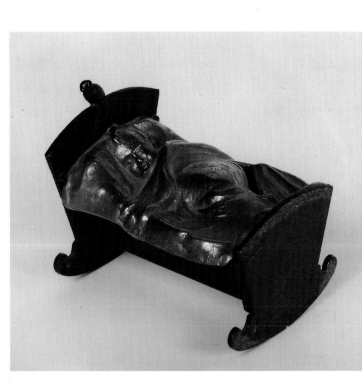

Dutch boy and girl, 6.75" tall. *Courtesy of Nancy and John Smith.*

Baby in cradle, 3.5" x 3.75". *Courtesy of Nancy and John Smith.*

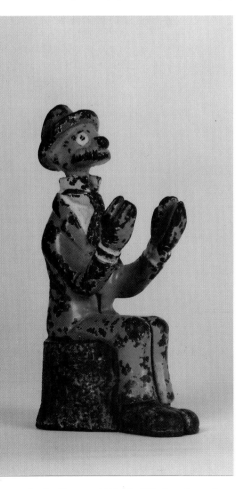

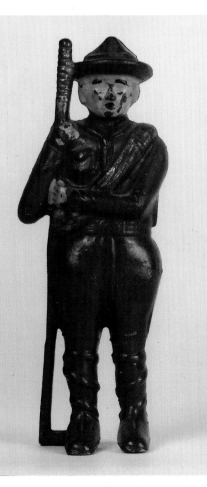

Andy Gump, 4.5" x 1.75". *Courtesy of Nancy and John Smith.*

Boy scout with scarf and buckle, 5.75" x 2.25". *Courtesy of Nancy and John Smith.*

Doughboy, 7" x 2.5". *Courtesy of Nancy and John Smith.*

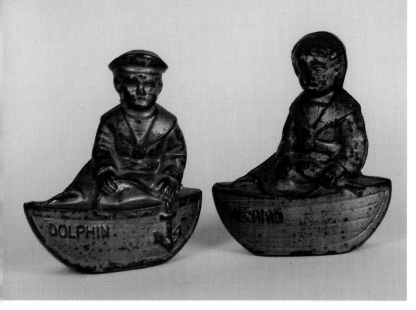

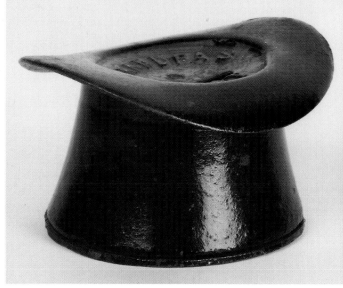

Mermaid and Dolphin, 4.5" x 4". *Courtesy of Nancy and John Smith.*

Grandpa's Hat, 2" x 4". *Courtesy of Nancy and John Smith.*

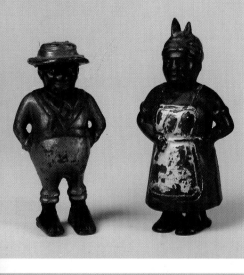

Aunt Jemima with spoon and share-cropper banks, both A.C. Williams, 5.25" x 2.75". The slot for Aunt Jemima is at the bottom of her feet. The share-cropper is the rarer variety with the toes of both feet showing.

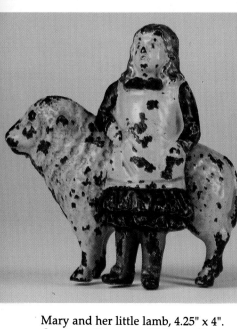

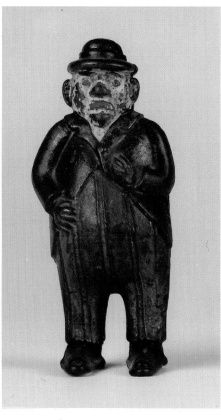

"Pass 'Round the Hat", 1.5" x 3". *Courtesy of Nancy and John Smith.*

Mary and her little lamb, 4.25" x 4". *Courtesy of Nancy and John Smith.*

The Capitalist, 4.75" x 2.5", c. 1890. *Courtesy of Nancy and John Smith.*

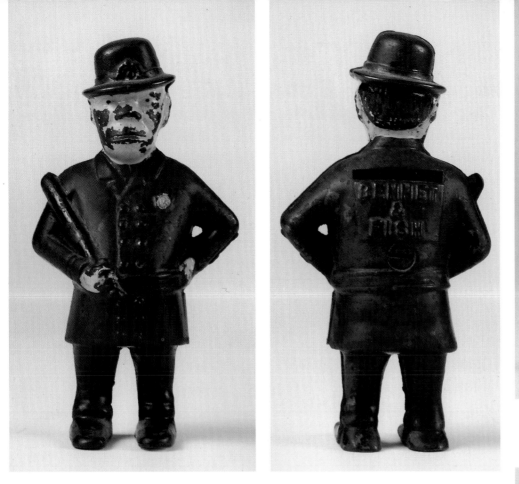

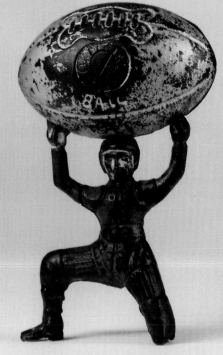

Boy with large football resembling Atlas holding the world. Hubley, 5.25" x 3.25". *Courtesy of Nancy and John Smith.*

Mulligan the cop bank, with advertising for Bennet & Fish on the back. Hubley, 5.75" x 3". *Courtesy of Nancy and John Smith.*

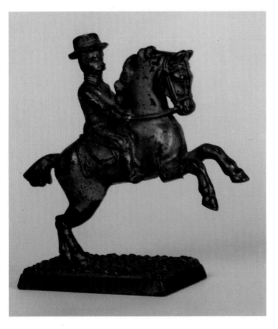

Sheridan on his steed, 6" x 6". *Courtesy of Nancy and John Smith.*

Beehive, Kaiser Rex. 2.5" x 3". *Courtesy of Nancy and John Smith.*

"Wisconsin's Historic War Eagle-Old Abe," 3" x 3". *Courtesy of Nancy and John Smith.*

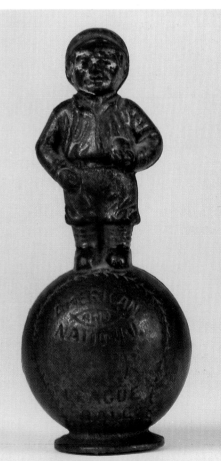

The Mascot, ballplayer on baseball, 6" x 2.5". *Courtesy of Nancy and John Smith.*

***Banks* 163**

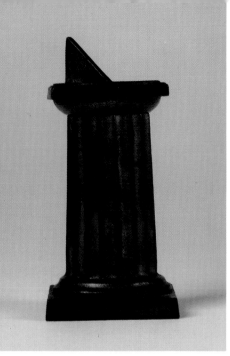

Arcade sundial, 4.25" x 2". *Courtesy of Nancy and John Smith.*

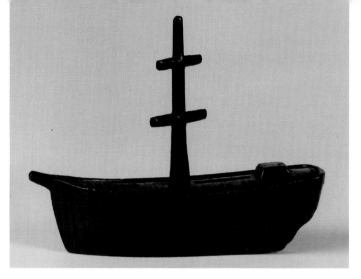

"Fortune" ship. On the deck it says "Fortune" and "When My Ship Comes In.". 4" x 5.25". *Courtesy of Nancy and John Smith.*

26-sided alphabet bank, 4", *Courtesy of Nancy and John Smith.*

Cannon bank, A.C. Williams, 3.5" x 8". *Courtesy of Nancy and John Smith.*

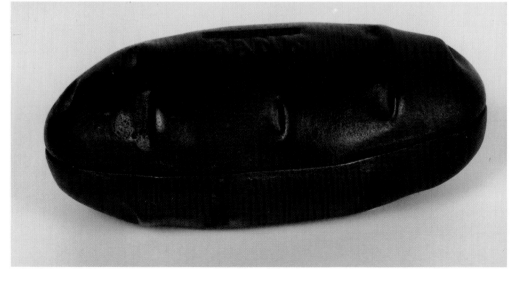

Potato bank, 2.25" x 5.5". *Courtesy of Nancy and John Smith.*

LAWN SPRINKLERS

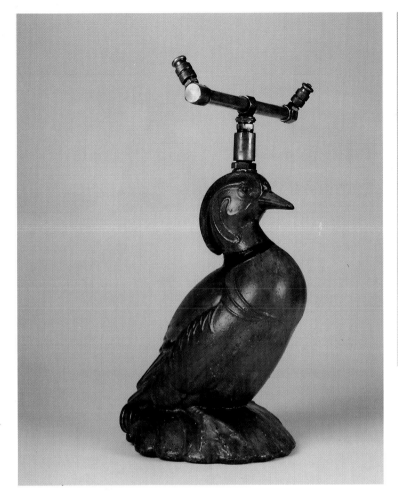

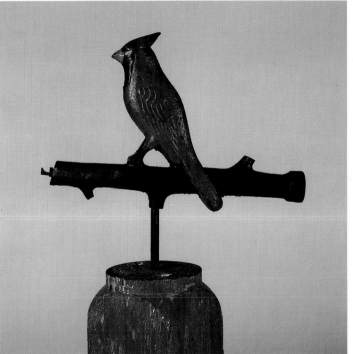

Cardinal on a branch, 10" x 12". *Courtesy of Nancy and John Smith.*

Wood duck lawn sprinkler, 14" x 7". *Courtesy of Linda Bilo.*

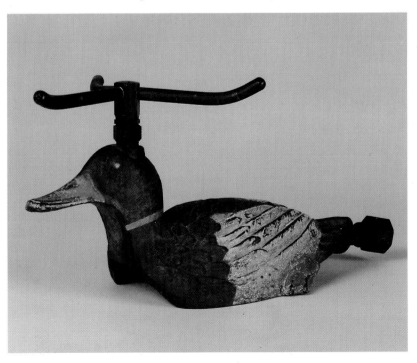

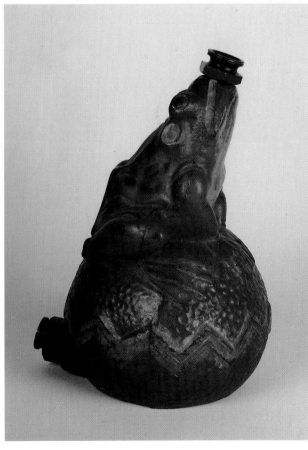

Mallard lawn sprinkler, 6.75" x 13". *Courtesy of Linda Bilo.*

Frog on globe water sprinkler, 9" x 6.5". *Courtesy of Nancy and John Smith.*

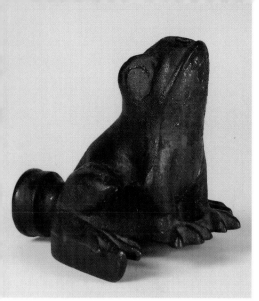

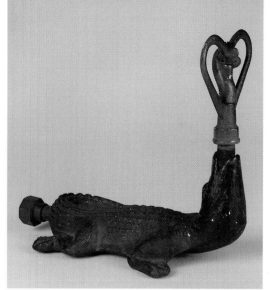

Alligator lawn sprinkler, 9" x 10".
Courtesy of Linda Bilo.

Frog lawn sprinkler, 4" x 4.5". *Courtesy of Linda Bilo.*

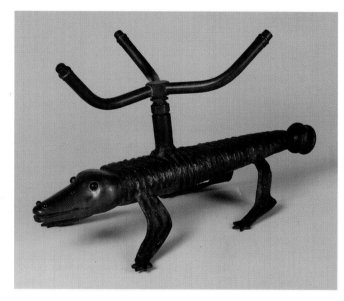

Crocodile lawn sprinkler, 7" x 12".
Courtesy of Linda Bilo.

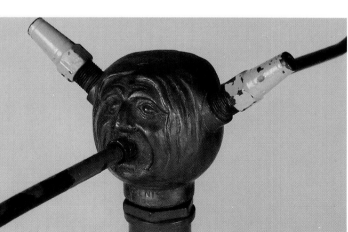

Two-faced man, 18" x 30". *Courtesy of Linda Bilo.*

Space ship lawn sprinkler, 10" x 9.5". *Courtesy of Linda Bilo.*

MISCELLANEOUS

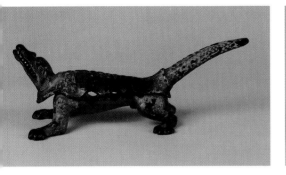

Alligator cork press, 4" x 11". *Courtesy of Nancy and John Smith.*

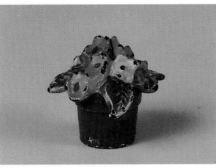

Rare Hubley cardholder in the shape of a pot of flowers. 1.5" x 1.5". *Courtesy of Nancy and John Smith.*

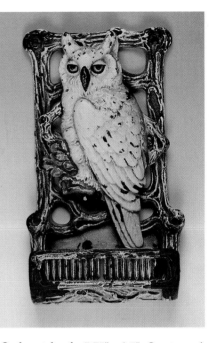

Owl matchsafe, 5.75" x 3.5". *Courtesy of Nancy and John Smith.*

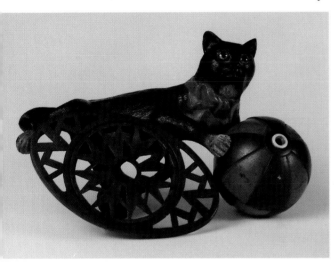

This contraption was used by a seamstress to seal the hem of a garment. Wax went beneath the trivet-like piece, over which the fabric was pulled. Binding material was stored in the ball. The cat has glass eyes. 4.5" x 11.5" x 8". *Courtesy of Nancy and John Smith.*

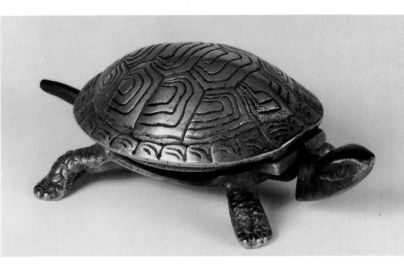

Turtle servant's bell, 2.5" x 7". *Courtesy of Brooke Smith.*

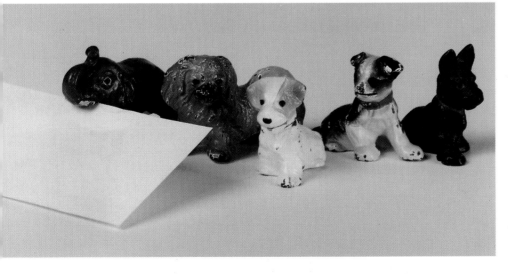

Cardholders. These hold the cards in their mouths. *Courtesy of Brooke Smith.*

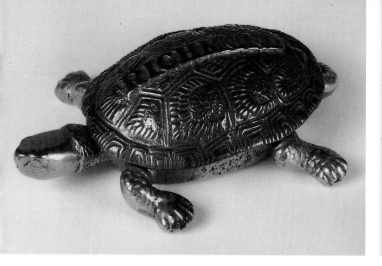

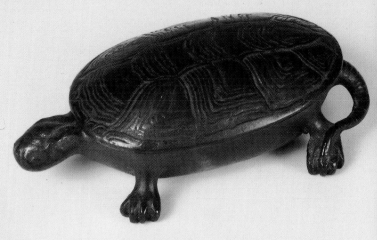

Turtle box, advertising Richmond Stove Company, Norwich, Connecticut. 1.5" x 4.75". *Courtesy of Brooke Smith.*

Turtle box, 1.5" x 5". *Courtesy of Brooke Smith.*

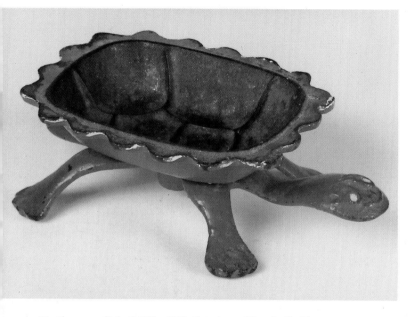

Turtle soap dish, 1.75" x 5.5". *Courtesy of Brooke Smith.*

Vest advertising matchsafe. On the front it says Wanamaker & Brown, 6 & Market, Men's & Boy's Clothing. On the back it says "Kyser & Rex., Variety Iron Works, Frankford, Phila. Pa. 3.5" x 2.75". *Courtesy of Nancy and John Smith.*

Yale Bull Dog hanger attachment, 6.5" x 5". *Courtesy of Brooke Smith.*

Cat head gate latches, patented 1895.
Left: 5.5" x 5"; 4.5" x 5". *Courtesy of
Nancy and John Smith.*

Target, 11" x 10.25". *Courtesy of Nancy and John Smith.*

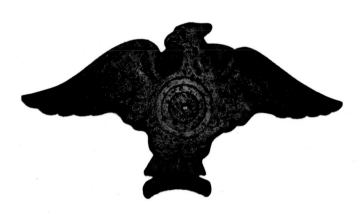

Eagle target, Smith Manufacturing Co., Chicago, Illinois. 11" x
22". *Courtesy of Nancy and John Smith.*

Woman lying on back bootjack. 2.75" x 9.25". *Courtesy of Sheila
and Edward Malakoff.*

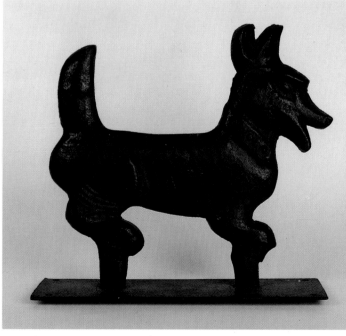

Dog boot scraper, 11" x 12". *Courtesy of Nancy and John Smith.*

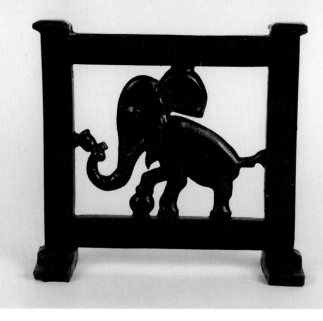

Elephant with bell boot scraper, 8" x 8.5". *Courtesy of Nancy and John Smith.*

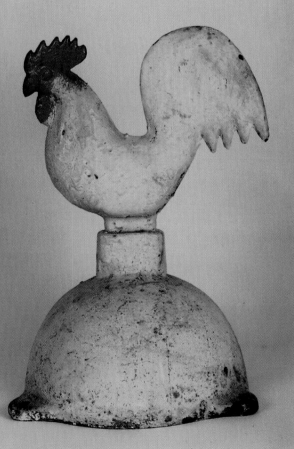

Bull windmill weight, 12.5" x 14.5". *Courtesy of Nancy and John Smith.*

Rooster windmill weight,

Poinsettia candleholders.

THE MODERN DAY CASTING OF IRON

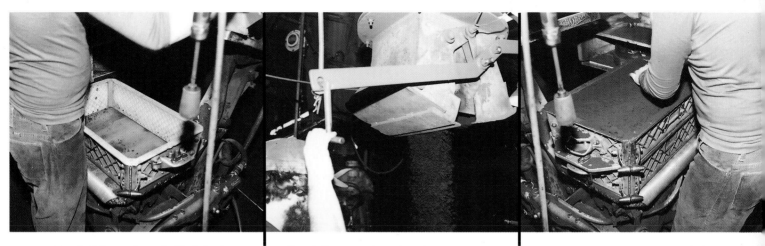

Randy Isham places half of the frame on the pallet.

Specially treated sand with good packing properties is dumped into the frame from the hopper above.

More sand is then added to fill the frame.

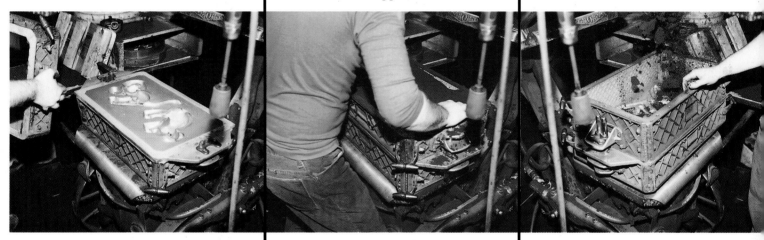

The doorstop mold is fitted to the top of the frame...

The sand is spread by hand to fill the mold and frame evenly.

When one side is filled the frame is flipped and the process is repeated on the other. First it is filled...

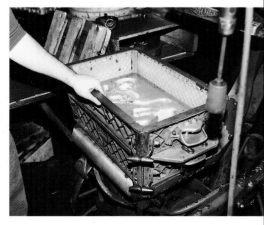

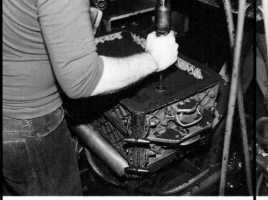

and the other half of the frame is attached.

A power tamper is then used to tighten the packing.

Then it is tamped and leveled.

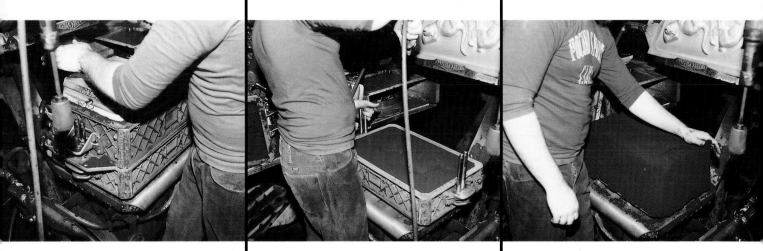

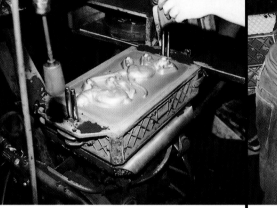

A wooden board cut to fit inside the frame is placed on top of the sand.

The top half of the frame is removed with the sand intact so that the mold can be removed from between the two halves.

the edge knocked off...

Hydraulic pressure is applied to compress the sand so it will hold the shape of the mold after frame is removed.

Loose sand is removed with a stream of air.

and the mold moved to the conveyor for casting.

A brass tube is inserted to create a hole through which the molten iron will be poured.

The two halves of the sand mold are reassembled and the frame removed...

Molds awaiting casting.

A jacket is placed around the mold and weights placed on top of it to help the mold hold its shape during casting.

Further down the belt the sand is removed and returned for recycling, while the casting proceeds to the next step.

and runs them through the Pangborn Blast Machine. This uses ball bearings to clean and smooth the rough castings.

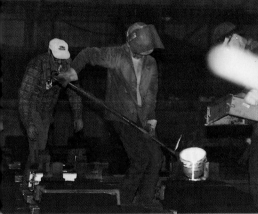

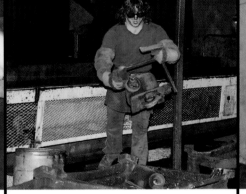

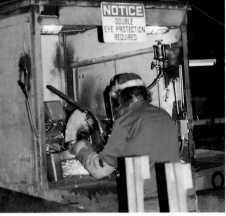

Charlie Fillmore uses a ladle to pour the molten iron into the mold.

Shawn sorts the pieces as they come off the shakeout belt.

The casting is then cut to remove excess metal from the casting process. Jim Whitmore operates the cut-off saw.

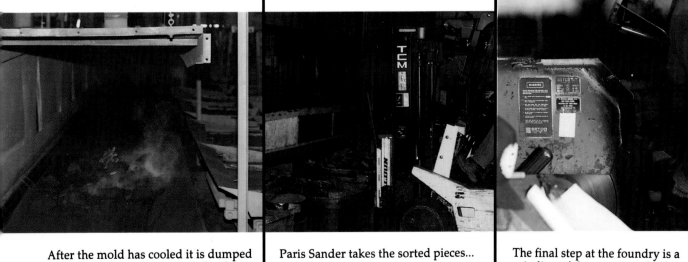

After the mold has cooled it is dumped onto the shakeout belt. The belt vibrates to remove the sand from the casting.

Paris Sander takes the sorted pieces...

The final step at the foundry is a grinding of the casting to further refine it. The piece is then sent to the finisher.

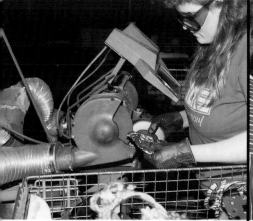

In the finishing area the castings undergo a finish grinding. Melissa Figer works on flower basket doorstops.

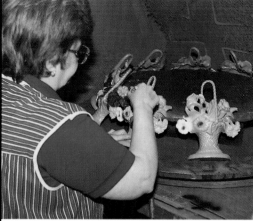

At another station Nancy Gipe adds detail to the flowers and paints the foliage.

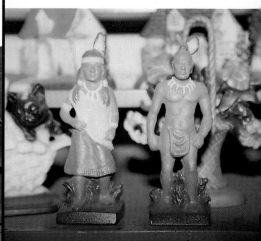

Among the John Wright designs currently being produced are the Indian Brave and Maiden...

Doorstops then receive a base coat of paint and are stacked for the detail painting.

An antiquing spray is finally applied...

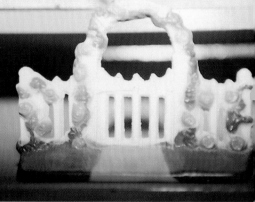

the Rose Arbor...

At the painting station the doorstops are placed on a revolving table. Today most painting is done by spraying. Jane Fritz paints flowers according to the designer's color choices.

and the excess removed.

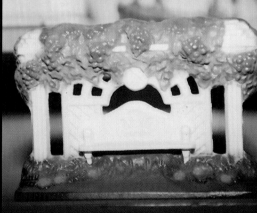

and the Grape Arbor.

Opposite page photo:

Color coded molds are hung from the rafters between use. They are not damaged in the casting process and last for many years. Many of these molds were purchased from Hubley in the late 1940s.

Price Guide

This price guide was established with the help of some of America's foremost experts in figurative cast iron. The prices reflect the value of a fine or perfect example of the item shown, even if the particular item photographed may be of either lower or higher quality. Prices will vary in different geographic locations and according to particular dealers. As always, the best advice for beginning collectors is to deal with an experienced professional dealer in figurative cast iron. They are more than happy to share their expertise with you and will usually stand by the authenticity of the piece they sell you. Reproductions are always a problem with cast iron, and until you develop a good eye, it is easy to be fooled. Because of a variety of factors that go into pricing, this can *only* serve as a guide. The publisher and author cannot be help responsible for any gain or loss the reader may incur by using this guide.

CODES

Position:

T=TOP **TL**=TOP LEFT **TC**=TOP CENTER **TR**=TOP RIGHT
CL=CENTER LEFT **C**=CENTER **CR**=CENTER RIGHT
BL=BOTTOM LEFT **BC**=BOTTOM CENTER **BR**=BOTTOM RIGHT

If more than one item is in a photo they are numbered from l-r

Price:

A= less than $50 (most of these items are thought to be in current production)	B=$50-100	E=$500-750
	C=$100-300	F=$750-1000
	D=$300-500	G=Over $1000

PAGE	POS.	$	PAGE	POS.	$	PAGE	POS.	$	PAGE	POS.	$	PAGE	POS.	$	PAGE	POS.	$	PAGE	POS.	$
8	TL	B		BR	A		CR	G		TR	C	43	TL	C		C	E		TR	C
	BL	C	13	TL	A	20	TL	D		CR	A		CL	F		BR	D		BR	G
	TR	C		CL	D		BL	D		BC	C		BL	C		BC	C	66	TL	B
	BC	A		TR	B		TR	A	32	TL	E		TR	D	54	TL	B		CR	D
	BR	D		BC	E		BR	G		TR	C		BR	E		CL	B		BL	B
9	TL	C		BR	B	21	TL	C		BR	C	44	TL	D		BL	B	67	TL	B
	BL	E	14	TL	D		BL	D	33	TL	C		CL	A		TR	B		R	B
	TC	E		BL	D		TR	F		BL	B		BL	A		BR	B		BL	C
	BC	A		TR	E		CR	C		CR	D		TC	F	55	TL	D	68	TL	B
	TR	E		BR	C		BR	D	34	TL1	C		TR	G		CL	D		BL	B
	BR	F	15	TL	E	22	TL	B		TL2	C		BR	A		B	F-set		TR	B
10	TL	G		BL	D		CL	C		BL	C	45	TL	D		TR	D		BR	D
	BL	C		TR	C		BL	E		TR	D		BL	G		CR	D	69	TL	B
	TC	D		BL	B		TC	E		CR	D		BC	F	56	TL	D		TC	C
	C	D	16	TL	F		BC	D		BC	D		TR	A		CL	D		TR	B-ea.
	BC	F		BL	B		TR	D	35	TL	C		BR	B		BL	C		B	G-ea.
	TR	E		TR	B	23	TL1	D		BL1	B	46	TL	D		TR	C	70	TL	G
	(reproduction less than $50)			BC	B		TL2	D		BL2	D		BL	C		CR	C		BL	G
11	TL	A		BR	B		TL3	E		TR	D		TR	C	57	TL	E		TR	C-ea.
	CL	A	17	TL	C		CL	E		CR	E		CR	B		CL	C		CR	D
	BL	D		BL	B		BL	E		BR	D		BR	D		TR	E		BC	D
	TR	D		TR	D		CR	F	36	TL	E	47	TL	D		CR	D	71	TL	D
	CR	E		BR	C	24	TL	A		CL	E		CL	A		BR	D		TC	D
	BC	B	18	TL	E		CL	D		BL	C		BL	A	58	TL	D		TR	D
	BR	A		BL	D		TR	D		TR	C		TR	B		CL	D		BL	B
12	TL	D		TR	D		BR	D		CR	C		CR	D		BL	E		BC	G
	CL	D		BR	D	25	TL	B		BR	C		BR	C		TR	E		BR	D
	TR	B	19	TL	C		CL	F	37	TL	E	48	TL	G		CR	D	72	TL	F-Sambo
				CL	C		TC	D		CL	E		CL	A		BR	B			F-Tiger
				BL	C		TR	C		BL	E		TR	B	59	TL	D		BL	E
				TR	G		CR	C		TR	E		CR	C		CL	E		TR	F
							BC	B		BR	C		BR	C		BL	D		BR	F
						26	TL	B	38	TL	F	49	TL	C		TR	D	73	TL	F
							CL	D		BL	E		BL	D		BR	D		BL	D
							TR	D		TC	A		TR	A	60	TL	C		TR	G-ea.
							CR	E		C	E		C	D		BL	C		BC	E
							BC	D		CR	B		BC	C		TR	B		BR	D
						27	TL	C		B	F-set		BR	C		BR	C	74	TL	A
							BL	D	39	TL	B	50	TL	G	61	TL	B		TC	F
							TC	D		CL	A		TC	A		BL	C		BL	D
							TR	E		TR	F		BL	D		C	C		TR	D
							BR	C		BR	F		TR	C		TR	C		BR	D
						28	TL	C	40	TL	D		BC	D		BR	C	75	TL	A
							CL	D		BL	D		BR	E	62	TL	C		BL	D
							TR	C		TC	C	51	TL	D		BL	C		TR	E
							BR	D		BC1	C		BL	F		TR	D		BR	E
						29	TL	E		TR	C		TC	G		BR	C	76	TL	E
							BL	D		BR1	B		R	D	63	TL	B		BL	G
							TC	B		BR2	C	52	TL	D		BL	B		TC	E
							TR	C	41	TL	C		CL	D		TR	C		TR	E
							BR	B		CL	A		BL	D		BR	C		BC	A
						30	TL	D		BL	C		BC	C	64	TL	B		BR	F
							BL	A		TC	D		TR	G		BL	D	77	TL	F
							TR	G		TR	D	53	TL	C		TR	B		BL	F
							CR	C		BR1	D					BR	C		TC	E
							BR	E		BR2	C				65	TL	C		BC	E
						31	TL	D	42	TL	E					BL	C		TR	?
							CL	D		BL1	D					TC	A			
							BL	F		BL2	D					BC	B			
										TR	D									

PAGE POS.$

PAGE	POS	$
	BR	D
78	TL	D
	TR	D
	BR	B
79	TL	E
	CL	E
	TR	E
	CR	D
	BC	D
80	TL	C
	TR	G
	CL	F
	C	E
	CR	D
	BC	G
81	TL	F
	TR	D
	BL	D
	BC	G
	BR	A
82	TL	E
	BL	E
	TC	E-ea.
	BC	A
	BR	A
83	TL	C
	BL	D
	TC	F
	TR	E
	BC	D
	BR	D
84	TL	F
	BL	D-ea.
	TC	E
	BC	E
	TR	D
	BR	G
85	TL	D
	BL	D
	TC	F
	BC	D
	TR	D
	BR	G
86	TL	A
	BL	A
	TC	A
	BC	A
	BR	G
87	TL	E
	TC	G
	TR	E
	BL	C
	BC	D
	BR	D
88	TL	D
	BL	C
	R	B
89	TL	D
	BL	D
	TC	D
	BC	D
	TR	?
	BR	A
90	TL	E
	BL	E
	TR	B
	BR	C
91	TL	C
	BL	D
	TC	C
	BC	D
	TR	B
	BR	D
92	TL	B
	TR	C
	C	C
	BL	C

PAGE	POS	$
	BR	E
93	TL	C
	TR	D
	BL	G
	BC	G
	BR	D
94	TL	A
	BL	D
	TC	E
	BC	E
	TR	D
	BR	D
95	TL	D
	BL	D
	TC	D
	BC	D
	TR	F
	BR	E
96	BL	C
	TL	D
	TR	E
	BR	F
97	TL	E
	BL	D
	TC	E
	TR	E
	BC	D
	BR	D
98	TL	D
	TR1	F
	TR2	B
	TR3	B
	BR	E-ea.
99	TL	A
	BL	D
	TR	E
	BR	B
100	TL	E
	BL	G
	TC	D
	BC	C
	TR	C
	BR	C
101	TL	C
	BL	D
	TC	D
	BC	?
	R	D
102	TL	F
	BL	D
	TC	D
	BC	D
	TR	E
	BR	D
103	TL	D
	BL	C
	TC	C
	BC	C
	TR	E
	CR	C
	BR	C
104	TL	D
	BL	C
	TC	D
	BC	F
	TR	C
	BR	G
105	TL	E
	BL	F
	C	F
	TR	E
	BR	E
106	L	C
	BR	C
107	TL	B
	CL	C
	BL	C

PAGE	POS	$
	TR	B
	CR	E
	BR	F
108	TL	B
	BL	B
	TR	B
	BR	B
109	TL	B
	BL	B
	TR	B
	BR	B
110	ALL	B
111	ALL	B
112	TL	B
	CL	B
	TR	C
	CR	C
	BR	D
113	T	D
	CR	C
	CL	C
	BR	C
114	T	C
	CL	C
	CR	C
	BL	D
	BR	D
115	T	D
	CR	D
	CL	C
	BR	D
116	T	D
	CR	C
	CL	D
	BR	C
117	TR	D
	TL	C
	CR	D
	CL	D
	BR	C
	BL	C
118	TL	D
	TR	B
	CL	B
	BL	B
	BR	C
119	TL	C
	TR	D
	CL	C
	CR	B
	BR	B
120	TL	B
	TR	D
	CL	C
	CR	E
	BL	C
	BR	C
121	TL	B
	TR	C
	CL	C
	CR	C
	B	B-ea.
122	TL	D
	CR	B
	CL	C
	CR	D
123	TL	D
	CL	D
	BL	B
	R	B
124	TL	D
	CL	D
	CR	C
	BL	C
	BR	B
125	TL	B
	TR	B

PAGE	POS	$
	CL	C
	CR	C
	BL	B
126	TL	C
	TR	C
	CL	B
	CR	B
	BL	B
	BR	B
127	TL	B
	TR	B
	CL	B
	BL	C
	BR	B
128	TL	A
	TR	A
	CL	B
	CR	B
	BL	B
	BR	C
129	TL	B
	TR	B
	CL	E
	C	B
	CR	B
	BL	D
	BR	D
130	TL	B
	TC	B
	TR	B
	BL	C
	BC	D
	BR	B
131	TL	B-ea.
	TR	C
	CL	B
	CR	B
	BL	C
	BR	B
132	TL	B
	TR1	C
	TR2	C
	TR3	B
	CL	C
	CR	B
	BL	B
	BR	D
133	TL	D
	TR	B
	BL	F
	CR	B
	BR	B-ea.
134	TL1	B
	TL2	C
	TR	C
	BL	B
	CR	B
135	TL	D
	TC	G
	TR	F
	BL	E
	BC	D
	BR	C
136	TL1	B
	TL2	C
	TL3	G
	TL4	D
	TR	G
	CL	C
	C	G
	CR	B
	BR1	A
	BR2	B
	BR3	A
	BR4	A

PAGE	POS	$
	BR5	A
137	TL	B
	TR	B
	CL	D-mold
	BC	B
	BR	C
138	TL	C
	TC	B-ea.
	TR	E
	CL	C
	C	E
	BR	D-ea.
139	TL	G
	TR	C
	CL	G
	C	D
	CR	G
	BC	G
	BR	G
140	TL	B
	TR	G
	CR	C
	BL	B
	BC	G
	BR	D
141	TL	B
	TC	C
	TR	B
	CL	B
	C	G
	CR	B
	BL	G
	BC	B
	BR	B
142	TL	D
	TC	C
	TR	D
	BL	G
	BC	B
	BR	B
143	TL	C
	TC	D
	TR	D
	CL	E
	C	E
	CR	D
	BC	B
144	TL	D
	TC	D
	TR	D
	CL	D
	C	D
	CR	D
	BC	D
145	TL	B
	TC	D
	TR	B
	BL	C
	BC	C
	BR	B
146	TL	E
	TC	B
	TR	E
	B	C-ea.
147	TL	F
	TC	D
	TR	D
	BL	D
	BC	DF
	BR	D
148	TL	C
	CL	C
	?	B
	TR	B
	CR	C
	BL1	A

PAGE	POS	$
	BL2	A
	BL3	B
	BL4	B
149	TL1	A
	TL2	B
	TL3	B
	TR	A
	CL1	C
	CL2	C
	CL3	B
	CR	B
	BL	B-ea.
	BR	B
150	TL	A
	TL	Cat with ball-B
	TR	B
	CL	C
	CR	B-set
	BL	C
	BR	b-set
151	TC	C
	TR	B
	CL	large-C
		small-B
	CR	G-set
	BL	D-set
	BR	C
152	TL	B
	TR	C
	CL	C
	C	B
	CR	C
	BL	C
	BC	B
	BR	B
153	TL	F
	TC	D
	TR	D
	CL	G
	BL	G
	BC	G
	BR	G
154	TL	D-ea.
	TR	C-ea.
	CL	E
	C	E
	CR	E
	BL	E
	BR	E
155	TL	D
	TR	C
	CL	G
	CR	G
	BR	D
156	TL	D
	TC	C
	TR	D
	CL	D
	C1	F
	C2	C
	CR	G
	BL	C
	BR	C
157	TL1	F
	TL2	F
	TL3	G
	TL4	E
	TR	G
	CL	C
	CR	G
	BL	E
	BR	G
	B	G

PAGE	POS	$
158	TL	G-ea.
	TR	G
	CL	G
	CR	D
	BL	D
159	TL	E
	TR	D-ea.
	CL	E
	C	C
	CR	D
	BL	E
	BR	C
160	TL	C
	TC	G
	TR	D
	BL	D
	BC	E
	CR	D
	BR	G
161	TL	E-ea.
	TR	G
	BL	G
	BC	D
	BR	E
162	TL	E-ea.
	TR	D
	CL	C-ea.
	CR	C
	BL	D
	BC	G
163	TL	G
	TR	G
	CL	E
	C	E
	CR	G
	B	G
164	ALL	G
165	TL	E
	TR	G
	BL	E
	BR	E
166	TL	B
	TR	E
	BL	E
	CR	F
	BR	D
167	TL	D
	TC	C
	TR	E
	CL	G
	CR	D
	BL	B-ea.
168	TL	C
	TR	C
	CL	B
	CR	D
	BR	D
169	T	D-ea.
	CL	G
	CR	G
	BL	C
	BR	D
170	L	F
	TR	D
	CR	G
	BR	B